# MECHA MANIA

W9-CNH-032

## HOW TO DRAW THE BATTLING ROBOTS, COOL SPACESHIPS, AND MILITARY VEHICLES OF JAPANESE COMICS

### CHRISTOPHER HART

RARITAN PUBLIC LIB.
54 E. SOMERSET STREET
RARITAN, NJ 08869
908-725-0413

WATSON-GUPTILL PUBLICATIONS/NEW YORK

*Dedicated to the mecha maniacs in all of us*

SPECIAL THANKS TO:

HEINZ SCHULLER and Fasa Studio at Microsoft for the wonderful interview and images from their amazing games,

to BILL FLANAGAN,

and of course, to the people at Watson-Guptill for making this possible.

CONTRIBUTING ARTISTS:

Lee Duhig: 89–98
Tim Eldred: 1, 7–19, 22–27
Keron Grant: 4, 99–117
Ruben Martinez: 28–35, 54–55
Grant Miehm: 82–88
Sean Song: 66–81
Dave White: 20–21, 36–51

Senior Editor: Candace Raney
Project Editor: Alisa Palazzo
Designer: Bob Fillie, Graphiti Design, Inc.
Production Manager: Ellen Greene

First published in 2002 by Watson-Guptill Publications
a division of VNU Business Media, Inc.
770 Broadway, New York, NY 10003
www.watsonguptill.com

Copyright © 2002 Art Studio LLC

**Library of Congress Cataloging-in-Publication Data**
Hart, Christopher.
    Mecha mania : how to draw the battling robots, cool spaceships,
        and military vehicles of Japanese comics / Christopher Hart.
            p. cm.
    Includes index.
    ISBN 0-8230-3056-3 (pbk.)
    1. Comic books, strips, etc.—Japan—Technique. 2. Robots—Caricatures
        and cartoons. 3. Drawing—Technique. I. Title.
    NC1764.5.J3 H3695 2002
    741.5—dc21

                                        2002006402

All rights reserved. No part of this publication may be reproduced or used in any form or by any means—graphic, electronic, or mechanical, including photocopying, recording, or information storage-and-retrieval systems—without the written permission of the publisher.

Manufactured in the United States of America

1 2 3 4 5 6 7 8 / 09 08 07 06 05 04 03 02

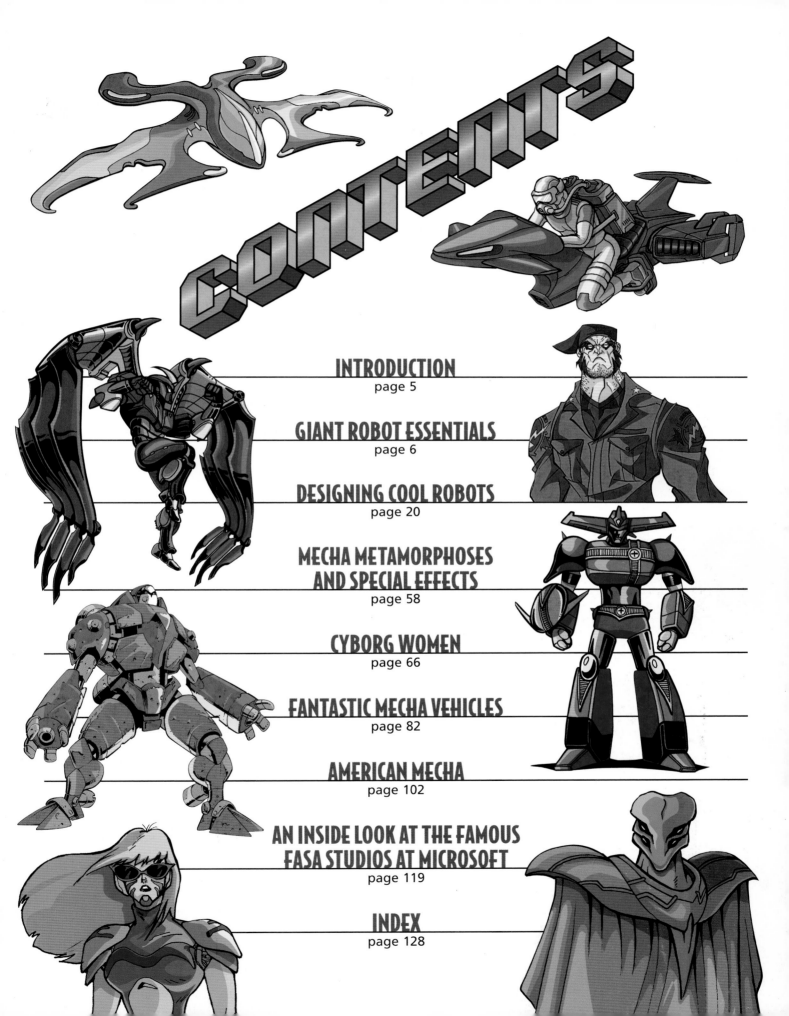

# CONTENTS

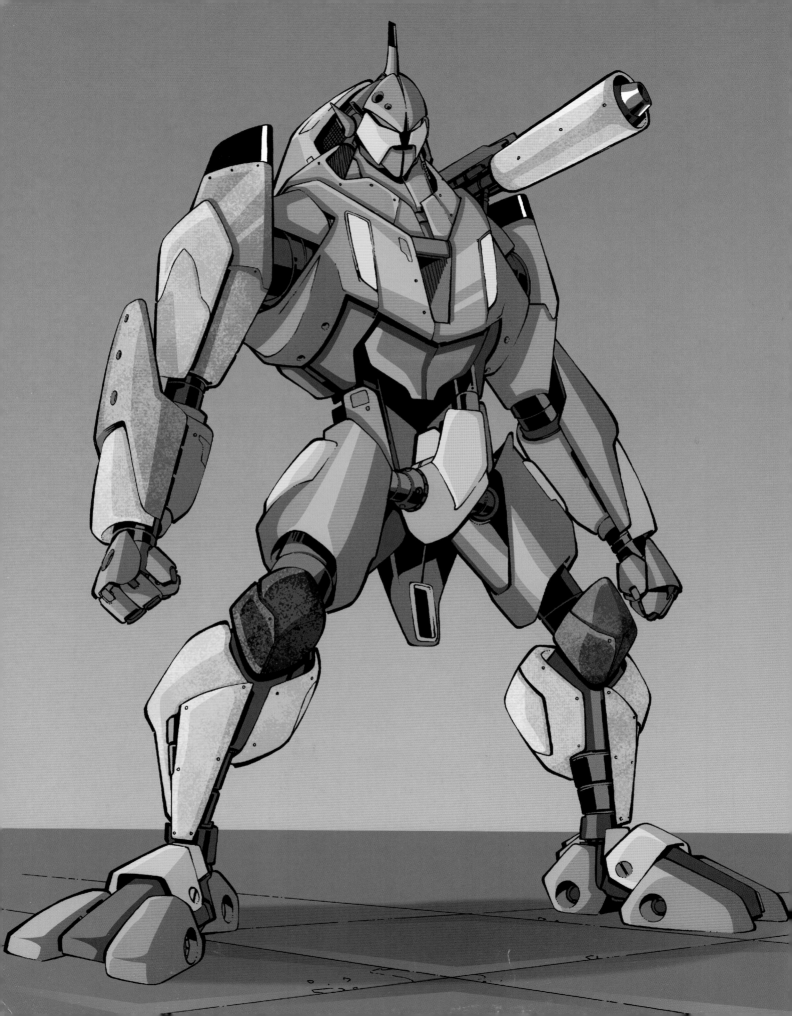

# INTRODUCTION

Everyone is catching mecha mania. *Mecha* is a popular term that stands for "mechanism" as it relates to battle technologies of the future. The most popular mecha are the giant robots, battling spaceships, tough military vehicles, beautiful cyborg women, and futuristic weapons of Japanese comics and animation. And, they're all in this book, in abundance.

In *anime* (Japanese animation) and *manga* (Japanese comics), the most intense battles are fought not by action heroes, but by those titans of high-tech power: the giant robots. These battling behemoths are featured in some of the most popular animated television shows both in the United States and in Japan. Unlike typical western-style robots, however, Japanese robots are piloted by humans from small cockpit command centers inside the robots themselves. Japanese robots are also gargantuan, standing many stories tall. With their awesome weight, they shake the very earth on which they fight and fall. They exist in a world ravaged by war, where the very survival of the human race is at stake. When two of them collide, there's no safe place to hide.

In this book, you'll learn the secrets of drawing giant robots so that they'll look super cool and authentic, and you'll learn how to design all the latest technology so that it appears logical and professional. Imagine drawing all of the hidden weapons systems, rocket boosters, jet packs, cockpits, and more. You'll learn how to draw the cyber body armor worn by human pilots and their crews. You'll also learn how to draw special effects, such as motion lines to indicate speed, and how to make spaceships turn into giant robots. In addition, there are great sections on drawing strange mecha, which are modeled after animals, and cyborg women—beauties with a heart of zinc.

From there, we zoom into outer space, where the battle rages on. You'll get blueprints and detailed instructions for drawing the best squadron fighters and space cruisers, as well as a host of eerie, alien spacecraft. As you reenter the earth's atmosphere, you'll get the skills you need to draw tough military vehicles, including an armada of jet fighters, tanks, amphibious vehicles, and more.

Next, you'll be introduced to a fabulous new feature: American mecha. Many top American comic book artists have taken Japanese mecha, retooled it, and put their very own spin on it. You'll see how mecha has taken hold in American comics, and how you can draw that way, too.

Then, last but definitely not least, there's an exclusive, invaluable interview with Heinz Schuller, art director of Fasa Studio at Microsoft, the producers of PC and X-Box games based on the Battletech license. Their MechWarrior 4: Vengeance® has been a top-ten best-selling PC action game since its Christmas 2000 release and continues the eight-year legacy of highly popular MechWarrior computer games. Heinz will give you his insights into the industry and tell you what you need to know to get the coolest job in the world: computer-game designer.

Here's your battle plan: to take on all the subjects in this book and conquer them, becoming the greatest mecha artist of all time. Let's suit up for action!

# GIANT ROBOT ESSENTIALS

The most complex anime robot is, in reality, just a combination of basic shapes. These shapes have been lengthened, shortened, rounded, sculpted, and arranged to form impressive figures that look cool but can be intimidating to draw. However, it's easier than you think.

The most complex anime robot starts with simple shapes and blocks that have been combined to create astounding creatures of immense proportions. While it might seem like it should be difficult, it's easier than you think! Here are some hints to help you create shapes that appear solid and three-dimensional.

## ADDING DEPTH

The first thing to do is stop thinking in terms of circles, squares, and rectangles. Think, instead, in terms of three dimensions, not two, and replace those terms with spheres, cubes, and blocks. Everything needs to appear to have volume.

*This square has no depth and looks hollow.*

*When turned, it becomes a cube with sides. It looks solid, doesn't it?*

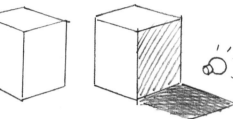

*To make it look more solid, shine a light on it. Now it's clear that it has an effect on the environment: It casts a shadow on the floor and wall.*

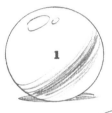

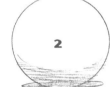

*Three common approaches to creating a solid-looking sphere are: (1) to add a shine to the top and a streak of shadow around the middle; (2) to shade the bottom only; and (3), to gradate the shadow.*

## COMMON SHAPES FOR ROBOT PARTS

*You can turn a flat rectangle into a three-dimensional block by giving it sides. One of the sides should be shaded; without this, the shape would appear hollow.*

*By rounding the sides of a rectangular block slightly, the form begins to look like a robot arm or leg.*

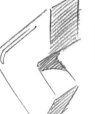

*Bending a rectangular block creates an entirely new shape.*

*A cut-off cone (not a triangle) is a common shape for robot parts. The tip of the cone is cut off so that the cone can attach to another part of the robot.*

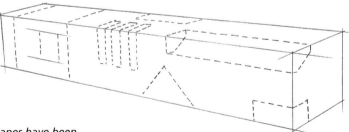

*Shapes have been chipped out of this rectangular block so that it resembles a weapon. Although it looks complex, you can see that, in reality, it's just a single shape.*

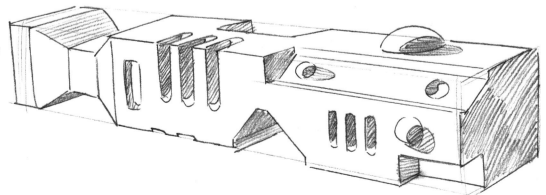

# TUBES

Tube shapes are *indispensable* for drawing giant robots. They are used to create limbs, weapons, and casings for the cables and wires inside the robot's body.

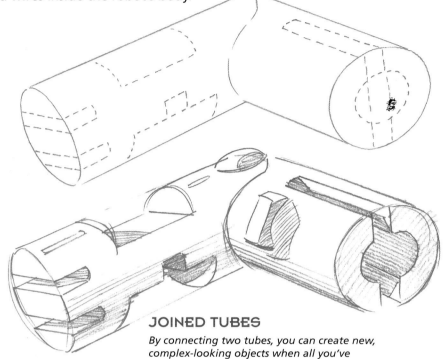

## SHADING A TUBE

*Highlights will accentuate a tube's roundness. Light falls off the rounded surface of a tube gradually, creating a gradating shadow. Here's how to shade a tube (or a robot's arm or leg) and achieve that three-dimensional look:*

*1. This is the bright side of the tube; it indicates the direction from which the light is coming—in this case, from the left.*

*2. The shadow begins in this area.*

*3. The shadow continues to transform, getting darkest in this area, not at the final edge of the tube, as most beginners think.*

*4. The final edge of the tube is illuminated by light being reflected back onto it after bouncing off a floor, wall, robot, or person. Sometimes, a secondary source of light also creates this less intense shine.*

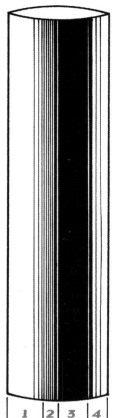

## JOINED TUBES

*By connecting two tubes, you can create new, complex-looking objects when all you've really done is attached two simple shapes together and hollowed out patterns in them.*

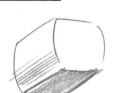

## ODDLY SHAPED TUBES

Widen or narrow tubes to create pleasing, organic-looking shapes.

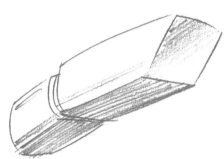

## CONNECTING TUBES OF DIFFERING LENGTHS

*By varying the length of connected shapes, you add variety and interest. Notice how this is starting to resemble a finger?*

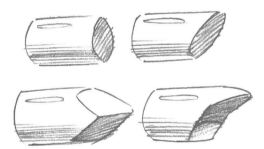

## ANGLING THE ENDS

*By angling the ends of a tube you can create some very cool shapes.*

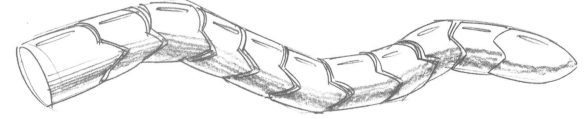

## CONTINUOUSLY INTERLOCKING SHAPES

*Interlocking one shape in another in a long procession creates a mechanical device that's actually quite flexible. This is how you would create a mechanical robotic serpent. Note how the ends of each joint are cut to allow them to wedge into one another in an interesting pattern.*

# SCULPTING AND SHADING

Now take a fresh look at some typical mecha objects, keeping in mind what we just covered. Instead of first seeing the complexity, try to notice the simpler, overall shapes; these have been sculpted and joined together. Then note how they've been shaded. Give these a try.

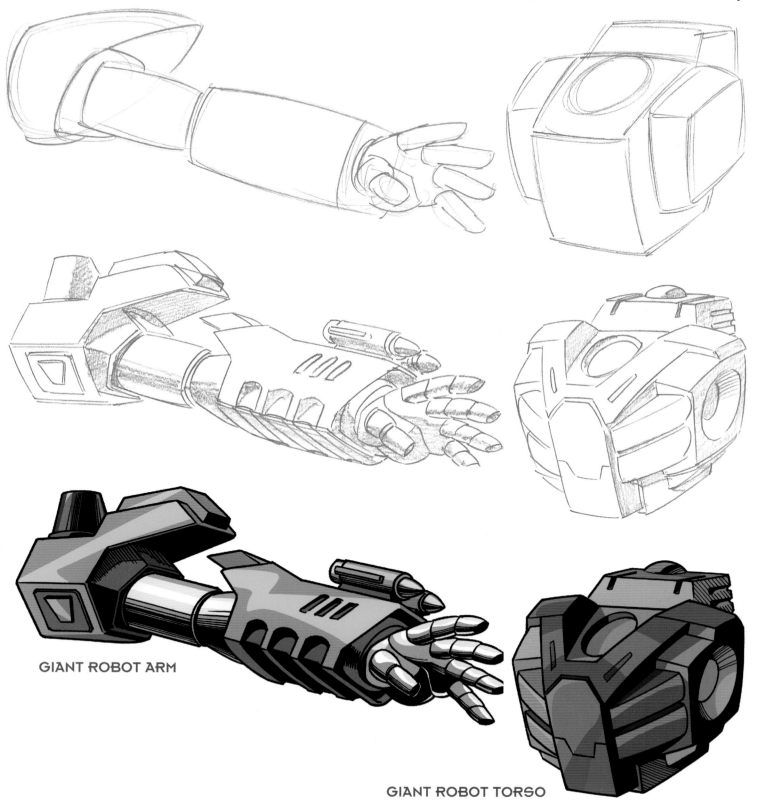

GIANT ROBOT ARM

GIANT ROBOT TORSO

Even these impressive objects are merely basic shapes that have been modified and fused together. Of course, you can build up objects like these with cool accessories, such as antennae, knobs, vents, and so on. But, that's all window dressing; the real drawing starts with basic shapes.

INTERGALACTIC WARSHIP

PHOTON RIFLE

# AVOIDING NEUTRAL POSITIONS

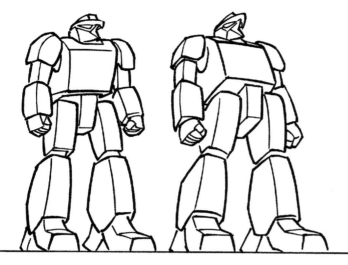

When you look at an object straight on—neither above it nor below it—that object appears flat. The general rule in anime is that you should avoid showing anything in a neutral position as it robs the image of impact. To create a bolder, more in-your-face look for your giant robots, draw them as if you were either looking up or down at them.

## NEUTRAL VS. ANGLED VIEWPOINT

The figure on the left is in a neutral position and, as a result, doesn't make a great deal of impact. The figure on the right shows an "up" shot and, therefore, looks mighty and awesome.

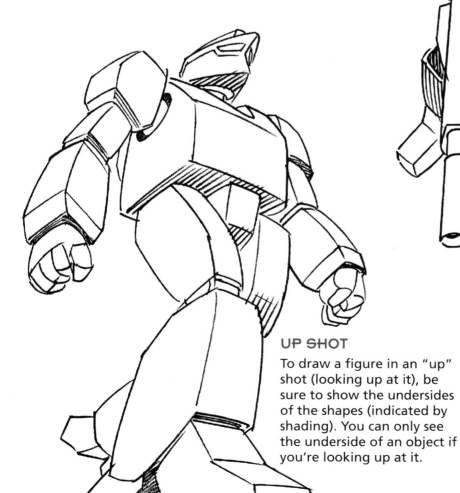

## UP SHOT

To draw a figure in an "up" shot (looking up at it), be sure to show the undersides of the shapes (indicated by shading). You can only see the underside of an object if you're looking up at it.

## DOWN SHOT

To draw a figure in a "down" shot (looking down at it), be sure to show the tops of the shapes, such as the tops of the shoulder and torso area, helmet, arms, and thighs. You can only see the top of an object if you're looking down at it. A down shot is good for action poses and to establish a scene, because you can more easily acclimatize yourself to an environment if you're looking down at it than if you're looking up at it.

# MECHANICAL HANDS

The hands of giant robots should look like industrial gloves. They're bulky and not nearly as flexible as ungloved human hands. You have to draw each moving part separately, and show a demarcation where one part attaches to another.

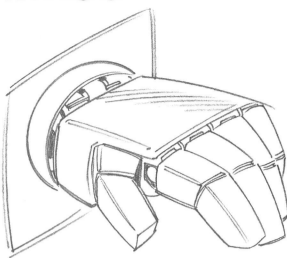

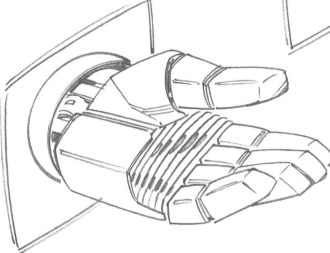

## SECTIONS OF THE HAND

*Notice that all of the moving parts are made up of sections held together with moveable joints.*

## ODD JOINTS

*The palm doesn't lend itself to a simple joint mechanism. Therefore, you can use an accordion-type cover that compresses and crinkles.*

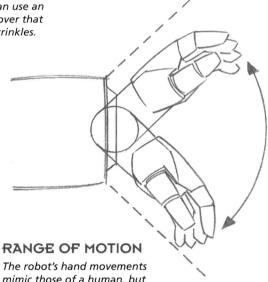

## THE NUMBER OF SECTIONS IN THE FINGER

*Although real fingers have three sections, robot fingers can have only two. It depends on how technical you want your robot to appear and how much time you want to spend on each drawing.*

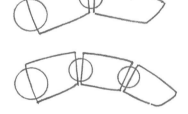

## RANGE OF MOTION

*The robot's hand movements mimic those of a human, but with a more limited range.*

## THE TWO BASIC TYPES OF MOTION JOINTS

*There are two basic types of joints: tongue-in-groove and ball-and-socket. The ball-and-socket type can move in any direction whereas the tongue-in-groove only moves up and down, like a toggle switch.*

*Whichever you choose, however, stay consistent. For example, if you use ball-and-socket joints for the index finger, don't draw tongue-in-groove joints for the middle finger. But, you can mix 'em up on different areas of the body.*

**TONGUE-IN-GROOVE JOINT**

**BALL-AND-SOCKET JOINT**

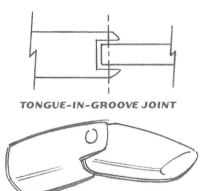

# HAND VARIATIONS

Not all robots have humanoid hands. Some have claws, clamps, and even weapons. Claw hands are not generally based on animal anatomy. The robot claw should look more like an industrial device.

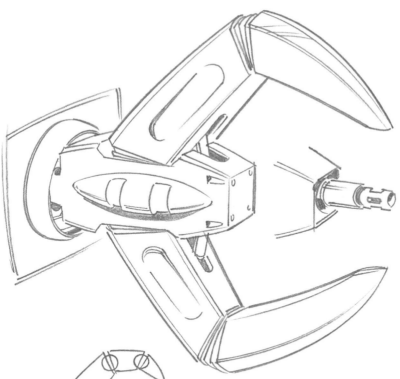

### CLAW

*Sharp and unforgiving, the claw doesn't mimic the human hand. It's an aggressive device, plain and simple. Sometimes, a weapon can be hidden in its center.*

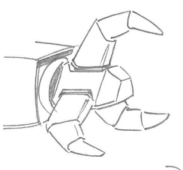

### THREE-TIPPED CLAW

*The more gripping prongs you add to the claw, the more the claw will become the primary focus of the robot because it's an eye-catching feature. That may or may not be what you intend. This is a consideration for you in designing your anime robot.*

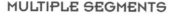

### MULTIPLE SEGMENTS

*Here, the upper claw has three individual segments, while the bottom has only two. You can add a reinforcement to the bottom prong to give it support.*

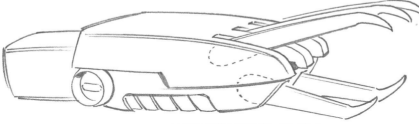

### WEAPONIZED CLAW

*Claws come in all shapes and sizes. This type of claw is sharp and can pierce, slash, rip, and grab.*

### NONGRIPPING WEAPON HAND

*Sometimes, the hands are mounted weapons with no ability to grasp.*

### COMBINATION HAND

*You can combine all three components— hand, claw, and weapon—into a single unit.*

# MECHANICAL FEET

Robot feet are highly adapted mechanisms designed for two specific purposes: to be a support system for the tremendous weight of the robot and for propulsion (often rocket powered). Artists don't usually pay a lot of attention to feet, but giant robots usually have very large boots that require a good degree of detail.

## BASIC ROBOT FOOT

*The human foot can be broken down into three main sections: the ball of foot, the arch, and the heel. The robot foot can mimic these three sections. Always indicate a slight cast shadow under the foot, to create the impression that it's firmly on the ground.*

## RETRACTABLE BALL AND HEEL

*This smaller foot has the advantage of being able to retract into its casing, allowing the opening to double as a jet.*

## ADDED STABILITY

*Minimizing the arch area simplifies the foot, allowing more of it to be in contact with the ground. This increases overall stability.*

## REAR WHEEL

*This robot was built for speed. A rear wheel powers it like a racecar on a track. Note the dust trail, which shows that it's moving at a good clip.*

## AUXILIARY POWER

*Some feet have auxiliary wheels to make small adjustments that would be difficult to make if the robot were to attempt a single, huge step. Some adjustments may include angling the robot into the exact position on a launch pad.*

## SNEAKER BOOT

*The worldwide popularity of high-end sneakers has now crossed over to the arena of anime robots. Take inspiration from their designs.*

## JET-POWERED FOOT

*Every area on a robot, no matter how obscure, offers an opportunity to add a new gadget or weapons system, like jets on the soles of the boots.*

# BODY ARMOR FOR PILOTS

Anime and manga robots are piloted from within by humans in cockpits. Piloting a giant anime robot is a rough-and-tumble business. The robot will get battered in epic battle scenes. The pilot might even get ejected, or worse, thrown from the robot during an explosion. That's why mechanical armor is so important for the warriors at the helms of these giant mechanisms. And, since this is the world of the future, the armor should be teeming with gadgets and electronic devices.

Keep in mind that this isn't a robot we're attiring, but a human being. Therefore, the outfit must fit the human, not the other way around.

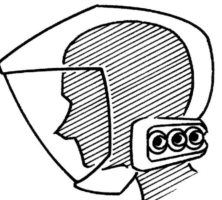

## BASIC PILOT HELMET

*The standard helmet provides a clear range of vision for the pilot. It's round, simple, and functional, but has no style or flair.*

## ANGULAR HELMET

*The forward tilt of this helmet gives it a more intense look. The helmet is also larger, which makes the pilot seem more important. The cable outlet at the base of the helmet is connected to the information system on the craft and can display data inside of the helmet's glass plate or by audio feed.*

## PROTECTING VULNERABLE PARTS

*The joints must be protected, because if they're injured, then the limbs will be immobilized.*

## NARROW VISOR

*The narrow visor minimizes face exposure and is used in dangerous situations, for example, exiting the craft during a meteor shower.*

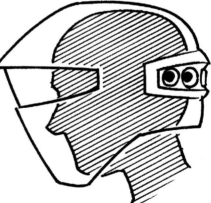

## ADAPTING A JET FIGHTER PILOT'S HELMET

*Jet pilot helmets can be adapted for use by mecha pilots with the addition of cable ports and connections to the robot's mainframe.*

## GOGGLES

*High-tech goggles provide an excellent way to show more of the face and thereby establish the character. Note the external ear piece, which is built in and unseen on the other helmets.*

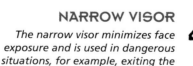

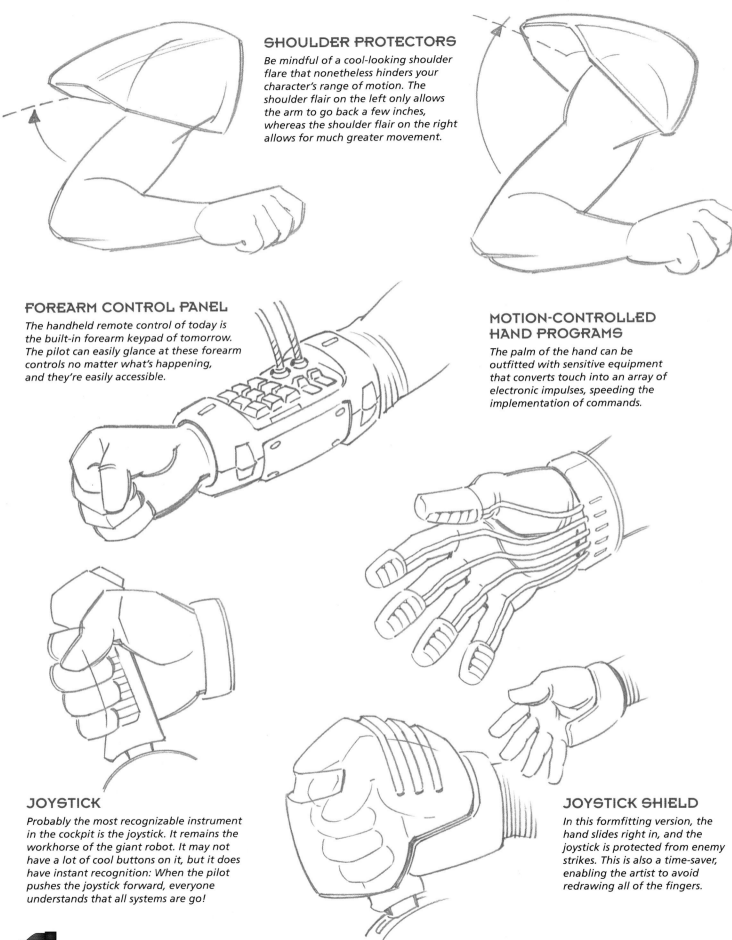

## SHOULDER PROTECTORS

Be mindful of a cool-looking shoulder flare that nonetheless hinders your character's range of motion. The shoulder flair on the left only allows the arm to go back a few inches, whereas the shoulder flair on the right allows for much greater movement.

## FOREARM CONTROL PANEL

The handheld remote control of today is the built-in forearm keypad of tomorrow. The pilot can easily glance at these forearm controls no matter what's happening, and they're easily accessible.

## MOTION-CONTROLLED HAND PROGRAMS

The palm of the hand can be outfitted with sensitive equipment that converts touch into an array of electronic impulses, speeding the implementation of commands.

## JOYSTICK

Probably the most recognizable instrument in the cockpit is the joystick. It remains the workhorse of the giant robot. It may not have a lot of cool buttons on it, but it does have instant recognition: When the pilot pushes the joystick forward, everyone understands that all systems are go!

## JOYSTICK SHIELD

In this formfitting version, the hand slides right in, and the joystick is protected from enemy strikes. This is also a time-saver, enabling the artist to avoid redrawing all of the fingers.

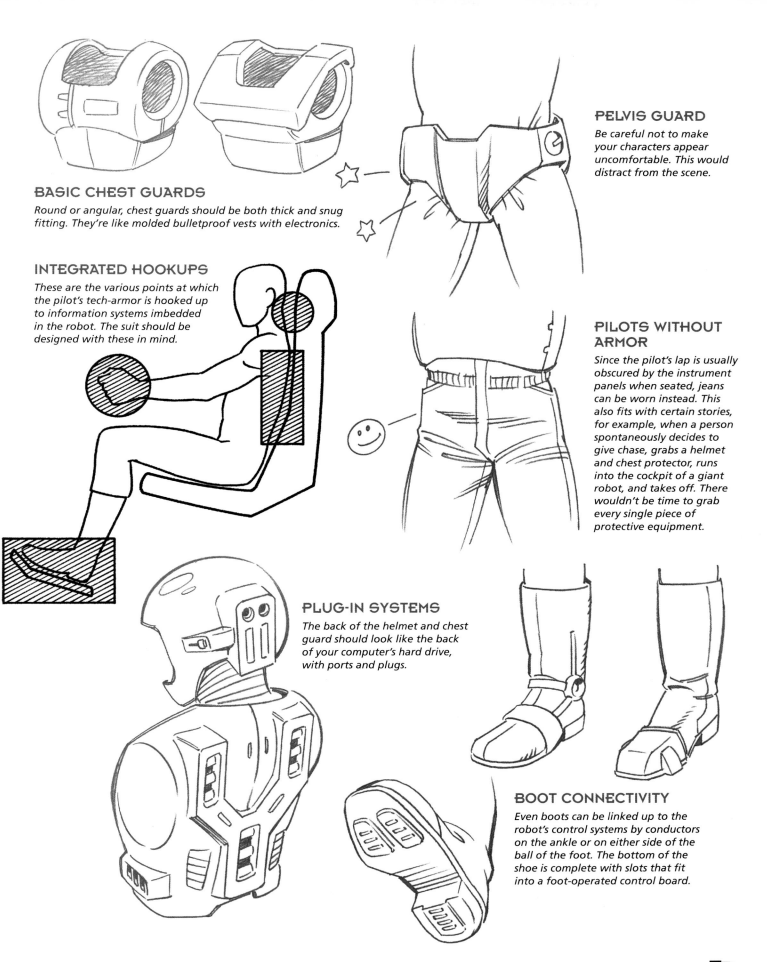

## BASIC CHEST GUARDS

*Round or angular, chest guards should be both thick and snug fitting. They're like molded bulletproof vests with electronics.*

## INTEGRATED HOOKUPS

*These are the various points at which the pilot's tech-armor is hooked up to information systems imbedded in the robot. The suit should be designed with these in mind.*

## PELVIS GUARD

*Be careful not to make your characters appear uncomfortable. This would distract from the scene.*

## PILOTS WITHOUT ARMOR

*Since the pilot's lap is usually obscured by the instrument panels when seated, jeans can be worn instead. This also fits with certain stories, for example, when a person spontaneously decides to give chase, grabs a helmet and chest protector, runs into the cockpit of a giant robot, and takes off. There wouldn't be time to grab every single piece of protective equipment.*

## PLUG-IN SYSTEMS

*The back of the helmet and chest guard should look like the back of your computer's hard drive, with ports and plugs.*

## BOOT CONNECTIVITY

*Even boots can be linked up to the robot's control systems by conductors on the ankle or on either side of the ball of the foot. The bottom of the shoe is complete with slots that fit into a foot-operated control board.*

# THE COCKPIT OF A GIANT ROBOT

This is command central, usually a cramped, one-person space. The genius of a Japanese mecha isn't the huge robot, per se, but the fact that it's piloted, usually, by a single teenager in a tiny cockpit surrounded by tons of instruments. And the teen is all alone. In the end, the survival of the world rests on the shoulders of a kid. And that, dear readers, is the ultimate human element in a story.

The pilot is wedged into the seat and surrounded by a complex series of control-heavy panels on all sides, including a viewing screen, monitor, or window. The cockpit is ergonomically designed as everything must be within a moment's reach.

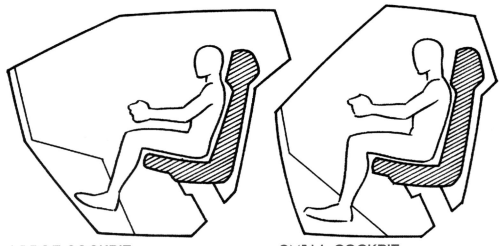

### LARGE COCKPIT

*The area inside of this cockpit, although compact, is actually on the large side for a piloted fighting robot. But, it's the brain center of the mechanism. (Note: You can also put controls on the ceiling of the cockpit.)*

### SMALL COCKPIT

*These reduced quarters don't allow for extensive control displays. Hookups and computer cable attachments to the electronic, armored gear on the pilot are now necessary.*

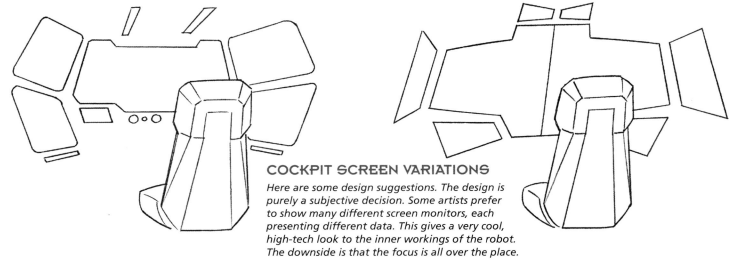

### COCKPIT SCREEN VARIATIONS

*Here are some design suggestions. The design is purely a subjective decision. Some artists prefer to show many different screen monitors, each presenting different data. This gives a very cool, high-tech look to the inner workings of the robot. The downside is that the focus is all over the place.*

*An alternative is to simplify and combine the screens and monitors into one larger shape, perhaps showing what is going on in the battlefield with computer graphs and data displayed over the image (left). Of course, a combination of the two is also possible (right).*

## COCKPIT COMMAND CHAIR

When giant robots fight in the battlefield, the pilot is buffeted about. This happens in every cool mecha fight scene. Therefore, the pilot is strapped tight in the chair, so as not to tumble out. Hunkered down, hands on the controls, this pilot is ready to go.

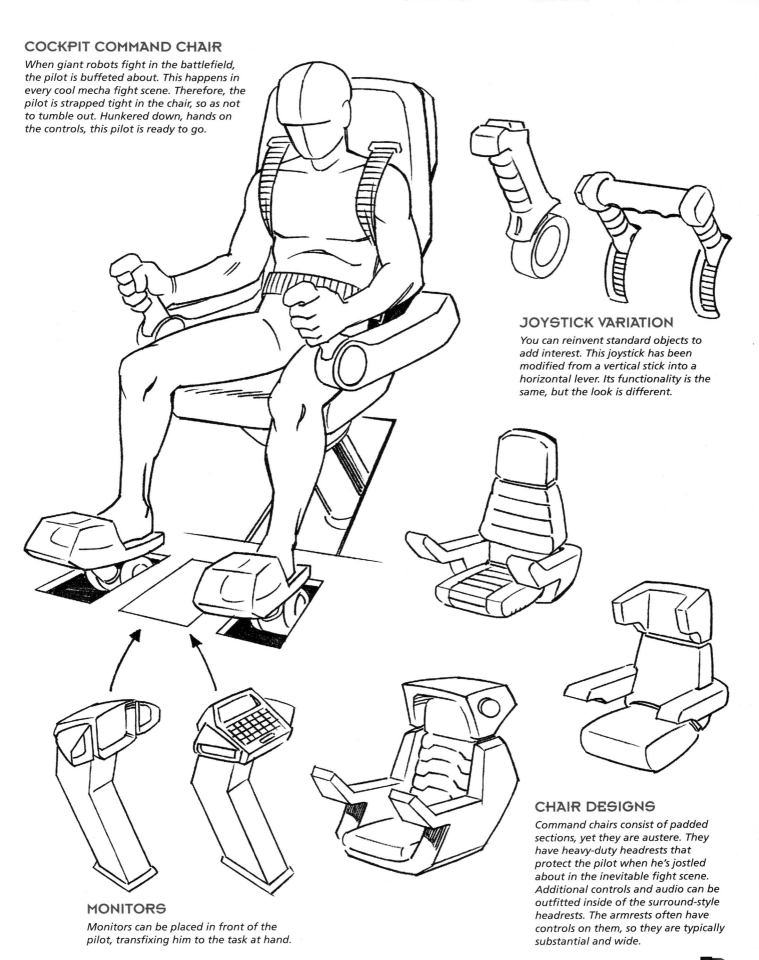

## JOYSTICK VARIATION

You can reinvent standard objects to add interest. This joystick has been modified from a vertical stick into a horizontal lever. Its functionality is the same, but the look is different.

## MONITORS

Monitors can be placed in front of the pilot, transfixing him to the task at hand.

## CHAIR DESIGNS

Command chairs consist of padded sections, yet they are austere. They have heavy-duty headrests that protect the pilot when he's jostled about in the inevitable fight scene. Additional controls and audio can be outfitted inside of the surround-style headrests. The armrests often have controls on them, so they are typically substantial and wide.

# DESIGNING COOL ROBOTS

Let's establish something important at the outset of this chapter: You can't make a mistake. You heard correctly. You can't do one of these drawings "wrong." None of these robots exist. They're completely fabricated by the imagination, so if your robot looks taller than the ones pictured here, or if his doodads and gizmos don't look identical to the examples given, well, heck, yours is just built differently. It has a different inventor: You!

# EVOLUTION OF THE GIANT ROBOT

Let's take a moment to examine the origins of the giant robot and the stages it went through to get where it is today. Many of the new trends in popular culture are actually mined from the past, with a fresh spin added to them.

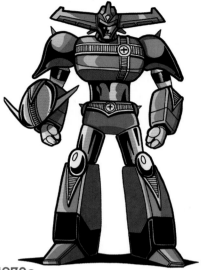

## 1950s

*The boxy robots of the 1950s looked like dishwashers on tracks. They had big, Martian-type antennae, because Martians were all the rage. And, if audiences found them scary—a dubious assumption—it was only because, at the time, everybody was intimidated by technology.*

## 1960s

*The 1960s brought forth robots with anatomy that mirrored humans, but with bulk and superstrength. Freed from their tracks, they could walk—or plod, as was more often the case. They had clawlike hands that were almost useless. Their immense size made them impressive villains at the time, but any toddler over the age of two was swift enough to outrun them, so you really had to be brain-dead to be captured. Everything was covered in a flexible casing.*

## 1970s

*The 1970s introduced the first modern fighting robot, with body casing that clearly resembled a knight's armor. It took this leap to the past to bring these robots into the future. The helmets sprouted wings and stabilizers. Sections of the body fit into other sections. The shoulders were huge, the lower legs and feet immense. The styles would change, but the basic design was now locked in place.*

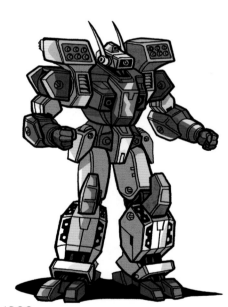

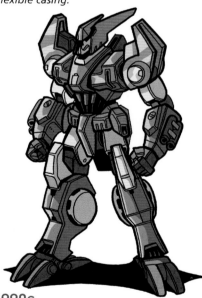

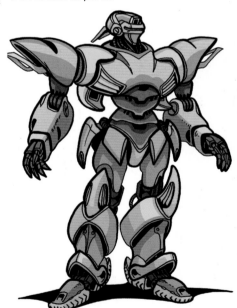

## 1980s

*In the 1980s, anime robots burst into comics and television like never before and they became a sensation. To accommodate their growing role in fight scenes, their body armor became reinforced, much heavier, and tanklike in appearance. Now, multiple weapons systems became abundant.*

## 1990s

*The 1990s saw a turn toward sleeker design, with an increased attention to agility and speed. Robots were now losing their direct link to the look of medieval armor. Their shoulders had strange, unpredictable forms. Their boots no longer looked human but, often, animalistic. Complex, hidden weapons systems and secret compartments were placed all over the fighting mechanism. The designers began to push the envelope.*

## 2000 AND BEYOND

*Current trends have been gravitating to a more organic feel, combining geometric and rounder shapes. And once again, there is more of a humanoid construction. But the organic curves and swirling patterns are eerie and strange, the stuff of enemy alien invaders. What are the next trends? That, my friend, may be up to you!*

# BASIC GIANT ROBOTS

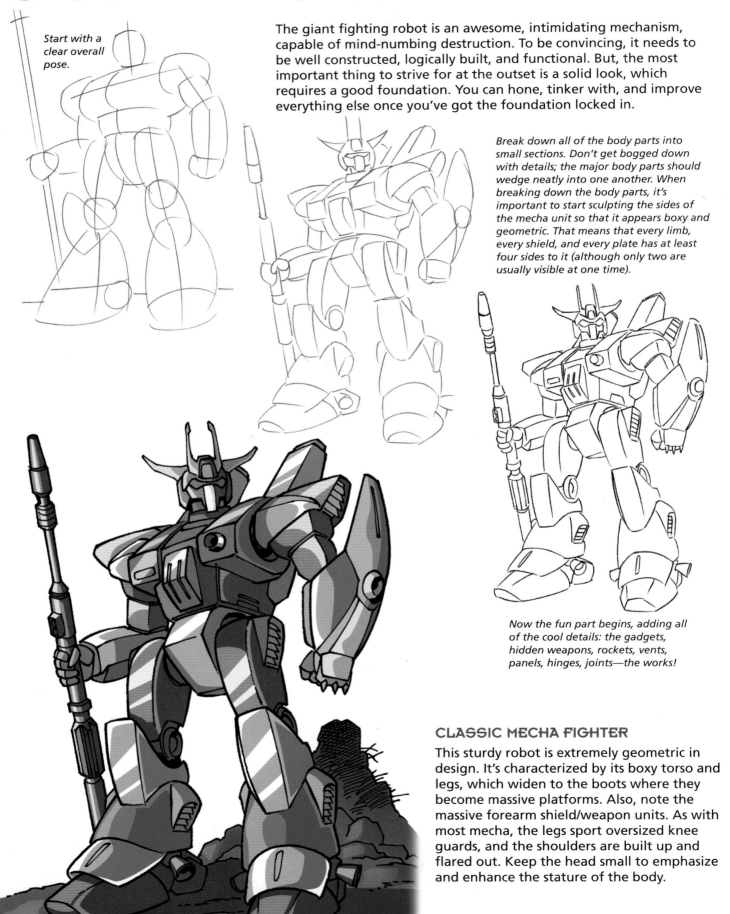

*Start with a clear overall pose.*

The giant fighting robot is an awesome, intimidating mechanism, capable of mind-numbing destruction. To be convincing, it needs to be well constructed, logically built, and functional. But, the most important thing to strive for at the outset is a solid look, which requires a good foundation. You can hone, tinker with, and improve everything else once you've got the foundation locked in.

*Break down all of the body parts into small sections. Don't get bogged down with details; the major body parts should wedge neatly into one another. When breaking down the body parts, it's important to start sculpting the sides of the mecha unit so that it appears boxy and geometric. That means that every limb, every shield, and every plate has at least four sides to it (although only two are usually visible at one time).*

*Now the fun part begins, adding all of the cool details: the gadgets, hidden weapons, rockets, vents, panels, hinges, joints—the works!*

## CLASSIC MECHA FIGHTER

This sturdy robot is extremely geometric in design. It's characterized by its boxy torso and legs, which widen to the boots where they become massive platforms. Also, note the massive forearm shield/weapon units. As with most mecha, the legs sport oversized knee guards, and the shoulders are built up and flared out. Keep the head small to emphasize and enhance the stature of the body.

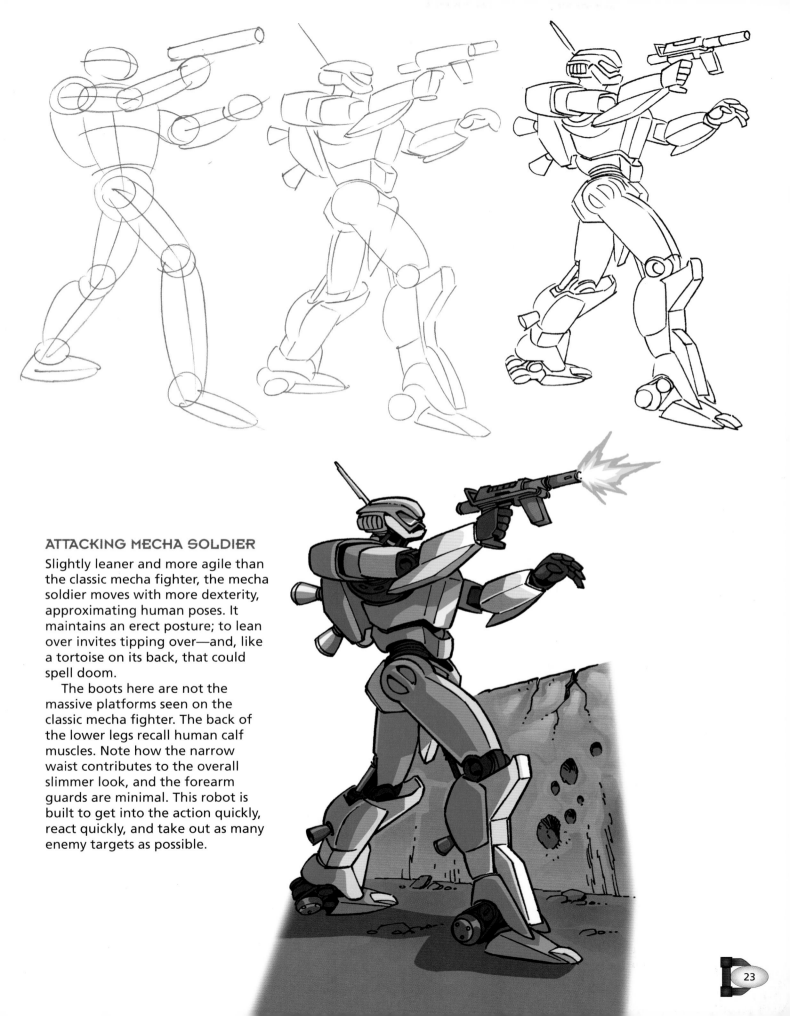

## ATTACKING MECHA SOLDIER

Slightly leaner and more agile than the classic mecha fighter, the mecha soldier moves with more dexterity, approximating human poses. It maintains an erect posture; to lean over invites tipping over—and, like a tortoise on its back, that could spell doom.

The boots here are not the massive platforms seen on the classic mecha fighter. The back of the lower legs recall human calf muscles. Note how the narrow waist contributes to the overall slimmer look, and the forearm guards are minimal. This robot is built to get into the action quickly, react quickly, and take out as many enemy targets as possible.

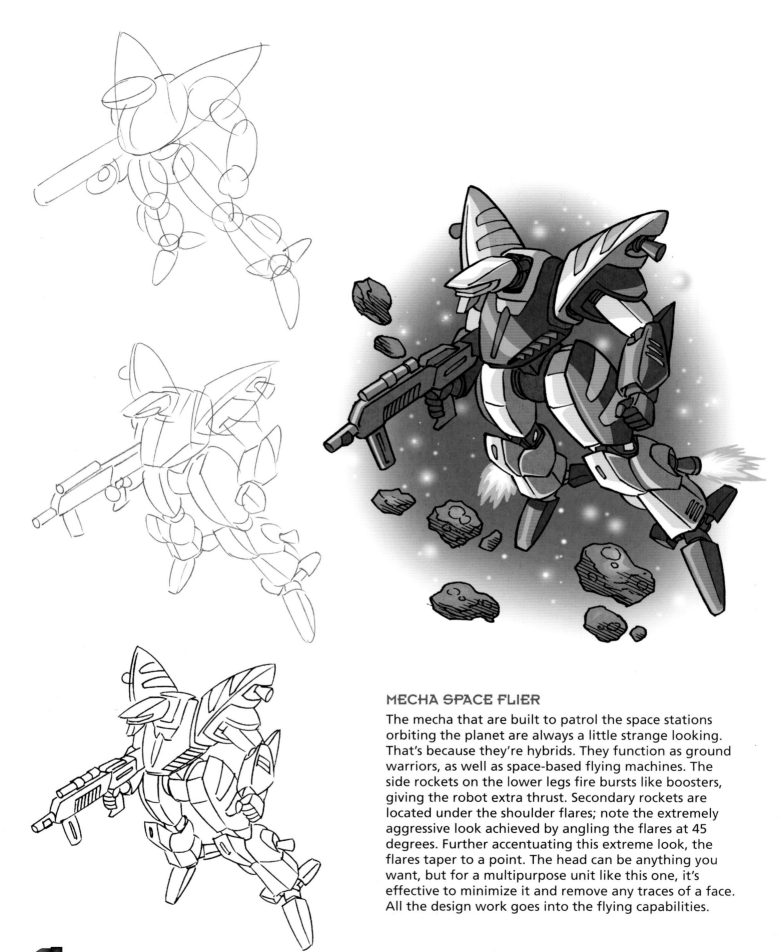

## MECHA SPACE FLIER

The mecha that are built to patrol the space stations orbiting the planet are always a little strange looking. That's because they're hybrids. They function as ground warriors, as well as space-based flying machines. The side rockets on the lower legs fire bursts like boosters, giving the robot extra thrust. Secondary rockets are located under the shoulder flares; note the extremely aggressive look achieved by angling the flares at 45 degrees. Further accentuating this extreme look, the flares taper to a point. The head can be anything you want, but for a multipurpose unit like this one, it's effective to minimize it and remove any traces of a face. All the design work goes into the flying capabilities.

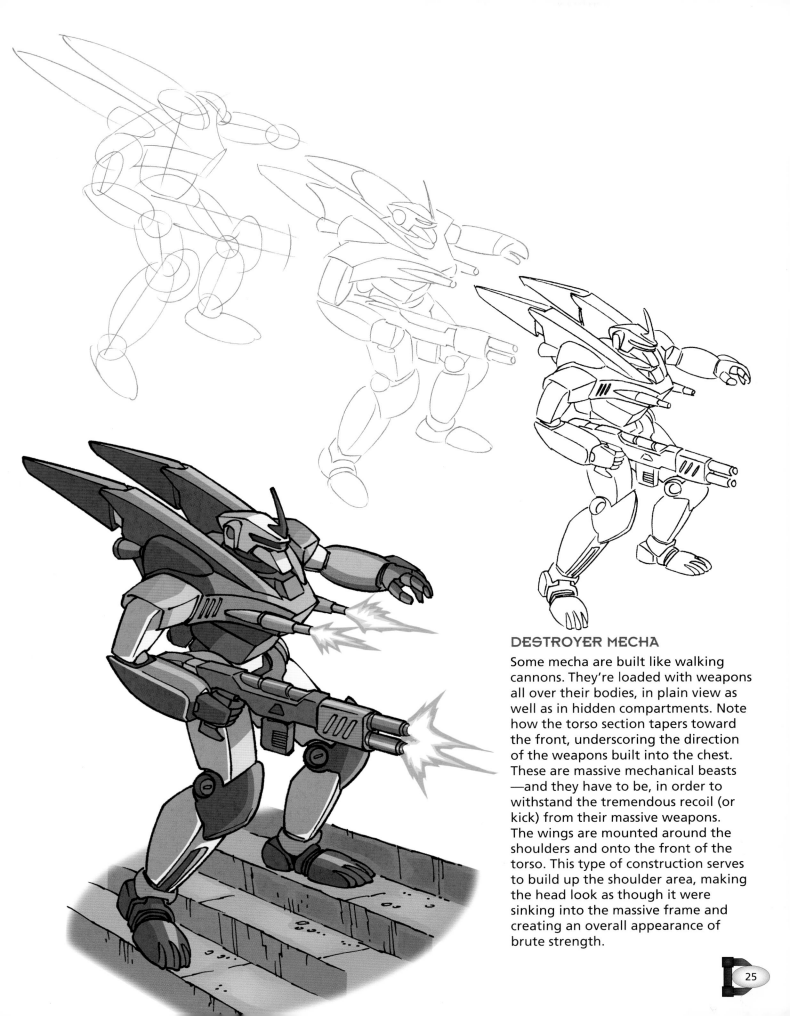

## DESTROYER MECHA

Some mecha are built like walking cannons. They're loaded with weapons all over their bodies, in plain view as well as in hidden compartments. Note how the torso section tapers toward the front, underscoring the direction of the weapons built into the chest. These are massive mechanical beasts —and they have to be, in order to withstand the tremendous recoil (or kick) from their massive weapons. The wings are mounted around the shoulders and onto the front of the torso. This type of construction serves to build up the shoulder area, making the head look as though it were sinking into the massive frame and creating an overall appearance of brute strength.

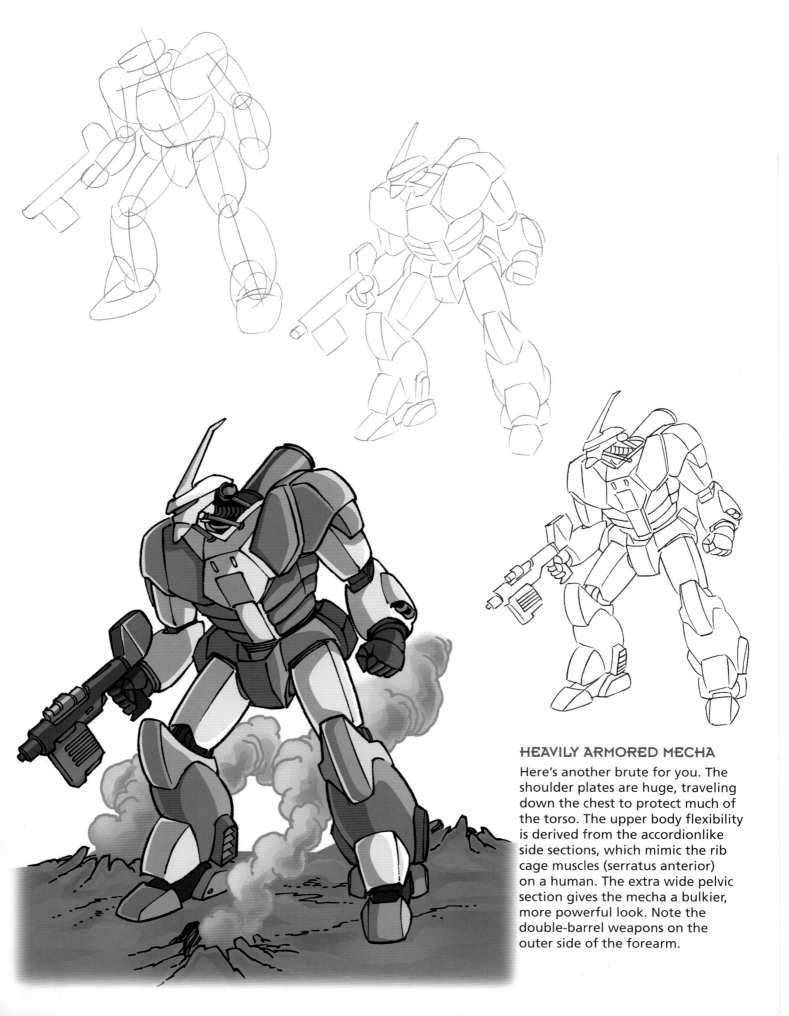

## HEAVILY ARMORED MECHA

Here's another brute for you. The shoulder plates are huge, traveling down the chest to protect much of the torso. The upper body flexibility is derived from the accordionlike side sections, which mimic the rib cage muscles (serratus anterior) on a human. The extra wide pelvic section gives the mecha a bulkier, more powerful look. Note the double-barrel weapons on the outer side of the forearm.

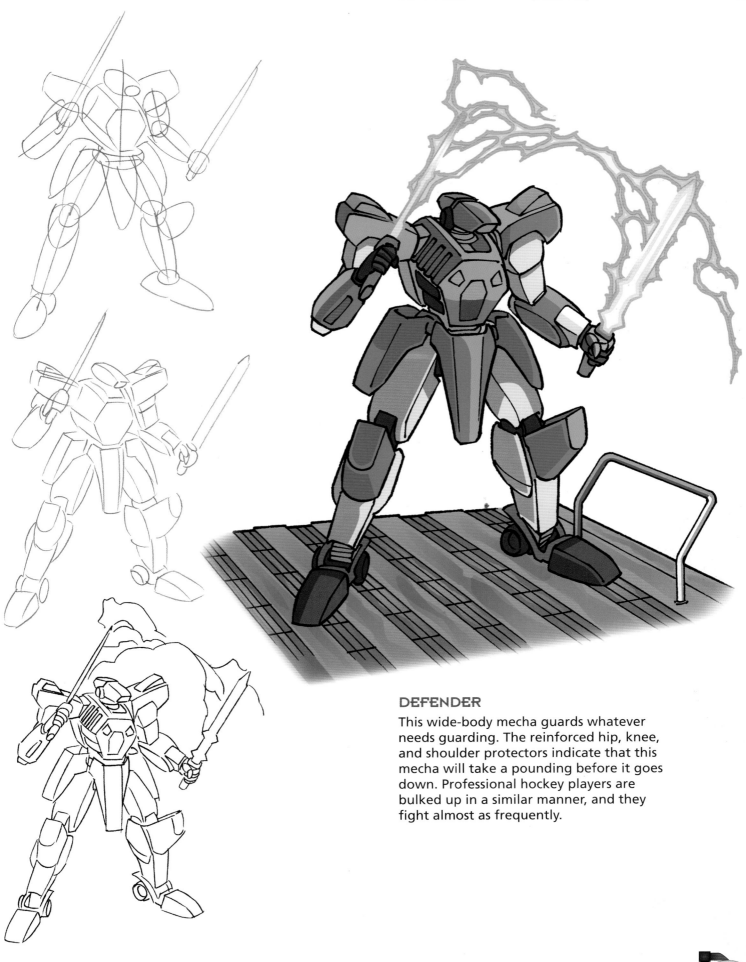

## DEFENDER

This wide-body mecha guards whatever needs guarding. The reinforced hip, knee, and shoulder protectors indicate that this mecha will take a pounding before it goes down. Professional hockey players are bulked up in a similar manner, and they fight almost as frequently.

# ADVANCED GIANT ROBOTS

Crush, destroy, crush, destroy. Every day, it's the same old thing. The robots in this section get a bit more advanced. They are extremely segmented, with the larger parts being connected by smaller joints. All of these sections—whether making up the torso, a forearm, or a kneecap—must appear to have volume. In other words, they're not flat, but display several sides as they're seen at various angles. These sharply defined sides give the robot a cool look. For example, observe the lower leg/boot combo. We see not just the tops of the lower legs but the inner sides of them, as well. This gives the form a solid, three-dimensional appearance. The shoulder protectors, into which the arms fit, aren't drawn as flat slabs either. They're drawn with sides that give depth. In fact, putting the sides on the bottom of the shoulder protectors gives the impression that we're looking up at the robot, and this underlines the robot's awesome quality.

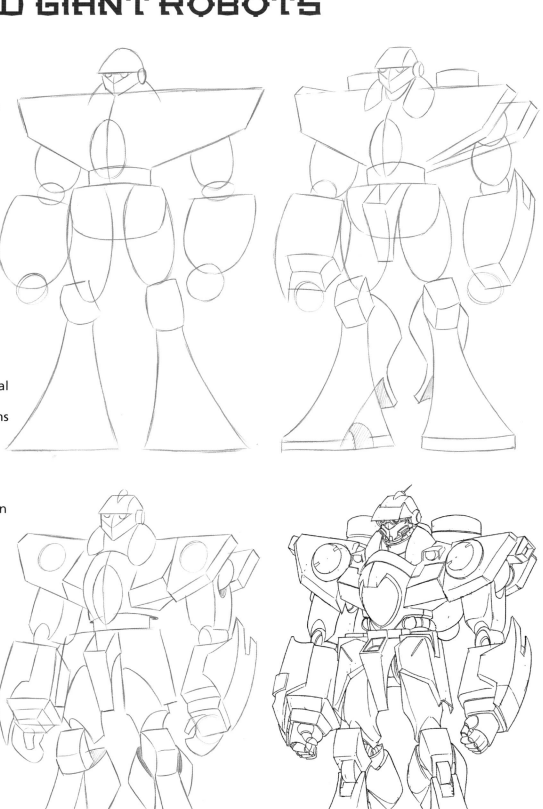

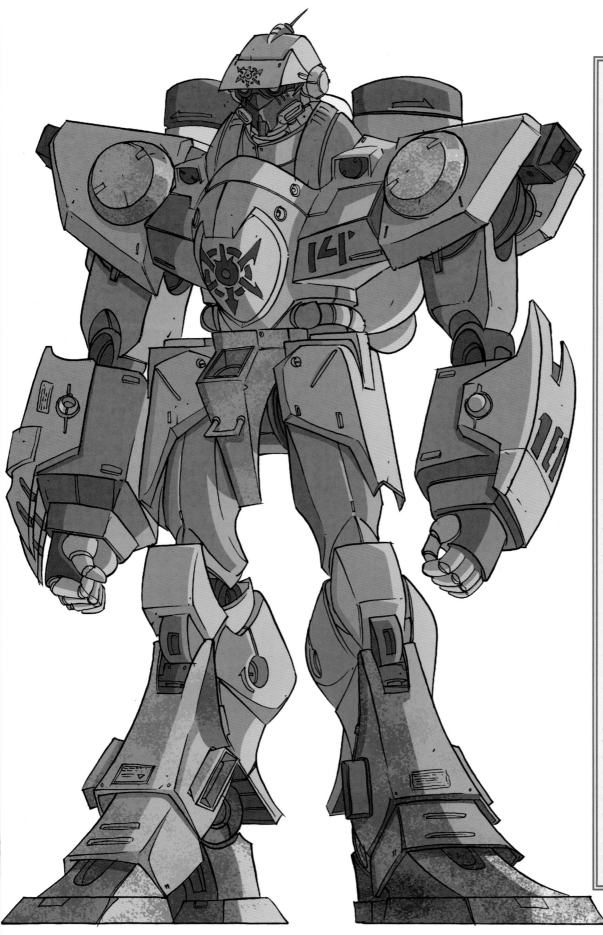

## A WORD ABOUT DRAWING

When I tell people that they don't have to be able to draw a straight line to be an artist, they can't believe it. It's true. Just because the object you're about to draw is supposedly made out of metal, doesn't mean you need a ruler. Many robots are drawn completely freehand. There's hardly a ruled line in this entire book. That's because a line drawn freehand is more lifelike than one drawn with a ruler.

A word of advice as we start the step-by-step learning process: Sketch lightly—but not timidly—as you follow the steps. Don't look to make it perfect at every step along the way. Go ahead and make mistakes. Don't correct them early on. Keep going. This is the creating stage, not the refining stage. After you've got the basics down, you can—and should—take a step back from your work to reevaluate it and make adjustments. Some professional artists make very few adjustments; others make quite a few. At step three, you still have a sketchy image. Proceeding to step four, choose the lines you want to keep, and draw them bolder. The remaining, sketchy lines are light. Erase them. Or, instead of erasing, you can trace your drawing over onto a new piece of paper, simply leaving out all of the unwanted, earlier sketch marks.

## GUN AND CLAW

Remember, these are heavily armed and armor-encrusted machines. Everything about them is hardware—and reinforced hardware at that. The body is protected with shields and plates; note, for example, the huge shoulder plates and ankle guards.

As for the proportions, this robot has extremely wide shoulders, a small waist, and powerful legs that have been adapted from those of bovines, with short upper thighs, long shin bones, and long feet with boots that balance on the balls of the feet. The heel attachment is necessary for this type of leg configuration, otherwise the robot would have to walk on tiptoes. And you can't be intimidating if you do that!

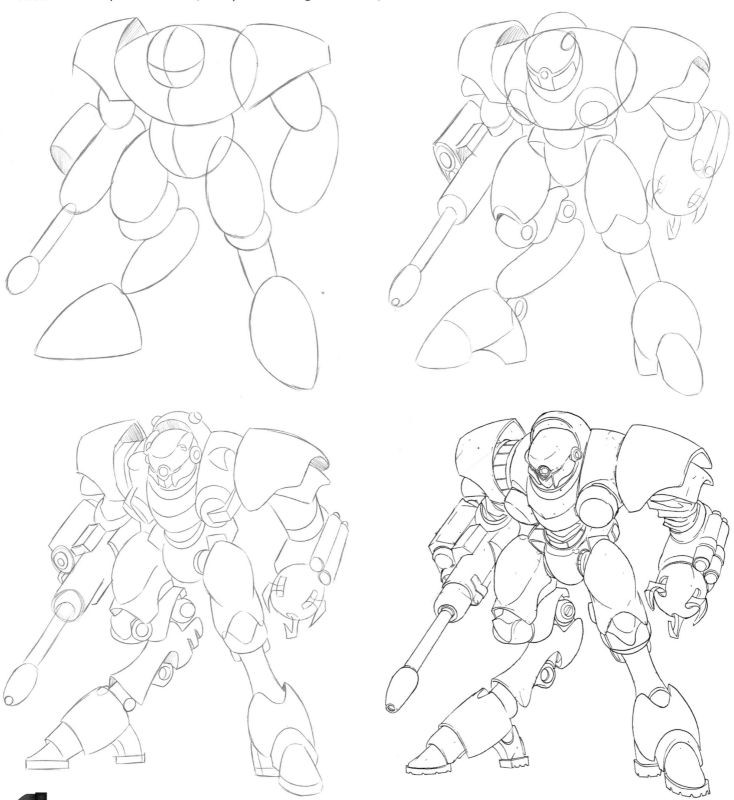

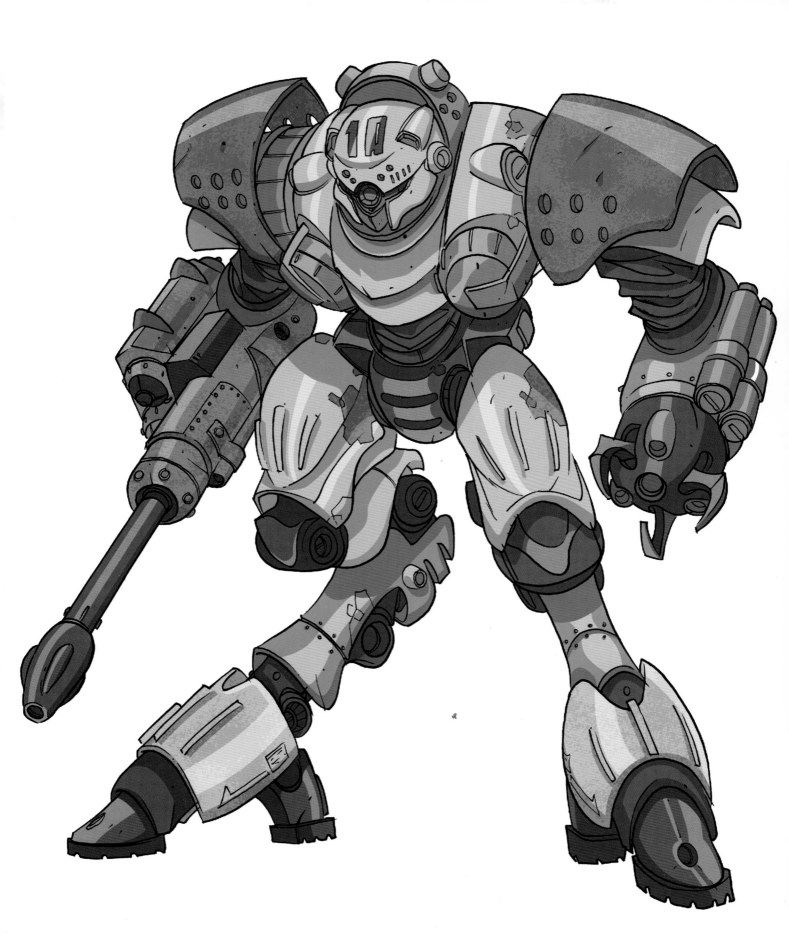

## WINGED ROBOT

When drawing a robot from scratch, try to use a visual theme, otherwise your robot could end up as a mishmash of ideas and have no overall "look." The theme for the robot on the preceding page was bulk, and this was achieved by using huge, round shapes. The theme for this robot is sleekness, which makes it perfect for flying.

The small head, tilted down, conveys the feeling of great height, as does the length of the body. The head and recessed eyes also create a commanding appearance. This robot is a flight risk: If it's flying, you're at risk. It has been specially adapted to its missions. Although it is a sleeker unit, it still requires its numerous layers of heavy plates to ward off air attacks from surface-to-air missiles. The boots are very large and mechanized with rocket launchers. The wings aren't huge, because they're really only used as stabilizers.

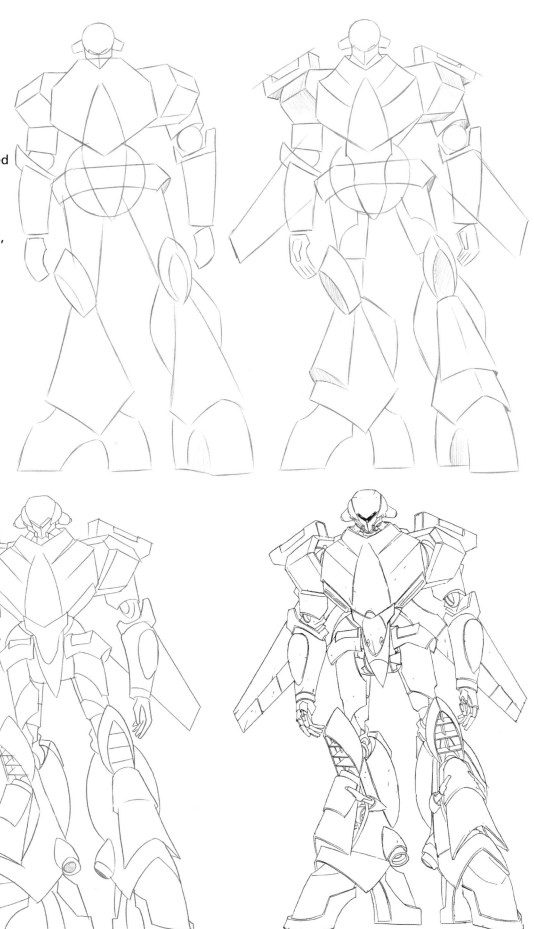

## SYMMETRY IN MECHANICAL DESIGN

It's essential to mention the concept of symmetry when designing mechanical figures. Symmetry, in this context, means that the right side of the figure should be identical to the left side. Symmetry isn't required at all times. For example, you might design a robot that has a gun mounted on its left shoulder but not on its right. However, most of the time, the design of each limb should be identical to the design of the same limb on the other side of the figure.

Remember, robots are featured in manga, anime, and computer games, where they move from panel to panel throughout the show or program. If you draw the coolest looking left forearm ever seen on a robot, but it takes you two hours to figure out how to repeat it on the right forearm, you haven't grasped the concept. Why struggle? Simplify the form so that it makes sense to you, remembering some of the basic concepts covered in the beginning of this book, and redesign something you can live with. And you know what? It'll probably be even cooler.

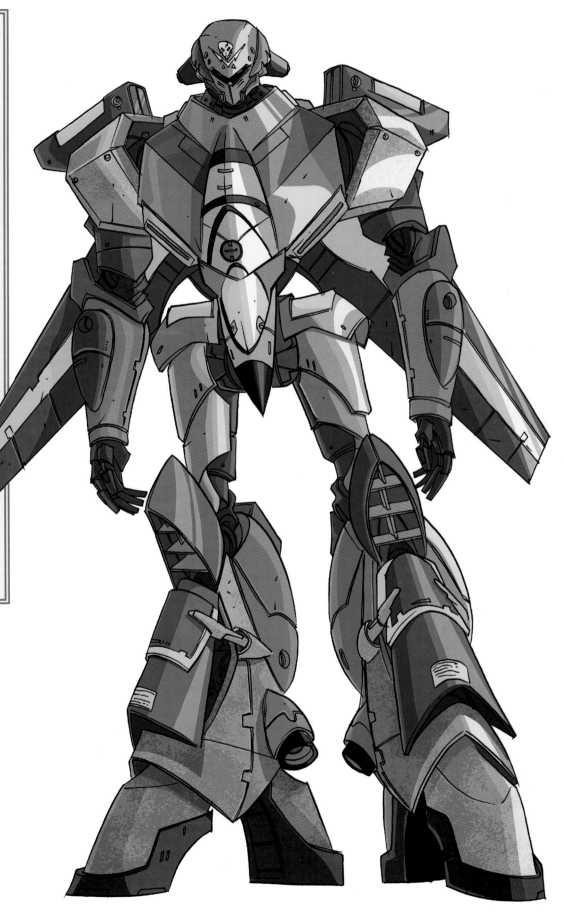

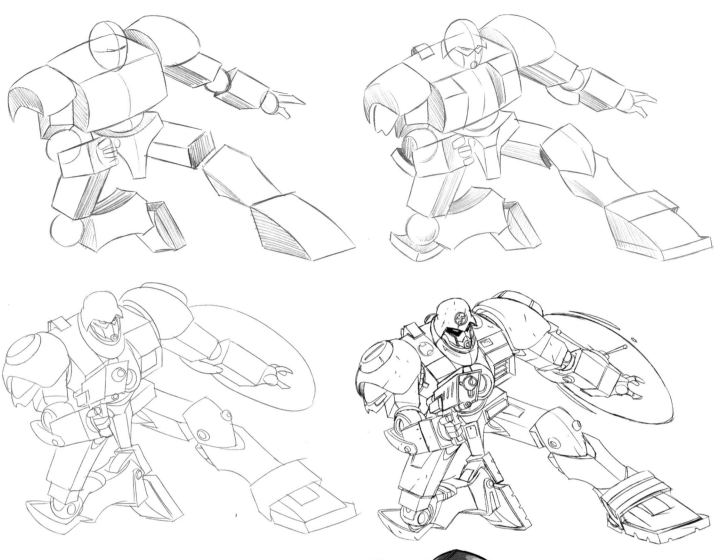

## HEAVILY ARMED ROBOT

Part of what makes mecha robots so cool is the built-in weapons systems incorporated into the designs of the robots themselves. Still, don't overlook the fun of ultraexplosive, handheld weapons. The advantage of handheld weapons is that you can choose a weapon to fit a given situation, rather than being stuck with the built-in. Further, when a character fires a handheld weapon, you can pose him (or her) in a cool stance, like a gun-fighter in a western.

The weapons your robot will be firing are extremely powerful. To withstand the recoil, the robot must brace itself with a sturdy stance. Whether the legs are spread apart or in a crouching position, as shown here, your character must be a part of the action and not just let the guns do the talking.

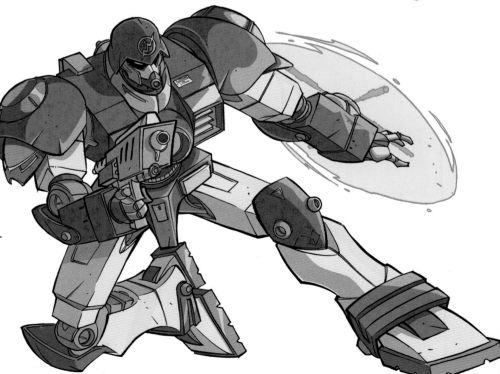

## TWEAKING THE WEAPONS SYSTEM

You should continue to allow new ideas to occur to you even after you've finished with your drawing, and even after you're happy with the final result. Yes, it can be burdensome when you realize you've got an idea that might be better than the one over which you just labored. But, this is what separates good artists from average artists. A good artist is always willing to go back and dig deeper, if it will serve the drawing. This is what I call the "what if" part of character design.

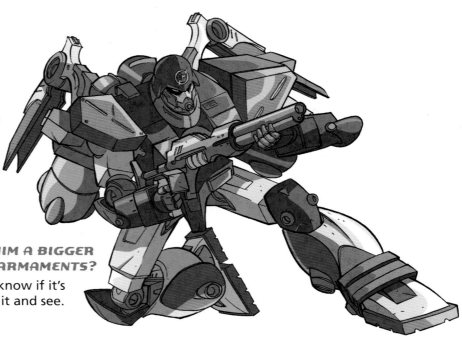

**WHAT IF I GAVE HIM A BIGGER GUN, AND WING ARMAMENTS?**

The only way you'll know if it's any good is to draw it and see.

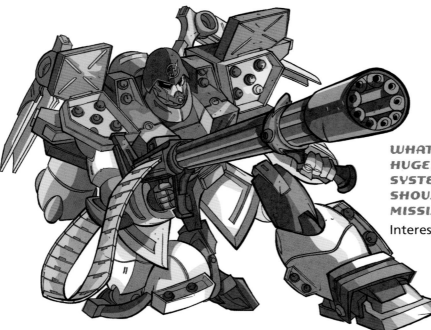

**WHAT IF I MADE THE GUN A HUGE, TWO-HANDLED WEAPONS SYSTEM AND OPENED UP THE SHOULDER PLATES, REVEALING MISSILE LAUNCHERS?**

Interesting. Let's see how that looks.

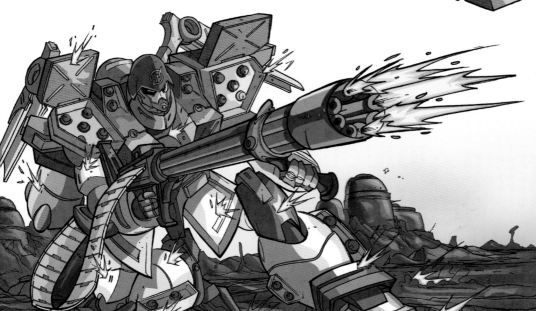

**WHAT IF I SHOWED THE ROBOT FIRING, WHILE TAKING SHOTS THAT ARE RICOCHETING OFF HIM?**

Cool. That's bringing the character into the action and making him part of the scene.

# SHIFTING EMPHASIS

For successful character design, you also need to think about what you're drawing and how to create a cool character. Shifting emphasis from one part of the body to another is a secret of character design. By emphasizing one area of the robot's construction over the others, you create new purposes for the mechanism. You make the robot a specialist, and this heightens interest in the character; it becomes the robot with the cool jet pack or the robot with the cool wings. So, shifting emphasis can also increase the recognition of the character.

Choose one area, aspect, or outstanding feature of the robot that you wish to emphasize above and beyond all the others. Expand it. Increase its size. Increase its complexity and power. Then build your robot around that central feature. Be careful not to let other areas of the robot compete with the central feature. For example, if you're focusing on giant hands, you might not want to add massive shoulders, which could overpower the hands.

Keep in mind that robots are extreme mechanisms to begin with. Therefore, while exercising restraint may be the best course of action when meeting your future in-laws for the first time, it pays no dividends here. Better to overshoot the mark in manga and anime than to undershoot it. And, better to smile and keep your mouth shut around the in-laws.

This spread illustrates what happens when you take a typical robot design and select an area to expand in order to create unique characters that really stand out.

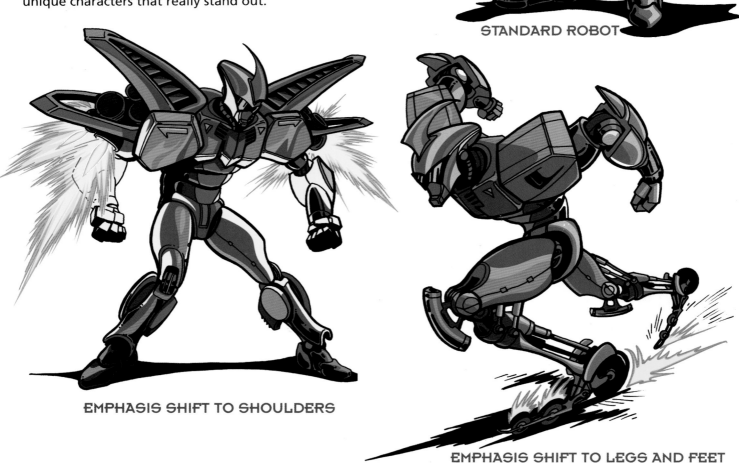

STANDARD ROBOT

EMPHASIS SHIFT TO SHOULDERS

EMPHASIS SHIFT TO LEGS AND FEET

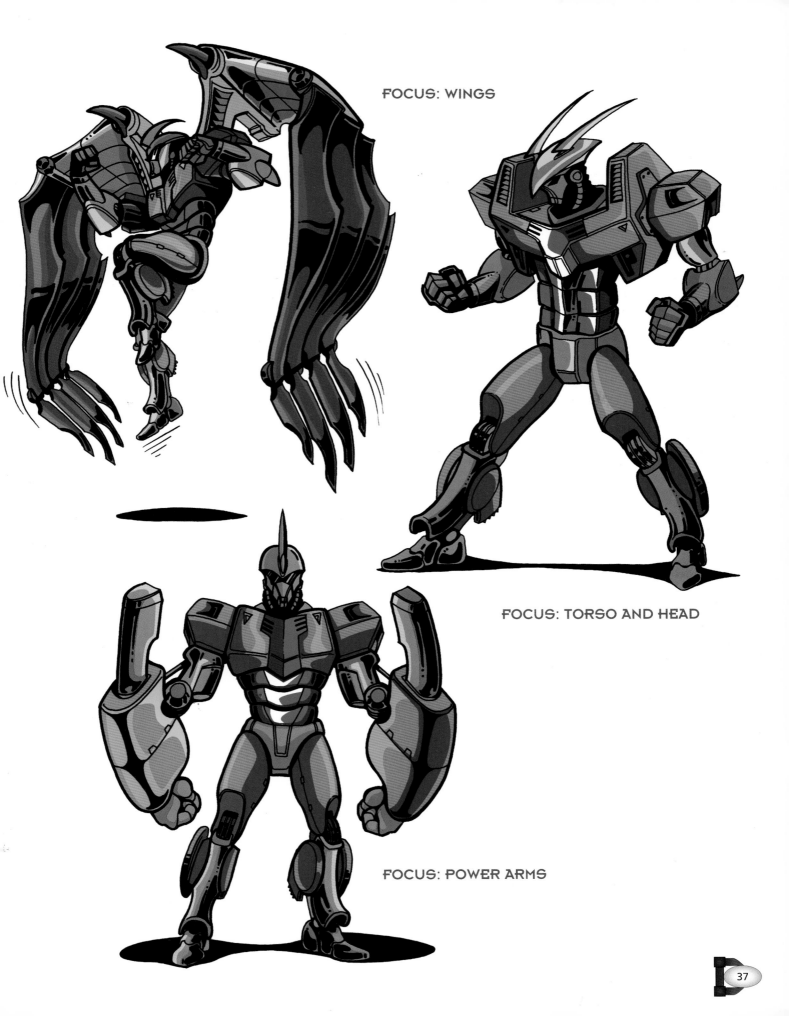

FOCUS: WINGS

FOCUS: TORSO AND HEAD

FOCUS: POWER ARMS

# STRANGE MECHA

Ready for the weird? The unexplained? The bizarre? No, I'm not talking about your mom's aunt. I'm talking about the world of *strange mecha,* where anything is possible. Odd and creepy creatures, whose appearances are like no other mecha on the planet, take on a sinister and a discomforting presence.

### ENERGY-CHARGED MECHA

The connective tissue of this robot isn't nuts or bolts but fields of roaring energy. Its conductivity is so powerful that it actually draws thunderous bolts of lighting to it, which it utilizes for its own everincreasing need for power.

It might seem curious that this figure would be bathed in so much shadow, while being hit by something as brilliant as lightning, but that's just the point: There needs to be contrast. Bursts of lightning juxtaposed against a very light background lose impact. White on white has no intensity. However, by creating a scene steeped in darkness, the lightning streaks become glowing rapiers, slashing their way through the air and illuminating the night sky (or, if this were a daytime scene, a science lab, for example).

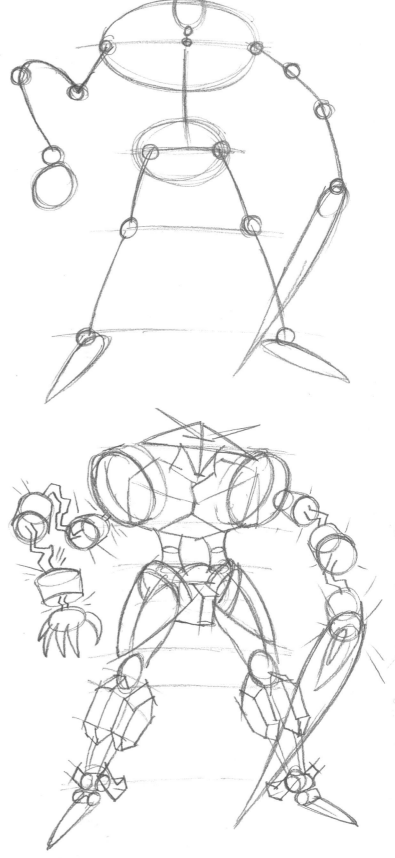

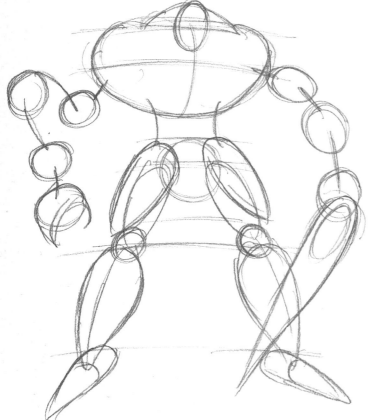

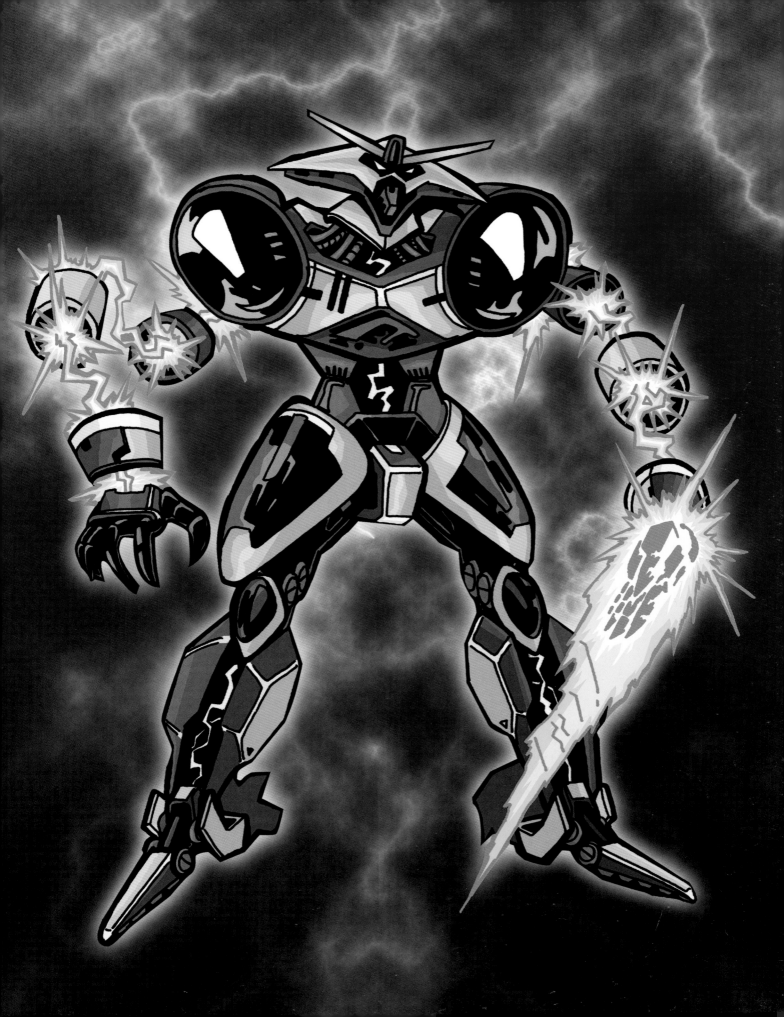

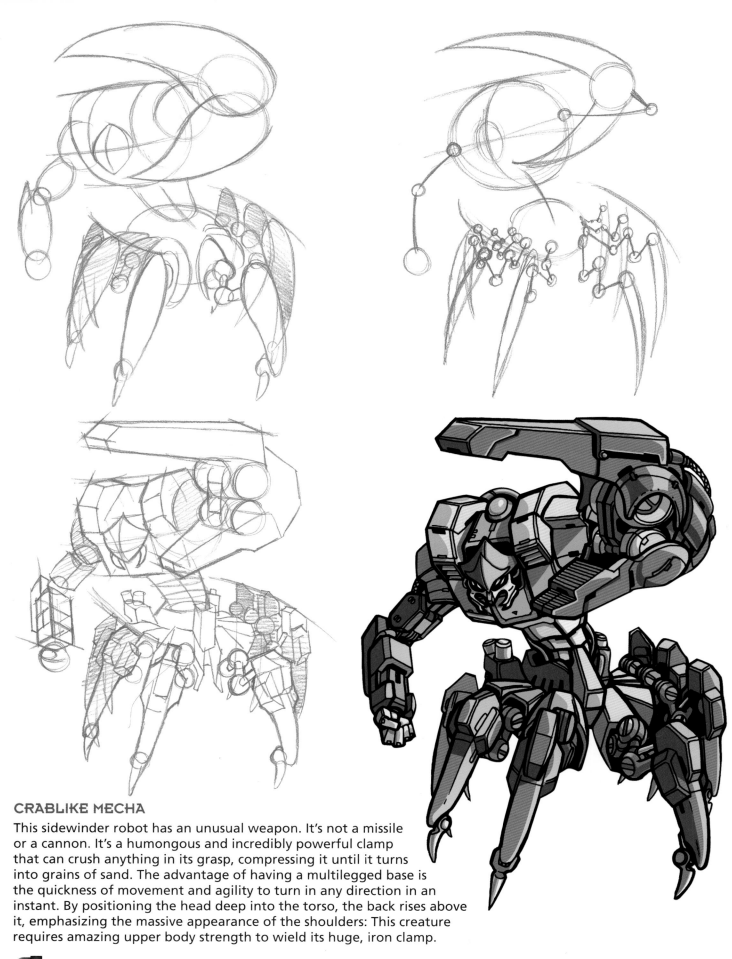

## CRABLIKE MECHA

This sidewinder robot has an unusual weapon. It's not a missile or a cannon. It's a humongous and incredibly powerful clamp that can crush anything in its grasp, compressing it until it turns into grains of sand. The advantage of having a multilegged base is the quickness of movement and agility to turn in any direction in an instant. By positioning the head deep into the torso, the back rises above it, emphasizing the massive appearance of the shoulders: This creature requires amazing upper body strength to wield its huge, iron clamp.

## RECONNAISSANCE MECHA

This mecha is all *fly*power, very little firepower. It flies aerial missions, scouting the planet surface for signs of enemy troops. When it sees them, it relays the information back to its controllers via that huge radar attachment, which accordions out from the rear of the helmet. The arms and hands are diminutive, compared to other robots, but the rockets are huge. This lets us know that this is an incredibly nimble flier that relies on speed to avoid detection and escape encounters with other, mightier robots.

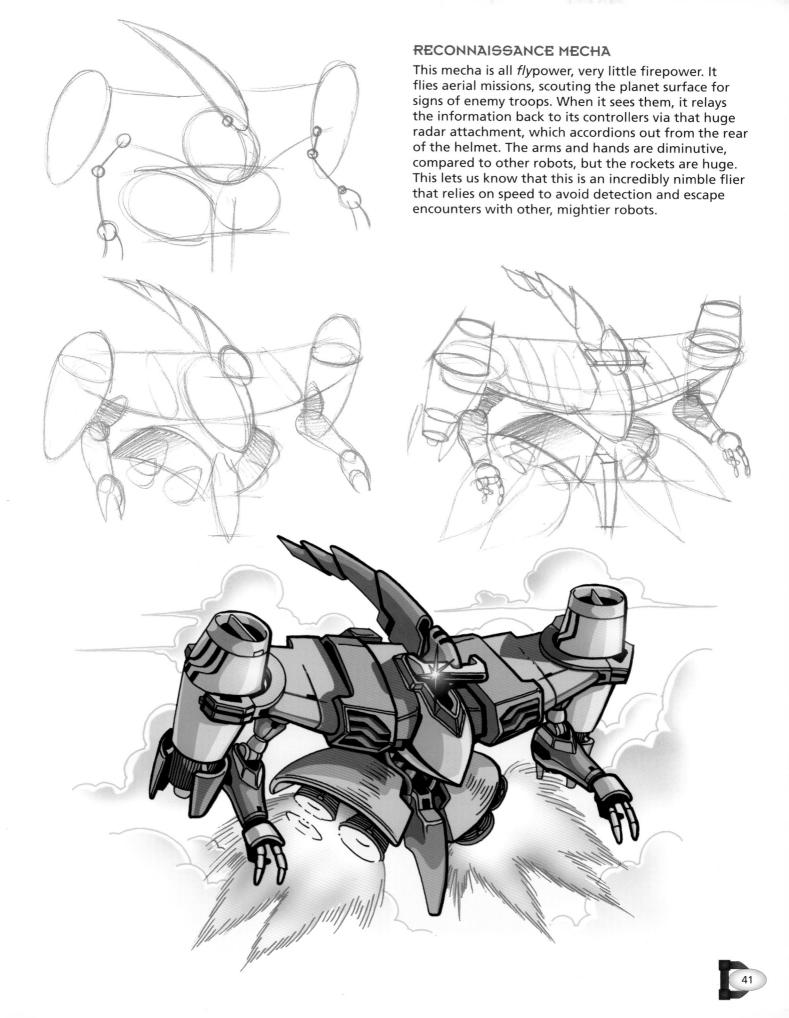

## SUBMERSIBLE MECHA

The land is no longer safe. Alien troops have invaded.
The skies are not safe. Giant robots own the skies.
The only refuge left is the ocean. But I'd think twice
before boarding a sub, my friend, because something
does indeed own the deep—the strangest of all
creatures: the submersible mecha robot.

This crustacean-shaped mechanism is hidden by the
light-deprived environment of the sea's bottom. That
means it can attack without warning. It's super quick
because of the flexibility of its back. One quick whip
of the tail sends it zooming through the water. (And
notice the tail's razor-sharp tip.) It uses multiple arms
to capture and hold prey, and then dismantle it.
Whether or not the robot utilizes air in its fuel
mixture isn't important; what is important is to
incorporate bubbles for the purpose of establishing
the watery, weightless feeling of the scene.

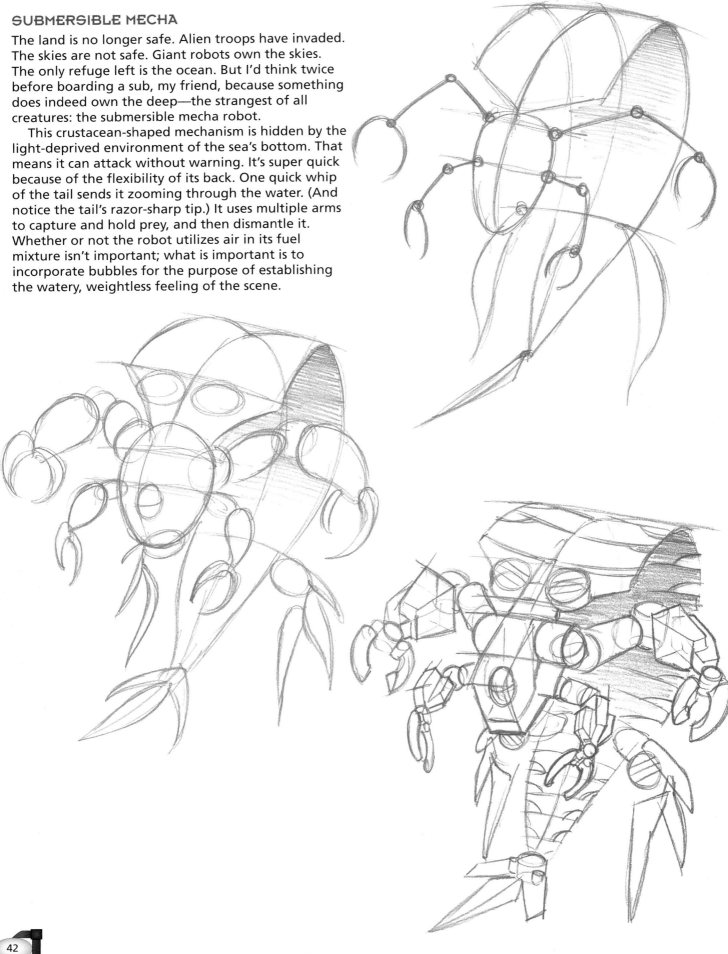

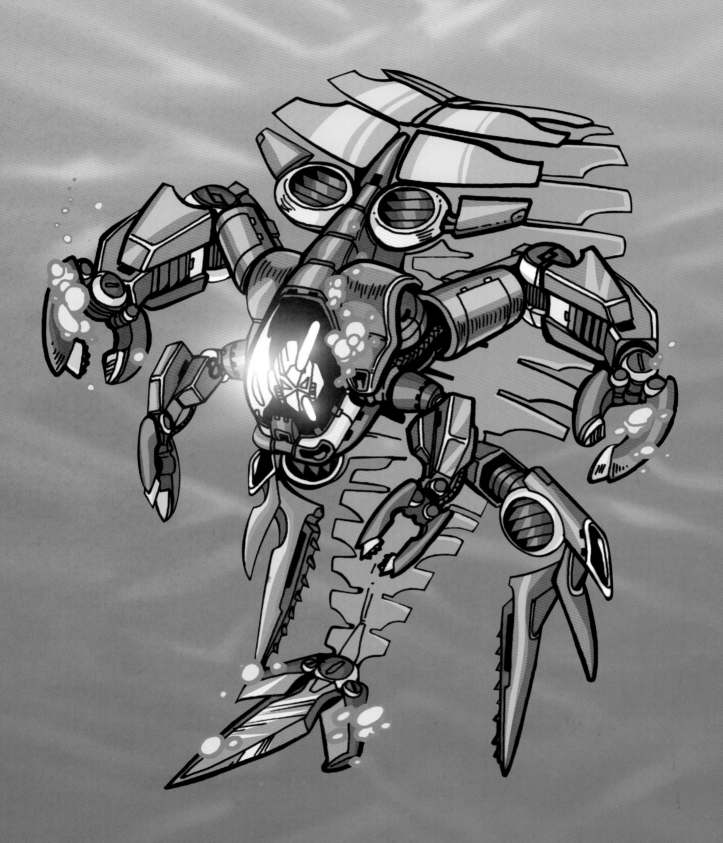

## TWIN MECHA

This mysterious, faceless machine is a messenger sent from its master to give humans their final warning to stop their armed resistance and allow themselves to be re-educated by the new order for the greater good. The two heads should have identical expressions—or a lack thereof. This is what makes them creepy: two of them, identical in all manner of looks, behavior, and speech.

This mecha is sophisticated in mannerism, almost droll. Its raised chins and hanging, draped garments give the impression of a superior being—or at least, of a being who considers itself superior. It doesn't require heavy armaments to round up mere humans. However, if you look closely, you'll see that there are two white dots in each chest, from which the Beams of Obedience are shot, like pulses, at the Earth creatures.

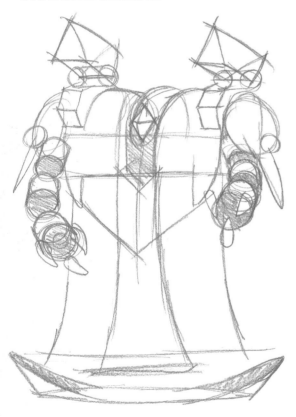

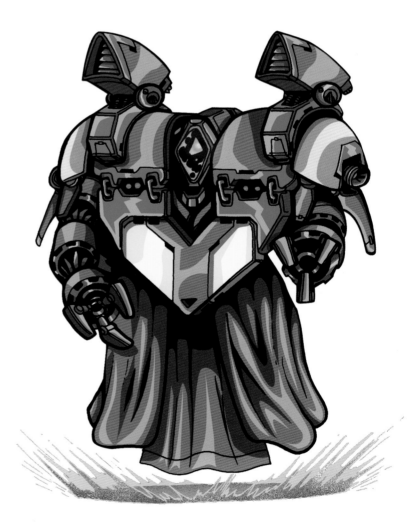

## ANIMAL-BASED MECHA

You can fashion a robot after any animal, but if you want to create strange mecha, you'd be better off choosing an offbeat creature such as a bird, rather than the more obvious choice of, for example, a lizard. Once, long ago, the lizard would have made a great robot, but by now we've been exposed to so many snakes, dragons, and lizards that we've become totally familiar with them and they no longer surprise us. So, you must dig deeper.

A mechanical, quasi bird is really bizarre, especially if doesn't have wings. A bird with arms and hands instead of wings is even weirder. The beak should be extremely long, drawing attention to its oddity, rather than masking it. Maintain the leg configuration of a bird, because instead of flying, this robot will walk (remember, we've taken away the wings). Birds tend to waddle awkwardly when they walk; it's an unnatural movement for them, and this awkwardness pays off when you're designing the weird and the curious.

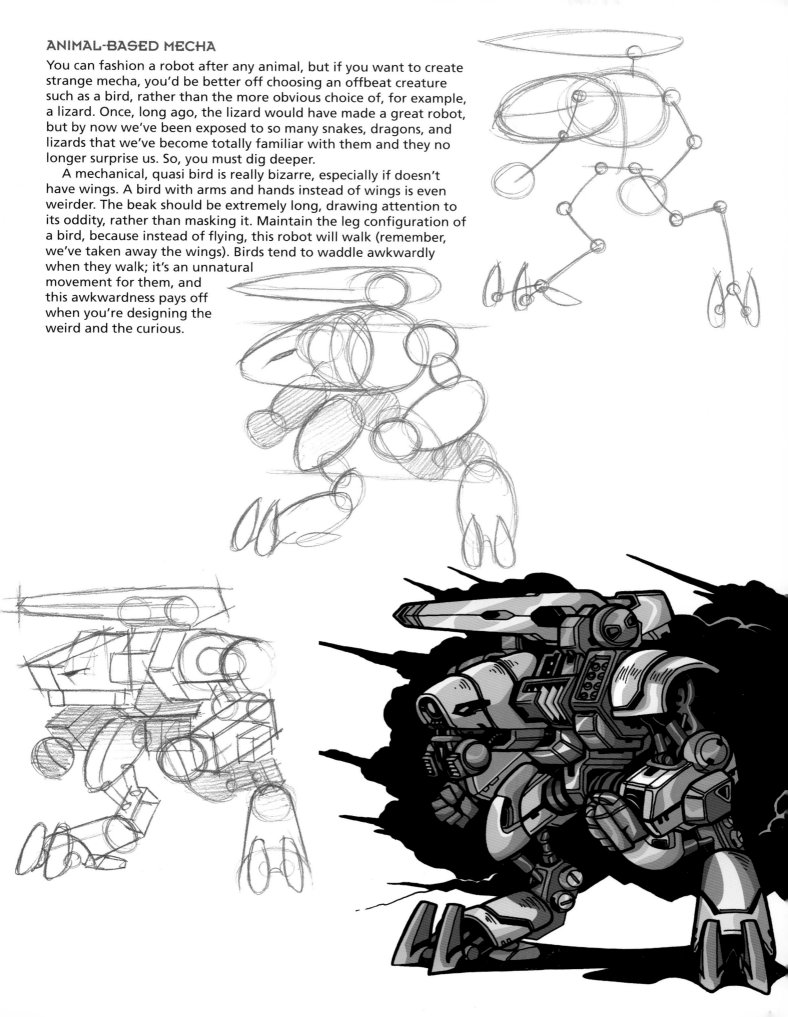

# THE COCKPIT

 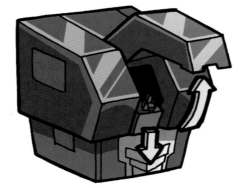 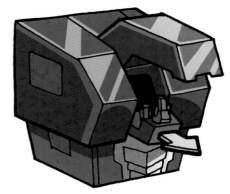

**CLOSED HATCH**　　　**OPEN HATCH**　　　**EMERGING COMMAND PLATFORM**

Taking a look at the cockpit of a giant mecha gives you a good idea of the true scale of these robots. They're immense! The cockpit is like a vault. It houses something very valuable: the controls of the giant mechanism. Therefore, it's protected by a very sturdy cover. When the cover opens, the command platform, which supports the pilot's chair, emerges.

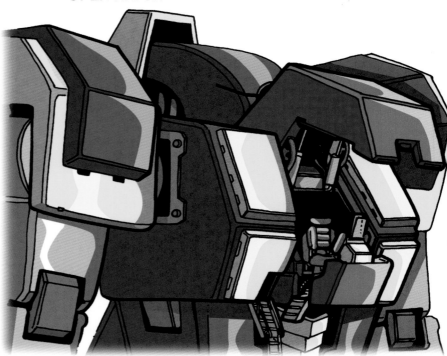

**CLOSED ESCAPE PORTAL**

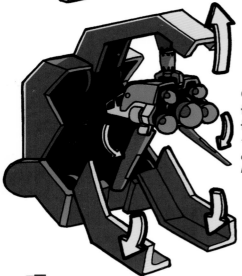

**OPEN ESCAPE PORTAL**

*The craft commences reentry here.*

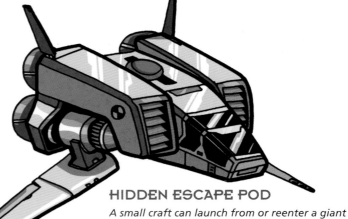

**HIDDEN ESCAPE POD**

*A small craft can launch from or reenter a giant mecha. This escape pod is also a good device when you want to show the huge scale of the robot. The port for the escape pod should look as though it's swallowing up the craft. Eyeball the wingspan up and down, left and right, before designing the portal, as the opening must be large enough for the craft to fly through.*

# SPECIAL EQUIPMENT AND FUNCTIONS

Robots have secret compartments, hidden weapons, jets, lasers, and more. Special effects are to mecha what special powers are to action heroes. They give them their edge. They're also the part that everyone looks forward to seeing. But unlike action heroes, who can fire beams from their fingertips, mecha robots must be created with much more inventiveness. You're now creating special functions and gadgets within gadgets, which have to look as if they were designed by a psychotic engineer. Sure, it would be easy to draw a robot tossing a fireball with its hand, but that's not what people want to see. They want to see how the robot's compartments unfold, and how the weapons emerge and retract. Special effects are covered more completely in the next chapter, but you need to keep any special equipment that your mecha will have in mind as you design the robots. So, take a look at the example here.

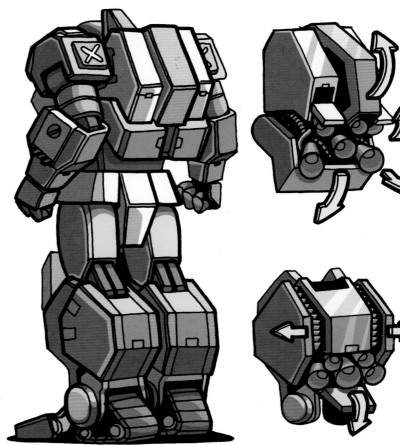

## HIDDEN JETS

Robots exist in a world at constant war, with heavy bombardment and heavy casualties. Therefore, many of the weapons systems and important functions of the robot are shielded and, as we've been examining, hidden inside the mecha. The more mechanical, methodical, and logical the unfolding, the cooler it will look.

Here, the hidden features are jets. Operating systems for hidden functions are multidirectional; they can open in one, two, three, or more directions at the same time. Some shields will open to the side, some will lift up, while still others will retract.

# HIDDEN LASERS

When the flaps open from the shoulders and chest, lasers blast the bad guys with a small starburst at the origin. This series of flaps demonstrates an increasing complexity in mecha design.

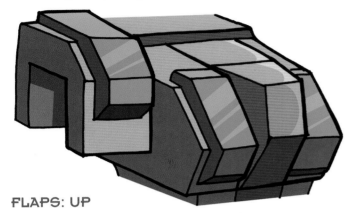

## FLAPS: UP

In this design, the flaps open upward.
Simple, direct, and effective.

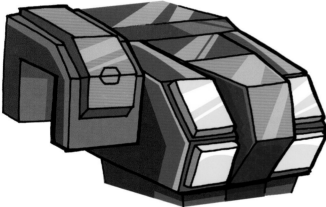

## FLAPS: UP AND DOWN

Here, each compartment is shielded by twin flaps, which open in opposite directions. This is more intricate and evolved.

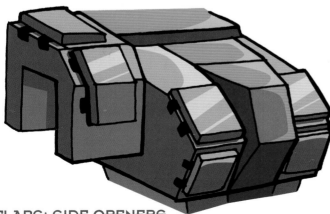

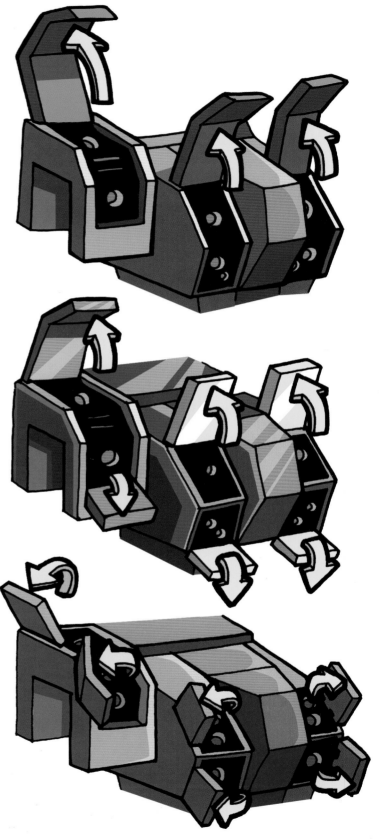

## FLAPS: SIDE OPENERS

Here, the flaps open to the side. They can open all at once or in rapid succession—pop, pop, pop—which is very cool.

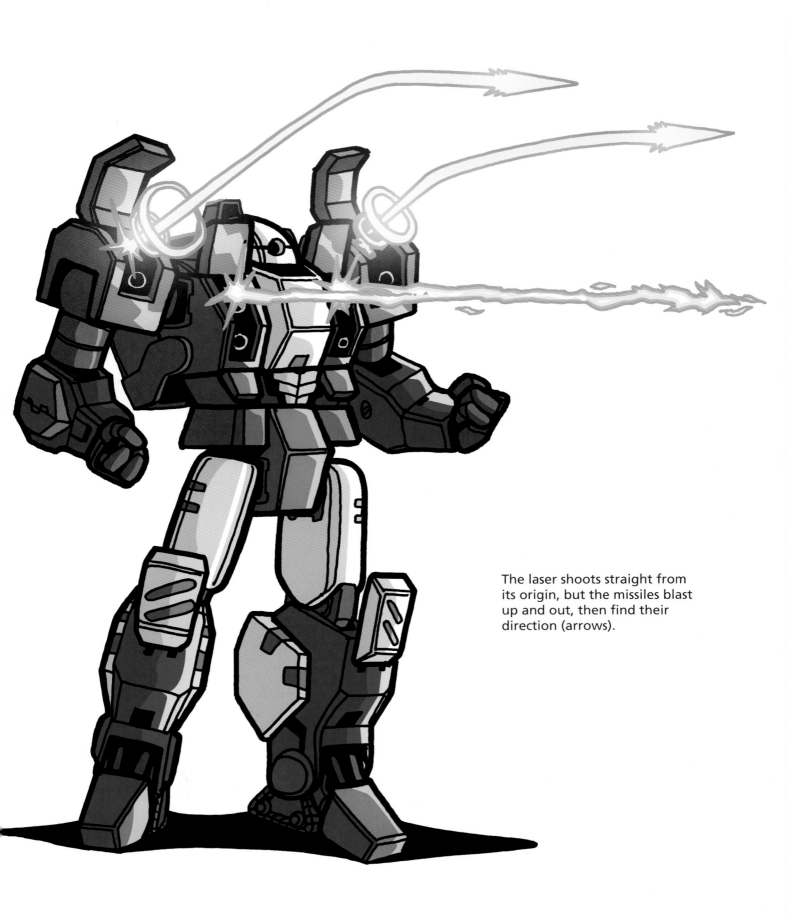

The laser shoots straight from its origin, but the missiles blast up and out, then find their direction (arrows).

# HIDDEN GADGETS

You can turn any gadget into an inventive projectile designed to capture the enemy or to be used by the robot to pull itself to safety.

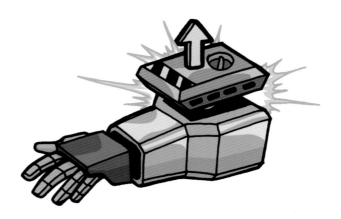

### GRAPPLING HOOKS

These hooks are shot like projectiles, and hook onto any object. They create a lifeline to retrieve helpless people, prevent a disabled spaceship from drifting, or scale a wall. The hook is fired in the open position, but when it hits its intended target, it snaps shut.

### FORCE FIELD SHIELD

This is a force field that explodes into action from a plate in the forearm. The shield must first rise from the forearm in order to allow the vent openings to emit the energy.

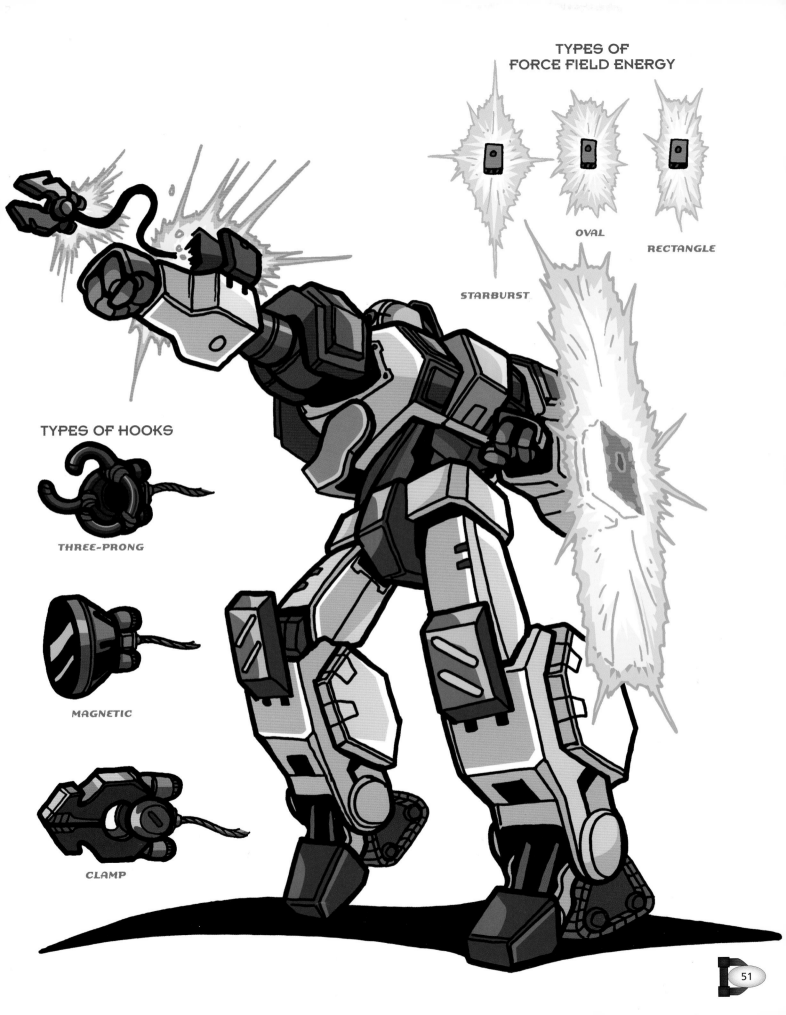

TYPES OF
FORCE FIELD ENERGY

OVAL

RECTANGLE

STARBURST

TYPES OF HOOKS

THREE-PRONG

MAGNETIC

CLAMP

# COOL MECHA BACKGROUNDS

Your characters are not the only thing you need to design. You also need to give thought to the locations for your stories. Much of mecha takes place on Earth, but an Earth in a parallel time—an Earth that isn't, but that could be. Other mecha takes place in the future or at some faraway place in the galaxy.

Wherever your story takes place, it should typically open with what's called an *establishing shot,* a long shot that shows the environment, giving the audience its bearings. Then, you can begin cutting in closer to your characters. So, let's explore some of the establishing shots for worlds in a time not our own.

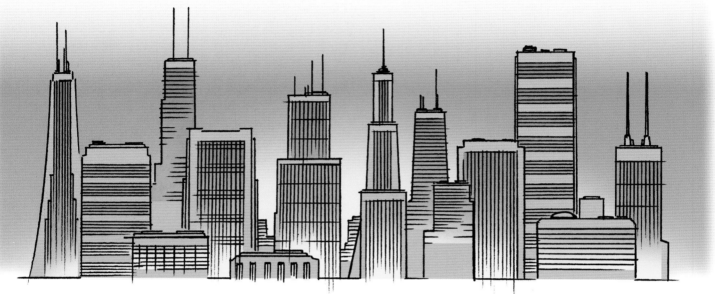

### PRESENT-DAY EARTH (ABOVE)

The Earth of today is typified by high-rises, towers, and buildings with lots of windows. At a distance, there's no need to indicate streets or trees. The buildings can overlap one another, leaving only skyline for negative space.

### EARTH OF TOMORROW (BELOW)

The biggest difference here is that a hot dog costs about 20,000 zarnacks. But also, the skyline has changed. There are flying craft all over, and the buildings are oddly shaped with multiple spires that reach skyward. Instead of big blocks of concrete, the buildings are thin, elegant, and display organic shapes that are not always symmetrical.

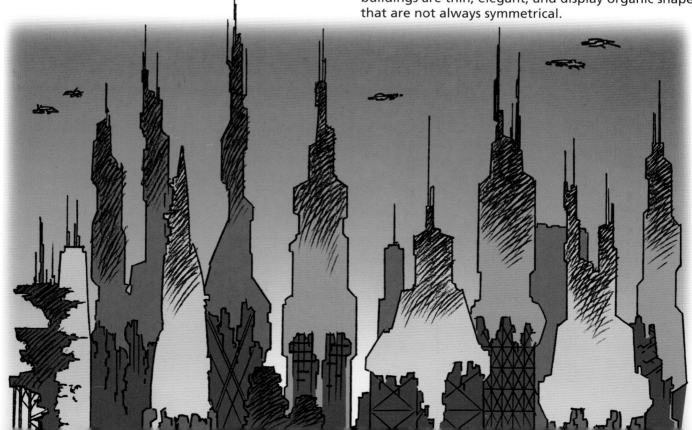

# CITIES OF THE FUTURE

These are very cool. As the spacecraft descends to the surface, you immediately know you're entering a different world. Maybe it's populated by nonhumans. Or, perhaps the humans have created an entirely new society. Or possibly, it's a society where humans and mutants coexist peacefully. Yeah, right.

Some of these futuristic designs are derivative of ancient South American civilizations, where indigenous people carved giant steps up the sides of a templelike mountain. Some popular alien cultures are presented as having primitive ways, with the Earthlings cast as the advanced ones. Sometimes the aliens have primitive cultures but advanced technology, which seems incongruous but has a cool look.

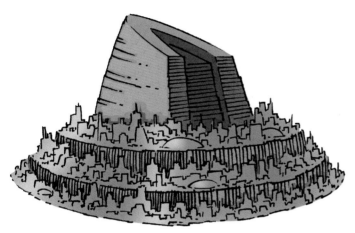

**PRIMITIVE MOUNTAIN WORSHIPPERS**

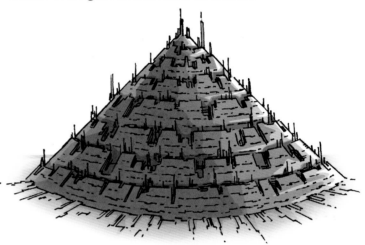

**ADVANCED CIVILIZATION**

**ALIEN CITY**

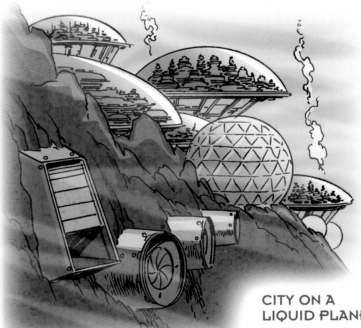

**CITY ON A LIQUID PLANET**

**ALIEN LANDING FIELDS**

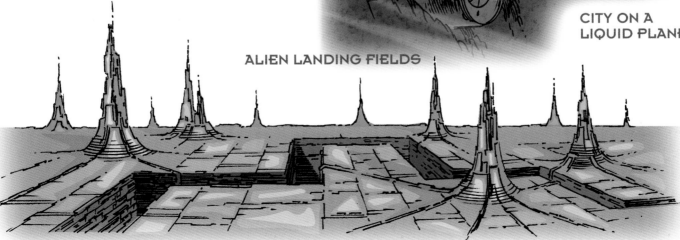

# HANGAR AND CREW

You can't draw intense robots and then stick them in a woodshed. We've all seen the cool industrial storage facilities, the underground silos, and the launching pads with their impressive scaffoldings, ten stories high. This is your robot's home base, where it launches and where it returns for needed repairs.

There's always a human crew around these hangars either getting ready to board the mecha unit, working on it, or scheming. It helps to know how to cast a few key personnel. The humans are sometimes no more than props in the scene, without whom it would look eerily empty. Remember, a robot can't launch itself, so you need to introduce people to operate the controls. In addition, the pilot does not own this huge machine; the pilot has to return the robot to the project base where it belongs.

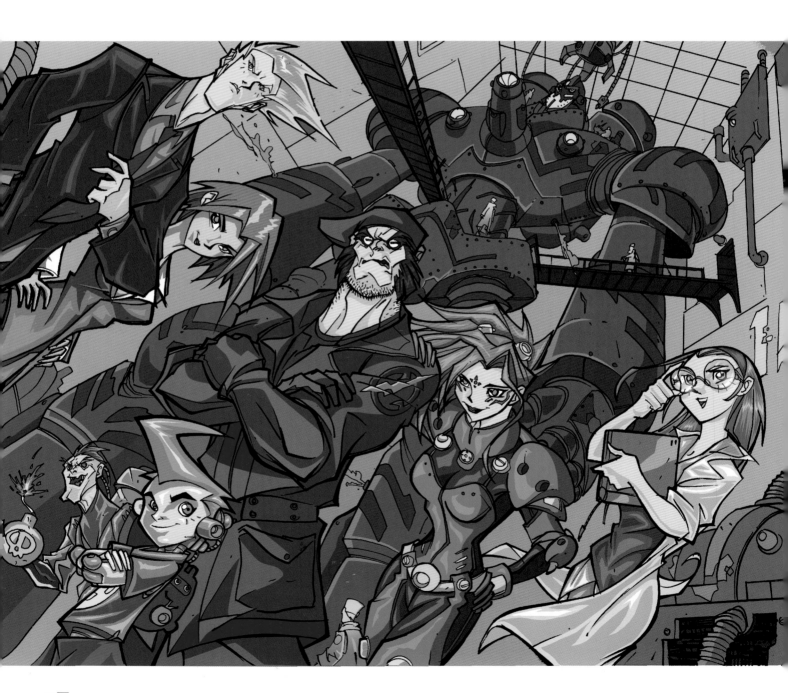

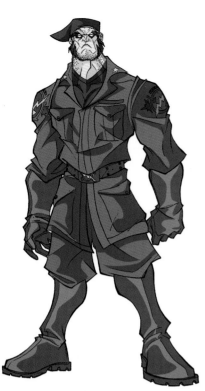

## PROJECT LEADER

*He's been through many wars and probably won't live to see the end of this one. He's headstrong and tough —and too blunt when his superiors ask for his opinion. He's loyal to the core. He cannot be bought off. But, that's no problem for his superiors, because to them, he's quite disposable, er, I mean replaceable. (Note: He can pilot the robot but has the habit of flying it too hard.)*

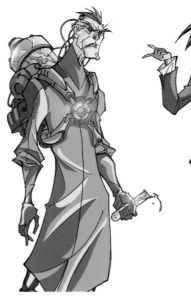

## EVIL SCIENTIST

*He's the architect of the mission. He's the one who has chosen the support crew, although none of them know his true agenda: world domination. He cares nothing about saving his planet, unless it means saving it for himself to rule! He has the final say in all decisions relating to the mission, and if someone suspects that he's really up to no good, then it's lights-out for the whistle blower! This guy's old, decrepit, and in need of an energy source to keep him alive. His slight build and sunken chest show that there is nothing healthy about him.*

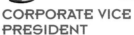

## CORPORATE VICE PRESIDENT

*She works for the corporate villain but isn't part of his inner circle. Traditionally, this character has also been used in a different role: as complicit in the wicked plot to take over the world and double-cross her own rebel fighters. While this option doesn't offer as much conflict as the one in which her heart's in the right place, it does set up a wider corporate power base of evil. And, strong villains make for good stories.*

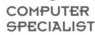

## COMPUTER SPECIALIST

*Her carefully crafted computer programs are the lifeblood of the giant robot. In an emergency, she can troubleshoot from wherever she is, as long as she's got a laptop handy. Since she's so technologically savvy, she can even pilot the robot if she has to take over in a pinch. Hers is a virtual world of blocking viruses, breaking through high security firewalls, and cracking impenetrable computer codes. When all seems lost, she's the one you can count on to pull a rabbit out of her hat. She's brilliant, serious, and intense. She's also young and energetic, but not polished. This is evident in her posture, which is not self-conscious and never pretentious, but a bit off-the-wall.*

## SIDEKICK HELPER UNIT

*There's often a humorous sidekick to balance out the melodrama of sci-fi. The helper unit is a sort of honorary member of the crew who doesn't get much respect because it doesn't have any real expertise or official rank. Its role is to do the odd jobs. Everyone finds the helper unit useful, and everyone likes it. It's trustworthy and can lend an ear when no one else will.*

## REBEL FIGHTER

*She's a rogue, not part of any team. She's only here to fight the bad guys because of what they did to her planet. She hates the enemy. Her blood boils for revenge, for freedom. She can fight. Believe it. She's loaded up with body plates, heavily armed and dangerous. And, she's an ace pilot who throws caution to the wind. If she's not given the opportunity to pilot a giant robot, she'll steal one. Don't try to win her confidence. She trusts no one.*

## CORPORATE VILLAIN

*This is Mr. Wallet, the guy who saw gold when he was presented with the evil scientist's idea. This guy's ruthless and supremely selfish, but has the gift of gab. He snoops around the hangar, keeping his eye on everyone. Wide shoulders and a narrow waist give him a predatory, hungry look. Note his sharp facial features, which in comics are indicative of evil.*

# GAINING ENTRY TO THE ROBOT

These titans of mechanical mayhem are too big to park along the curb; they need giant platforms in vast hangars that are acres large. Scaffolding surrounds the robot in the same way that scaffolding surrounds a rocket ready for launch. Mobile platforms are crucial to the design of the launch area. They enable the engineers to perform the preparations. They also allow the corporate big shots to take strolls around their toys. Most importantly, they gives the pilots a ledge from which to enter the fighting machines.

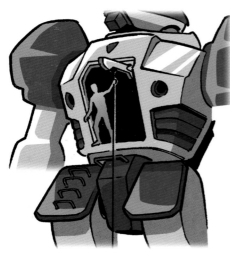

### EMERGENCY DEBOARDING CABLE

*When your robot gets pulverized in a clash with the forces of evil (and rest assured there will be plenty of pulverizing), you can't call AAA and wait for a tow. Your pilot has to get the heck out of there before it blows to smithereens! That's why it's a cool idea to incorporate an emergency cable that will lower the pilot to safety.*

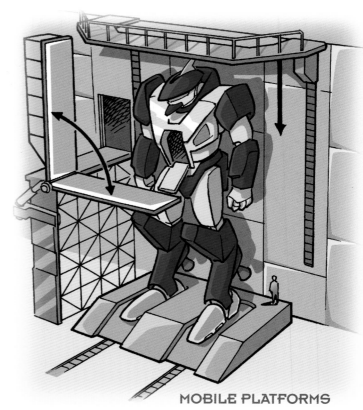

### MOBILE PLATFORMS

*Platforms can rise up, move down, or unfold.*

### DOUBLE BRACKETS

*Double brackets rotate around the robot from one end and lock into the hangar wall at the other, keeping the robot in launch position. Again, note how important it is to place a person in the picture to establish the size scale.*

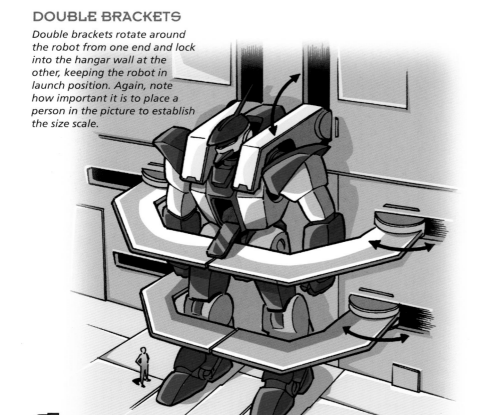

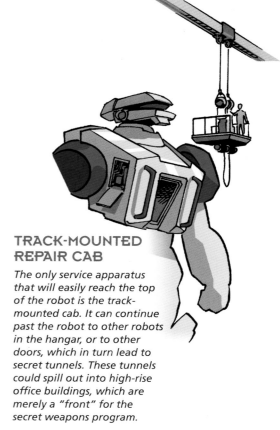

### TRACK-MOUNTED REPAIR CAB

*The only service apparatus that will easily reach the top of the robot is the track-mounted cab. It can continue past the robot to other robots in the hangar, or to other doors, which in turn lead to secret tunnels. These tunnels could spill out into high-rise office buildings, which are merely a "front" for the secret weapons program.*

## THE REPAIR DOCK

*Here, the robot is like a giant patient on a gurney. This type of setup is a good change of pace. Lying on its back, the robot appears more vulnerable, even somewhat human.*

## THE LAUNCH

*Launches are usually done vertically, through a retractable cutaway in the ceiling. They can, however, also begin with a ground-based acceleration.*

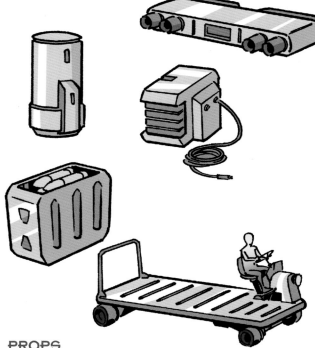

## PROPS

*The hangar isn't just a garage where you park the latest model robot. It's really a big work space with lots of tools. By placing tools about, you dress the set with props, giving the impression of a lot of activity. Some of these tools include motorized dollies, diagnostic equipment, battery testers, adapters, and the like. Heck, you can just make 'em up, as long as they look like robot components.*

## SERVICING THE WEAPONS

*Just as important as the robot itself is its weapon, without which the robot's toast. Since the robot is a giant, so is the weapon. Therefore, you can't just lean it in a corner; it requires its own compartment.*

# MECHA METAMORPHOSES AND SPECIAL EFFECTS

The sections of a robot can be rearranged to create an endless variety of forms. When the new form becomes a different object entirely (for example, when a robot turns into an armored tank or vice versa) a metamorphosis—or mecha metamorphosis, as I call it—has taken place. The mecha will perform its function flawlessly in its new role. Sometimes the purpose of the metamorphosis is to fulfill a necessary role; but, it's just as likely to be for stealth and guile. The fun is in seeing how the object turns into a giant robot, without being able to recognize, in advance, the robot's true form in the object.

# GROUND VEHICLE METAMORPHOSIS

Ground assault vehicles make great changeover objects because of the surprise value. Whereas most mecha robots fly (making the switch from a spaceship somewhat expected), no one thinks that a four- or six-wheeled, armored vehicle is going to suddenly sprout arms or legs!

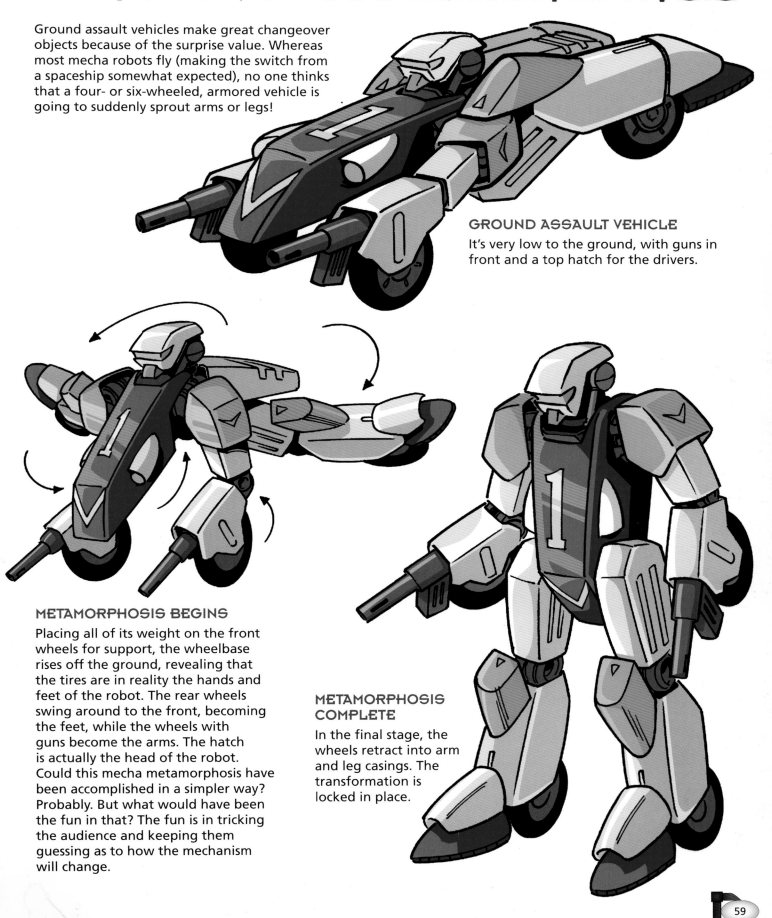

### GROUND ASSAULT VEHICLE

It's very low to the ground, with guns in front and a top hatch for the drivers.

### METAMORPHOSIS BEGINS

Placing all of its weight on the front wheels for support, the wheelbase rises off the ground, revealing that the tires are in reality the hands and feet of the robot. The rear wheels swing around to the front, becoming the feet, while the wheels with guns become the arms. The hatch is actually the head of the robot. Could this mecha metamorphosis have been accomplished in a simpler way? Probably. But what would have been the fun in that? The fun is in tricking the audience and keeping them guessing as to how the mechanism will change.

### METAMORPHOSIS COMPLETE

In the final stage, the wheels retract into arm and leg casings. The transformation is locked in place.

# FROM FIGHTER JET TO ROBOT

This mecha robot is nicely camouflaged to appear to be a serious aircraft.

The mecha metamorphosis doesn't have to be based on sound engineering principles, and it doesn't have to be efficient. You can purposely make it complex, with a series of difficult maneuvers if that's the look you're going for; sometimes, small explosions precede the decoupling of joints and hinges. All that matters is that the changeover looks cool and convincing.

## FIGHTER JET

We start with what appears to be an aircraft. It has a supersonic body structure and dual tail stabilizers.

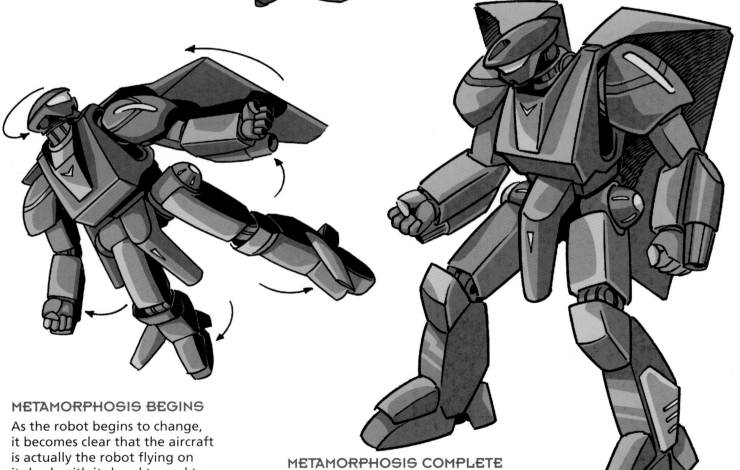

## METAMORPHOSIS BEGINS

As the robot begins to change, it becomes clear that the aircraft is actually the robot flying on its back with its head turned to face forward. When it begins to reassemble as a robot, the head spins around and the wings rotate around until they are behind the arms.

## METAMORPHOSIS COMPLETE

The robot now stands ready, and the wings are in the appropriate position for a robot warrior. *One note:* In order to help the audience's eyes follow the mechamorphosis, it's a good idea to add some markings or insignias to the robot that they can follow. Note the markings here on the shoulders, chest, and calves.

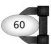

# SPACESHIP METAMORPHOSIS

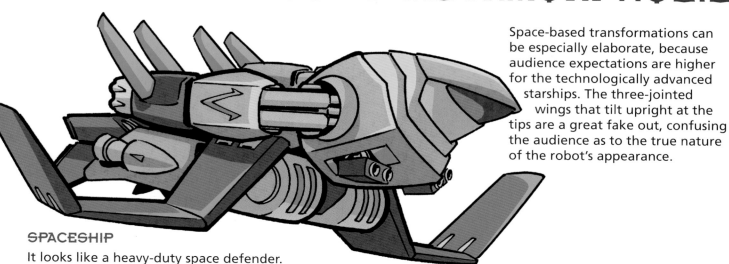

Space-based transformations can be especially elaborate, because audience expectations are higher for the technologically advanced starships. The three-jointed wings that tilt upright at the tips are a great fake out, confusing the audience as to the true nature of the robot's appearance.

## SPACESHIP
It looks like a heavy-duty space defender.

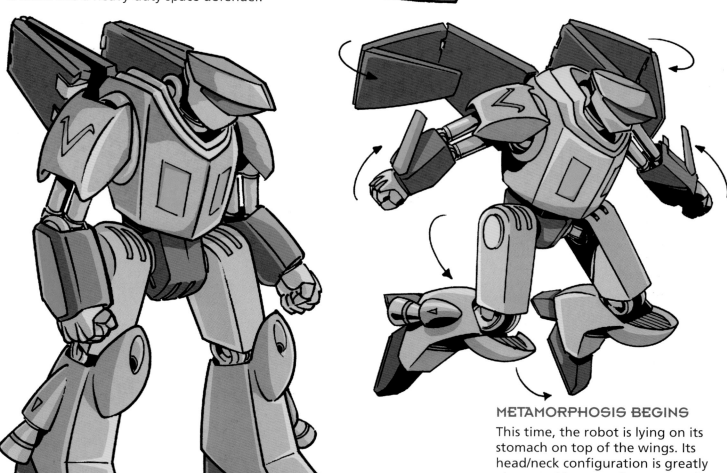

## METAMORPHOSIS COMPLETE
Now the robot is in fighting stance. It can resume flight as a spaceship, or if you prefer to keep it in its present form, the side jets on the boots can blast the robot back into the stratosphere.

## METAMORPHOSIS BEGINS
This time, the robot is lying on its stomach on top of the wings. Its head/neck configuration is greatly elongated by way of several neck spacers, which retract once the mecha metamorphosis nears completion. The robot raises its arms, allowing the wings to fold in. Legs release from the body of the craft and lower to a normal, vertical stance. Note that the side jets on the legs are visible in the spaceship mode.

# URGENCY: IN-FLIGHT METAMORPHOSIS

Sometimes a transformation is not done merely for camouflage but to show, visually, how urgent the action is. The robot here could have flown to its destination in its original, robot form, but by turning into a streamlined flying vehicle, its whole posture takes on a single-minded ferocity. Sure, we can still tell that it's a robot, but in this case, that's really the point: We're seeing the robot go all out at spectacular speeds to get to its destination before it's *too late*.

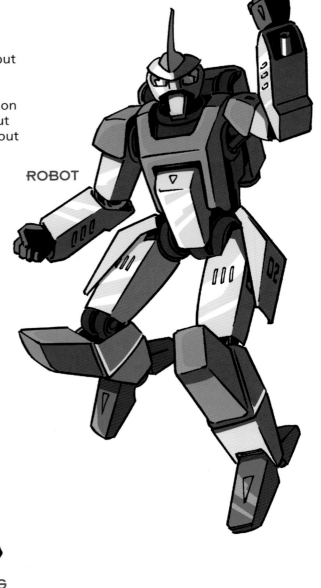

**ROBOT**

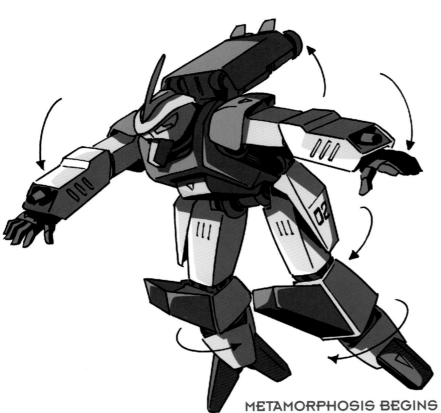

**METAMORPHOSIS BEGINS**

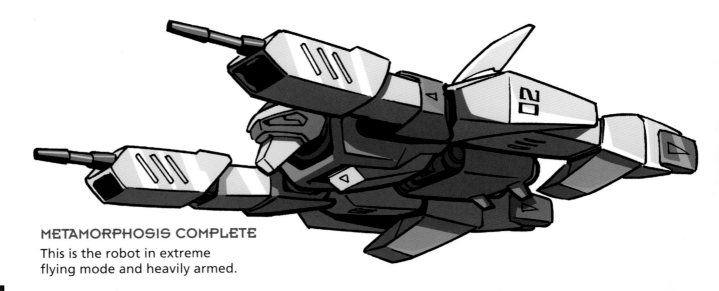

**METAMORPHOSIS COMPLETE**

This is the robot in extreme flying mode and heavily armed.

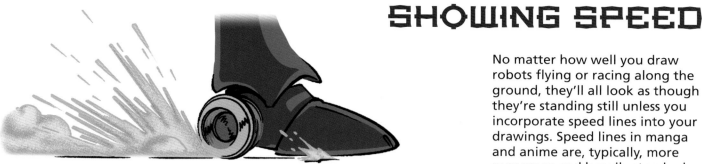

# SHOWING SPEED

No matter how well you draw robots flying or racing along the ground, they'll all look as though they're standing still unless you incorporate speed lines into your drawings. Speed lines in manga and anime are, typically, more numerous and heavily streaked than those in American comics. This dense streaking conveys the feeling that the robot is moving at truly astonishing speeds. Let's look at a few examples.

## HEEL-BASED MOTORS

*Wheels at the heel of the foot propel the robot forward. In order for the heel-based motor to work, the foot must remain flat on the ground. If the heel loses contact with the ground, the propulsion stops.*

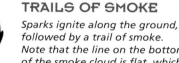

## TRAILS OF SMOKE

*Sparks ignite along the ground, followed by a trail of smoke. Note that the line on the bottom of the smoke cloud is flat, which serves to visually cut a trail on the ground, while the top of the smoke cloud is bumpy as it rises.*

## ALTERNATIVE SPEED LINES

*A long trail of smoke, along with some kicked up rocks, can substitute for speed lines.*

## FUEL STREAKS

*The fuel itself becomes a sort of speed line as it trails into the distance. If you don't show the fuel shooting out of the jets, it will look as if the jets have been turned off.*

## SHADOWS OF SPEEDING OBJECTS

*If you're moving at great speeds, everything seems to blur. To underscore this phenomenon, blur the shadow below the robot by streaking it with speed lines.*

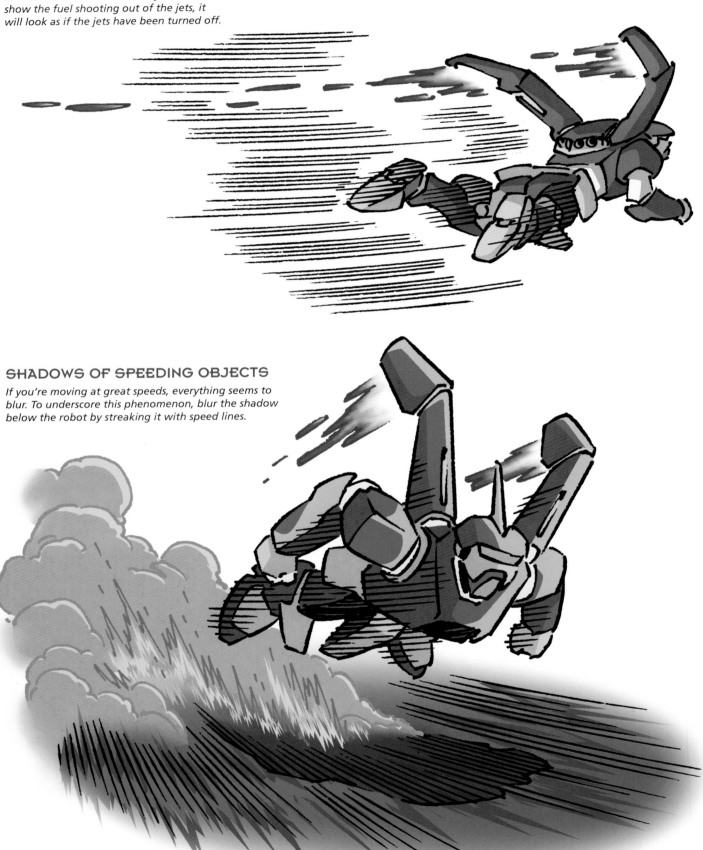

# THE LOOK OF ACTION

Speed lines add impact to fight scenes. Without 'em the combatants would look like statues.

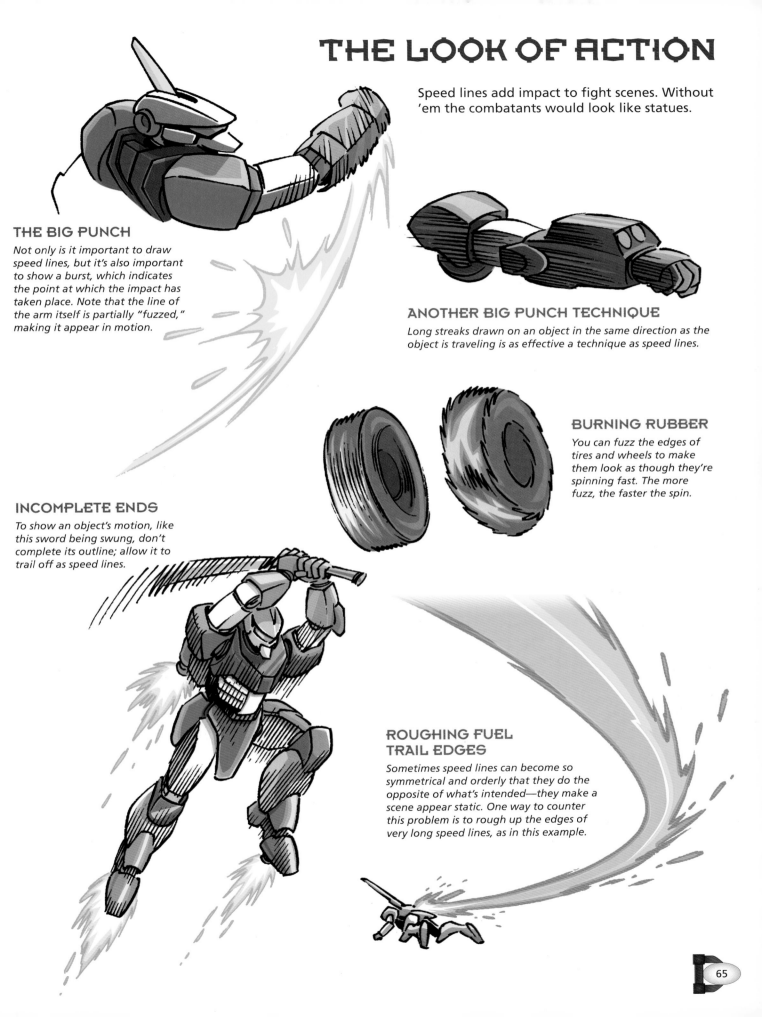

## THE BIG PUNCH

*Not only is it important to draw speed lines, but it's also important to show a burst, which indicates the point at which the impact has taken place. Note that the line of the arm itself is partially "fuzzed," making it appear in motion.*

## ANOTHER BIG PUNCH TECHNIQUE

*Long streaks drawn on an object in the same direction as the object is traveling is as effective a technique as speed lines.*

## BURNING RUBBER

*You can fuzz the edges of tires and wheels to make them look as though they're spinning fast. The more fuzz, the faster the spin.*

## INCOMPLETE ENDS

*To show an object's motion, like this sword being swung, don't complete its outline; allow it to trail off as speed lines.*

## ROUGHING FUEL TRAIL EDGES

*Sometimes speed lines can become so symmetrical and orderly that they do the opposite of what's intended—they make a scene appear static. One way to counter this problem is to rough up the edges of very long speed lines, as in this example.*

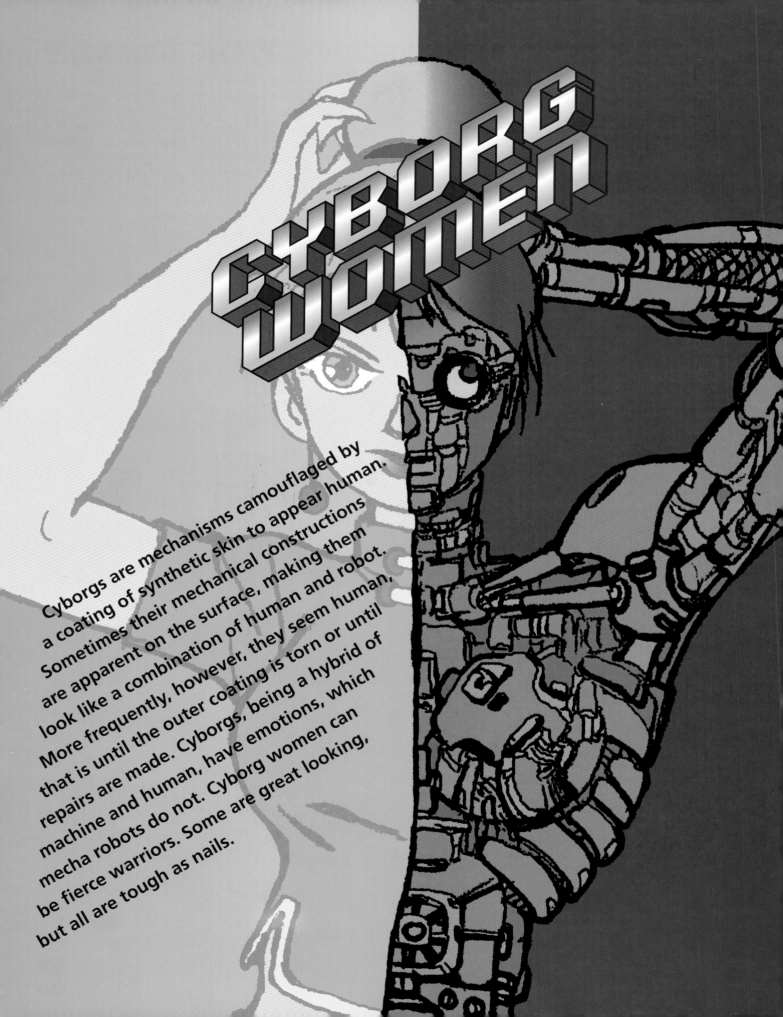

# CYBORG WOMEN

Cyborgs are mechanisms camouflaged by a coating of synthetic skin to appear human. Sometimes their mechanical constructions are apparent on the surface, making them look like a combination of human and robot. More frequently, however, they seem human, that is until the outer coating is torn or until repairs are made. Cyborgs, being a hybrid of machine and human, have emotions, which mecha robots do not. Cyborg women can be fierce warriors. Some are great looking, but all are tough as nails.

# EXTERIOR VS. INTERIOR

Here's the key to drawing cyborgs that will make your life easier: Don't draw cyborgs—draw people, and turn *them* into cyborgs. It's a whole lot easier to make a human frame look mechanical than it is to draw nuts and bolts in the shape of a human being.

Here's another important hint: Let the human anatomy dictate the size and shape of the mechanical components. In other words, if you're inventing metal casings for the shoulders, make sure they're the shape and size of a shoulder. If you're inventing cables and rods for the forearms, make sure that the cables and rods taper at the wrist in the same way that a human forearm tapers at the wrist. Cyborgs should look more human than giant mecha robots.

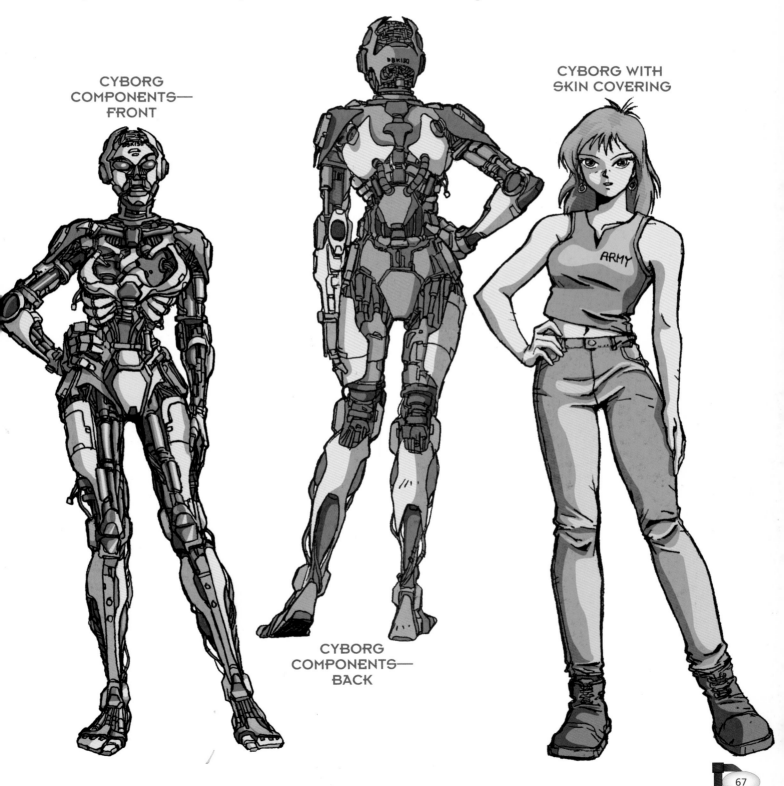

CYBORG
COMPONENTS—
FRONT

CYBORG
COMPONENTS—
BACK

CYBORG WITH
SKIN COVERING

# THE BASIC CYBORG WOMAN

Start by drawing the basic female figure, filling out the mechanical details only when you reach the final steps. You don't have to create as intricate a set of mechanics as shown in the drawings on this page. Perhaps you might have only her stomach plate open, revealing cables, switches, or just a simple control panel. And, you can always scale back. But for those of you who like a challenge, and want to see how creative and detailed you can get, here's the latest model with all the options.

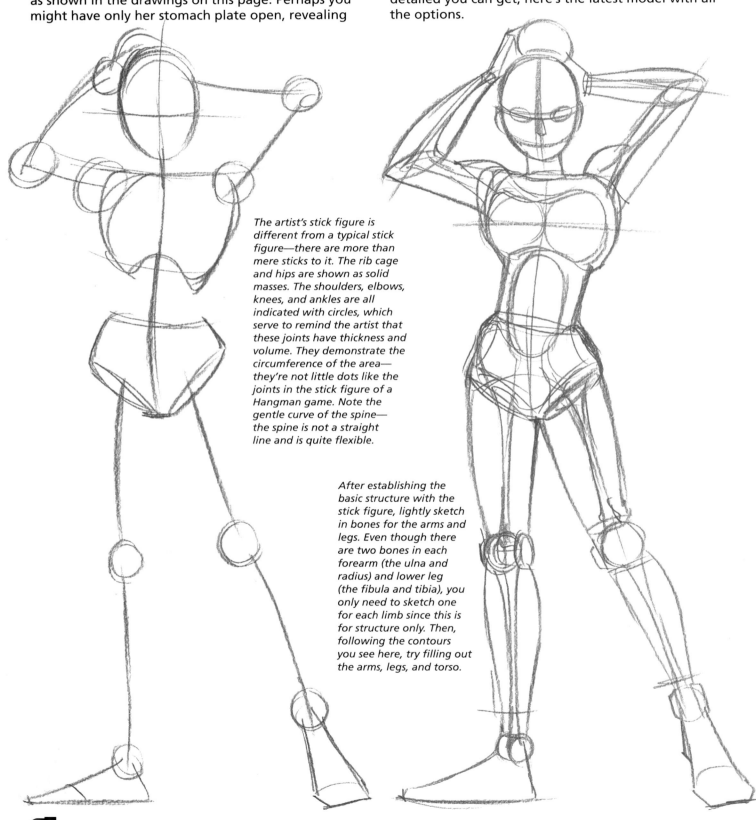

*The artist's stick figure is different from a typical stick figure—there are more than mere sticks to it. The rib cage and hips are shown as solid masses. The shoulders, elbows, knees, and ankles are all indicated with circles, which serve to remind the artist that these joints have thickness and volume. They demonstrate the circumference of the area— they're not little dots like the joints in the stick figure of a Hangman game. Note the gentle curve of the spine— the spine is not a straight line and is quite flexible.*

*After establishing the basic structure with the stick figure, lightly sketch in bones for the arms and legs. Even though there are two bones in each forearm (the ulna and radius) and lower leg (the fibula and tibia), you only need to sketch one for each limb since this is for structure only. Then, following the contours you see here, try filling out the arms, legs, and torso.*

Once the basic form is in place, all you need to do is add a costume and you've got an image of a normal woman. To turn her into a cyborg, add mechanisms within the form you've just created; then you've got a highly adapted, internally programmed mechanism capable of feats of incredible strength.

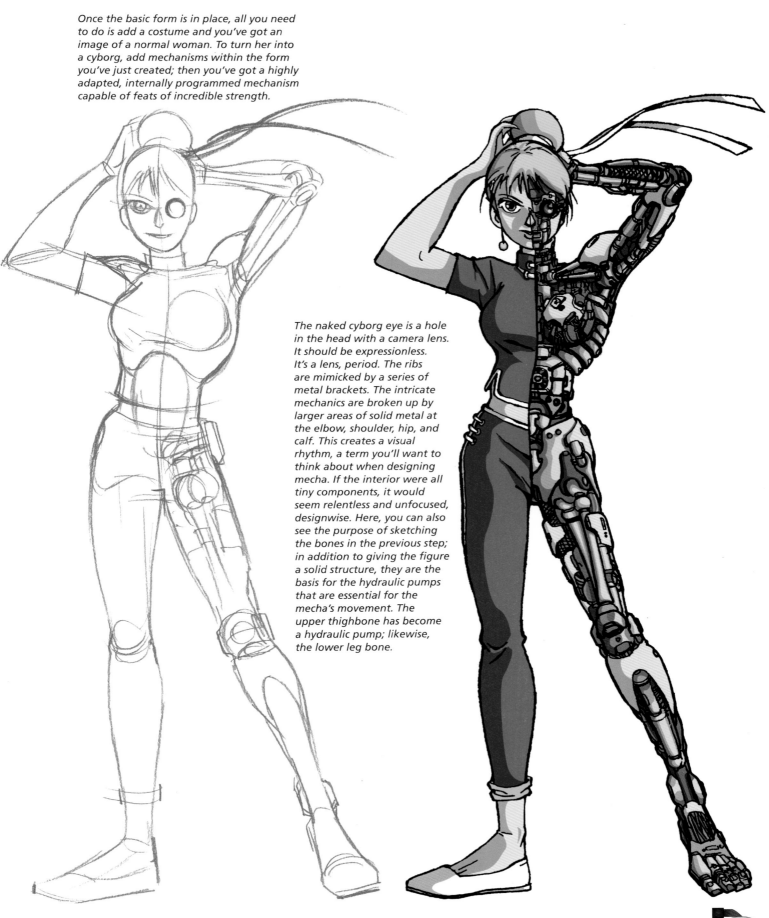

The naked cyborg eye is a hole in the head with a camera lens. It should be expressionless. It's a lens, period. The ribs are mimicked by a series of metal brackets. The intricate mechanics are broken up by larger areas of solid metal at the elbow, shoulder, hip, and calf. This creates a visual rhythm, a term you'll want to think about when designing mecha. If the interior were all tiny components, it would seem relentless and unfocused, designwise. Here, you can also see the purpose of sketching the bones in the previous step; in addition to giving the figure a solid structure, they are the basis for the hydraulic pumps that are essential for the mecha's movement. The upper thighbone has become a hydraulic pump; likewise, the lower leg bone.

# EVOLVED CYBORG UNIT

Some cyborgs are quite advanced technologically, created for missions well beyond the capabilities of ordinary humanoid machines. The technology is so cutting edge that it affects the outward appearance of the cyborg. No, she doesn't have cables and wires jutting from her arms—but she does show evidence of her energy source through reflective metal plates and markings where currents of energy pool, radiate, and glow.

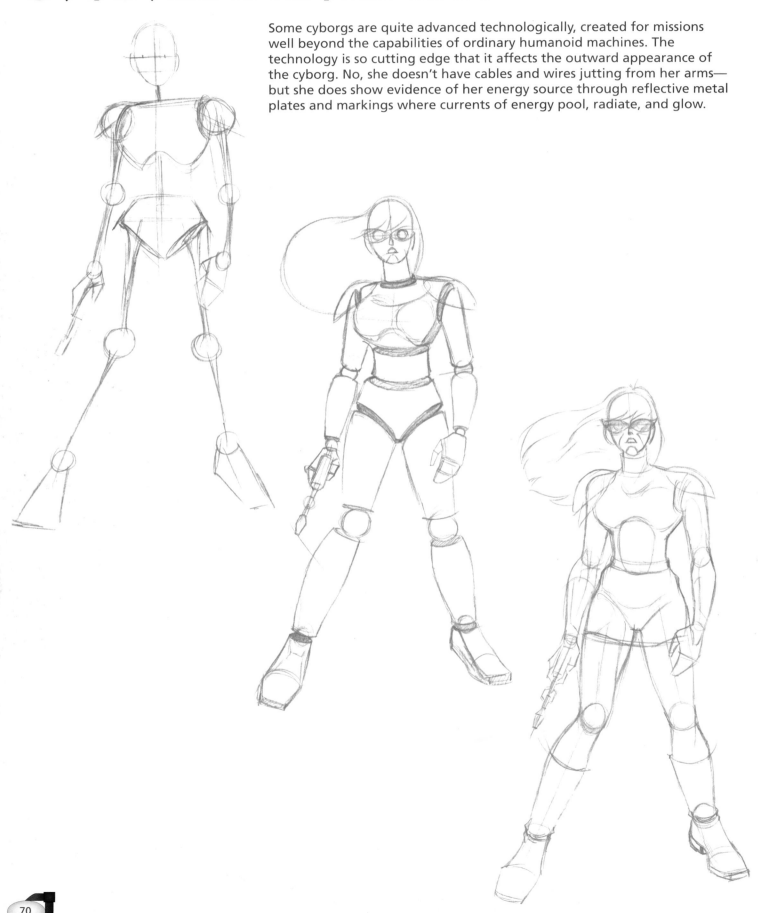

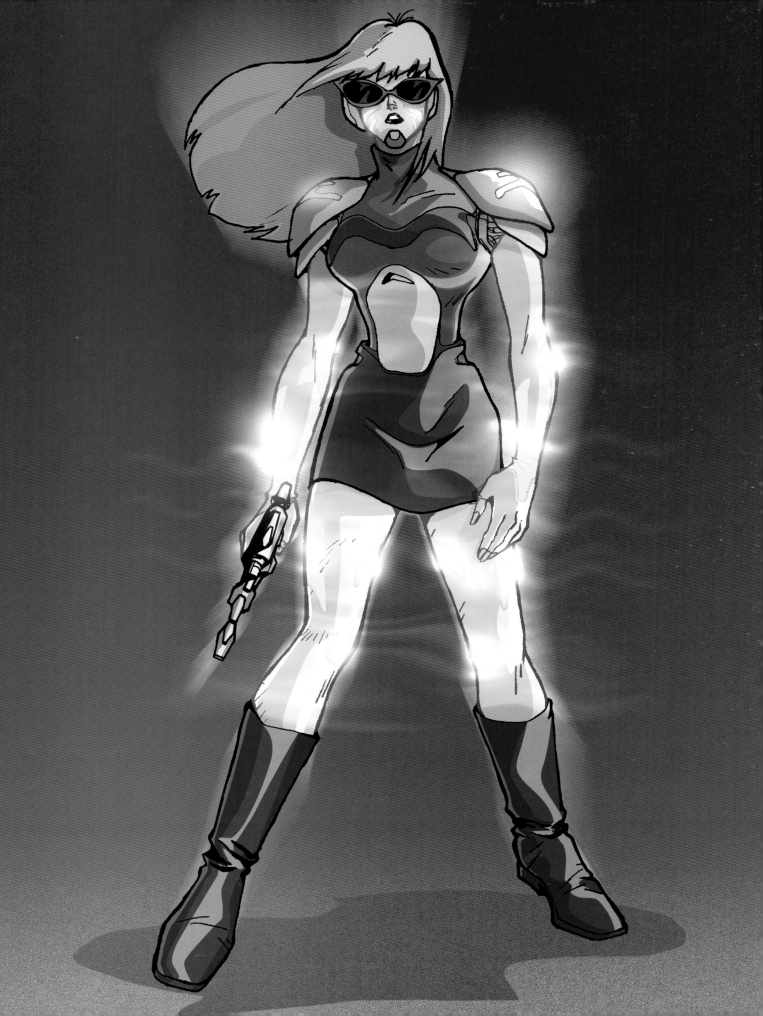

# COME IN EVERY 3,000 MILES FOR AN OIL CHANGE

It looks cool if you show your cyborg woman as a human with just a bit of the robot revealed. Note the blank look in her eyes; this indicates that she is turned off.

Drawing a human figure requires drawing large sections, such as the torso, hips, legs, arms, abdomen, and head. Drawing the internal mechanics requires an entirely different set of skills—the ability to create small, delicate mechanical mazes that look like circuitry. Keep these ideas separate as you create your cyborgs.

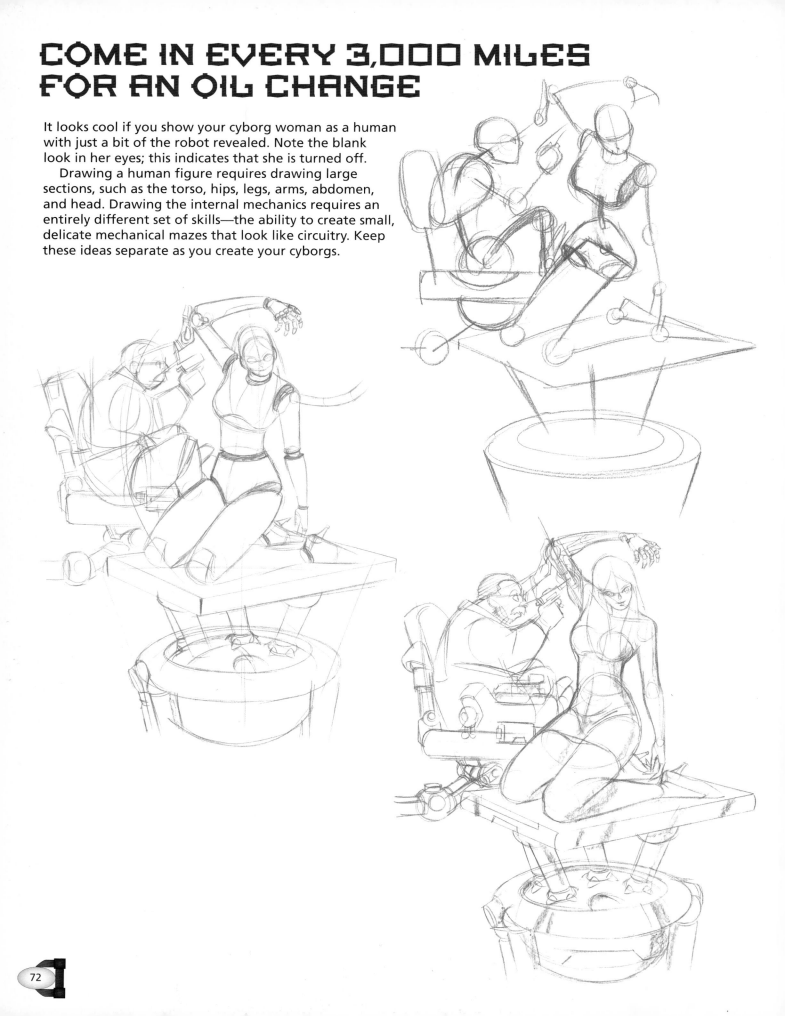

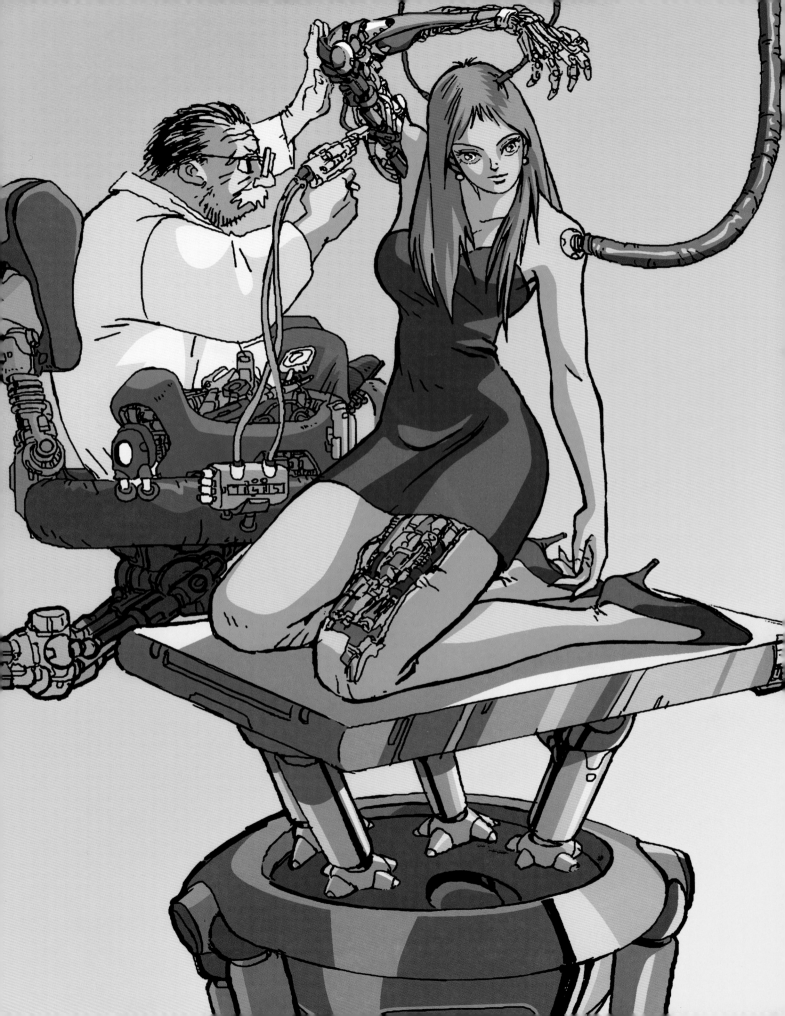

# COMBAT CYBORGS

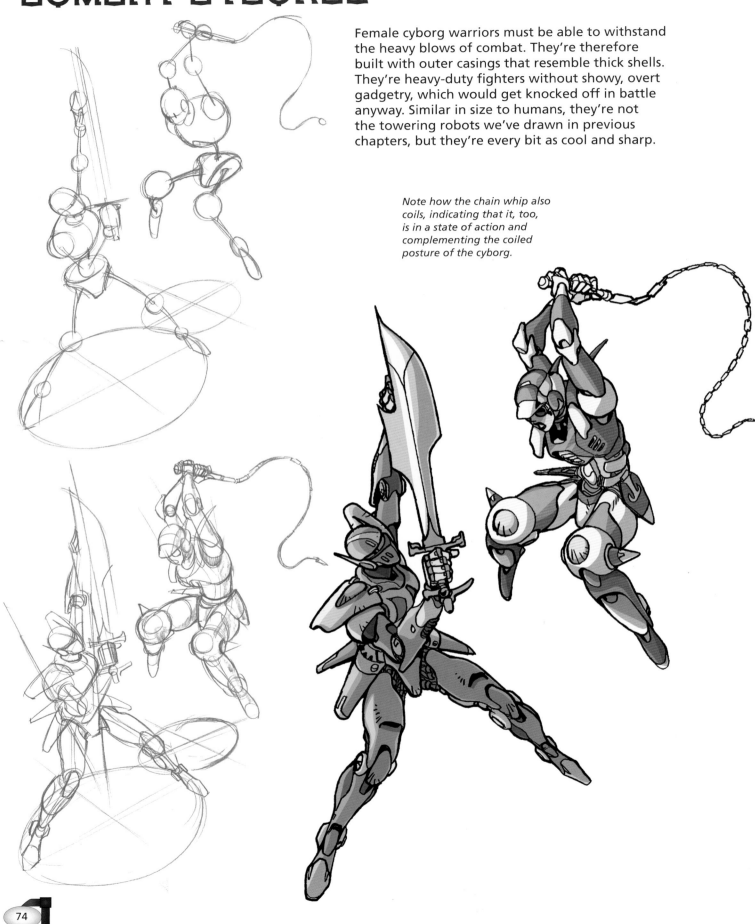

Female cyborg warriors must be able to withstand the heavy blows of combat. They're therefore built with outer casings that resemble thick shells. They're heavy-duty fighters without showy, overt gadgetry, which would get knocked off in battle anyway. Similar in size to humans, they're not the towering robots we've drawn in previous chapters, but they're every bit as cool and sharp.

*Note how the chain whip also coils, indicating that it, too, is in a state of action and complementing the coiled posture of the cyborg.*

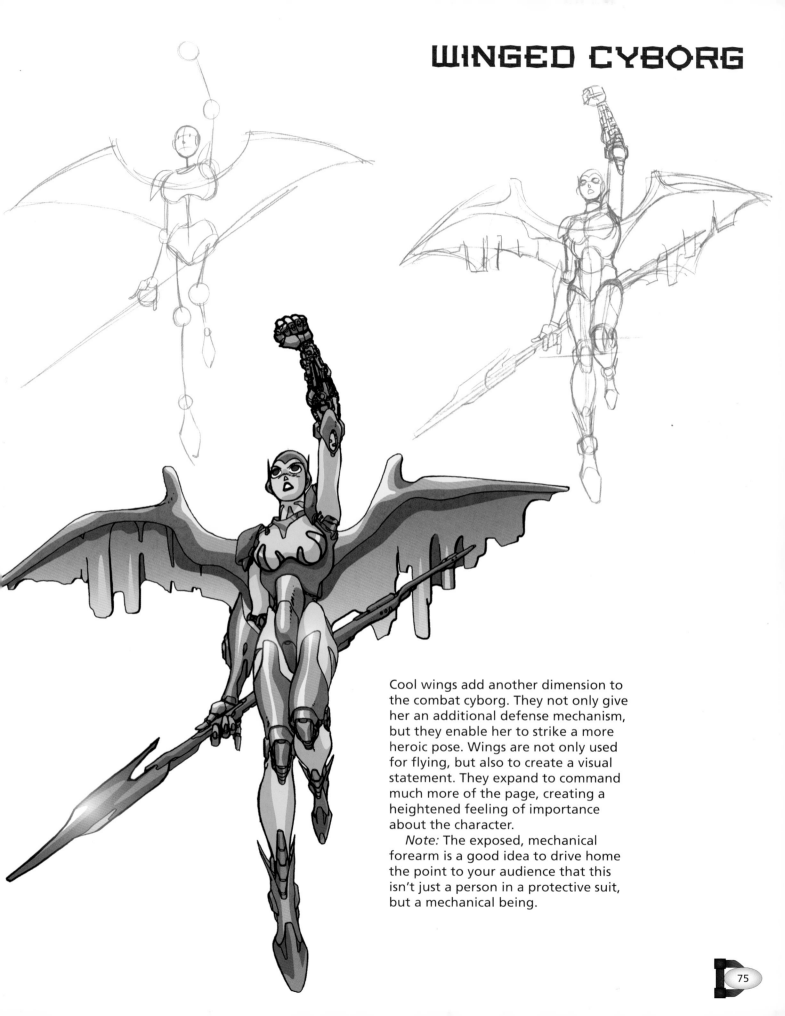

# WINGED CYBORG

Cool wings add another dimension to the combat cyborg. They not only give her an additional defense mechanism, but they enable her to strike a more heroic pose. Wings are not only used for flying, but also to create a visual statement. They expand to command much more of the page, creating a heightened feeling of importance about the character.

*Note:* The exposed, mechanical forearm is a good idea to drive home the point to your audience that this isn't just a person in a protective suit, but a mechanical being.

# DEFEAT ON ANOTHER MOON

When your army has been defeated, your commander has been kidnapped, your fuel cells are running low, and you are crawling in the valley of some godforsaken Jovian moon, this is *not*—I repeat—*not* what you're hoping to see.

Cyborgs can have incredibly feminine and expressive faces. They can display a range of subtle emotions. As you can tell from her desperate eyes, she *feels* something, even though she's just a machine. She is, for all intents and purposes, a sentient being. If your cyborg feels nothing, neither will your audience.

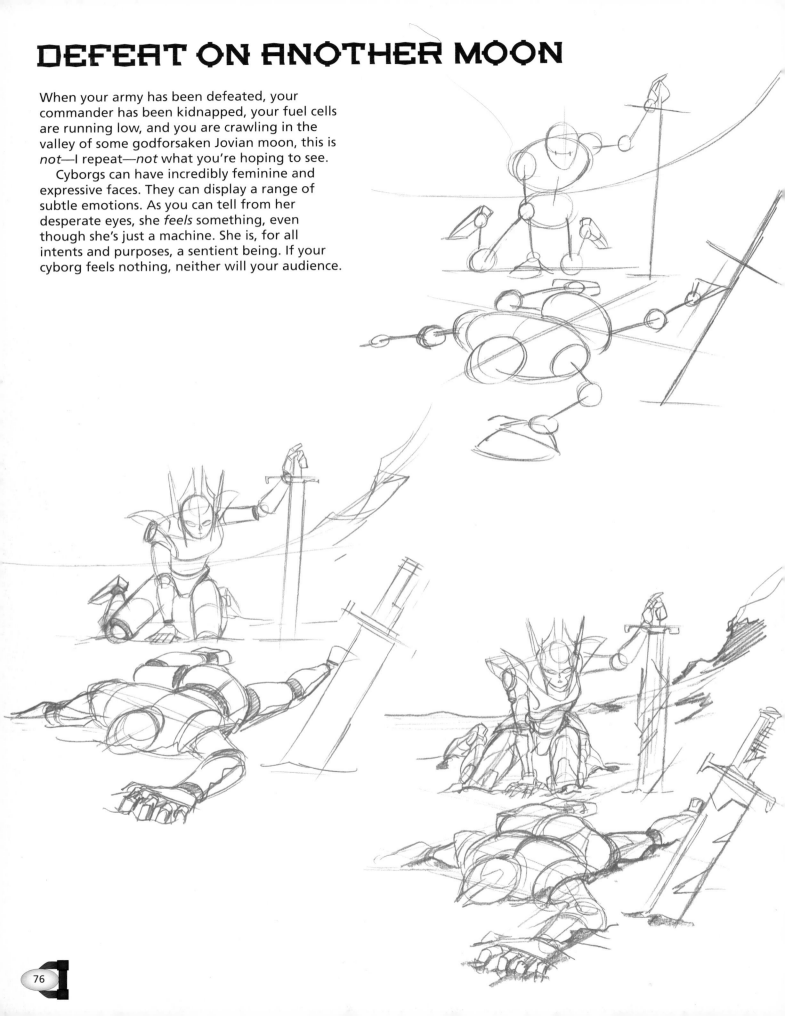

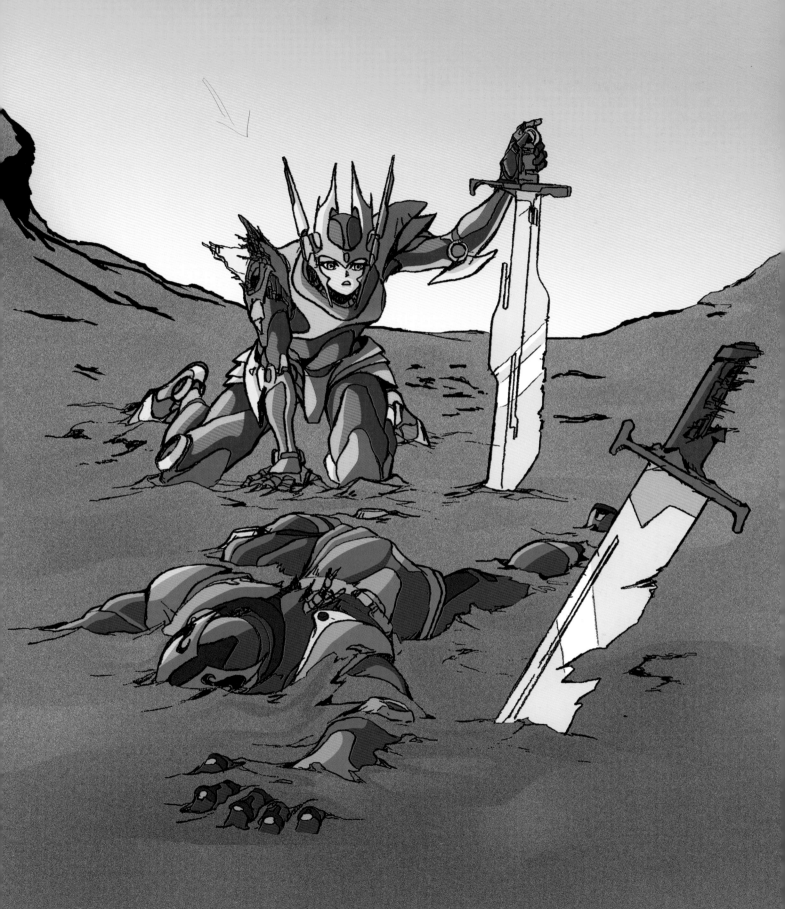

# YOUNG MANGA-STYLE CYBORG

Young-looking anime and manga characters—the ones with the huge eyes—are very popular. This particular style of manga is called shōjo for comics geared for girls, and shōnen for comics geared for boys. You can also turn these young manga characters into cyborgs. However, in order to retain their cute qualities and youthful appearance, you have to handle them differently from adult characters. The body should retain most of its pudginess and roundness. The arms of the young cyborg, for example, still have immature muscles. Leave the integrity of the character in place; just punctuate the form with some mechanisms, but don't overdo the gizmos or you'll take away from the appealing nature of these characters.

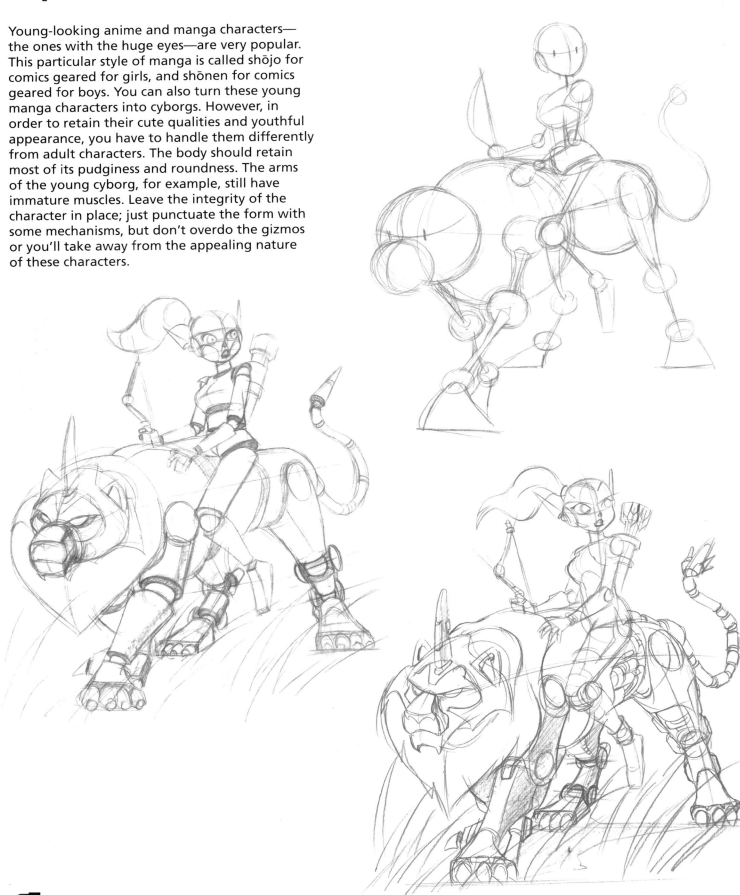

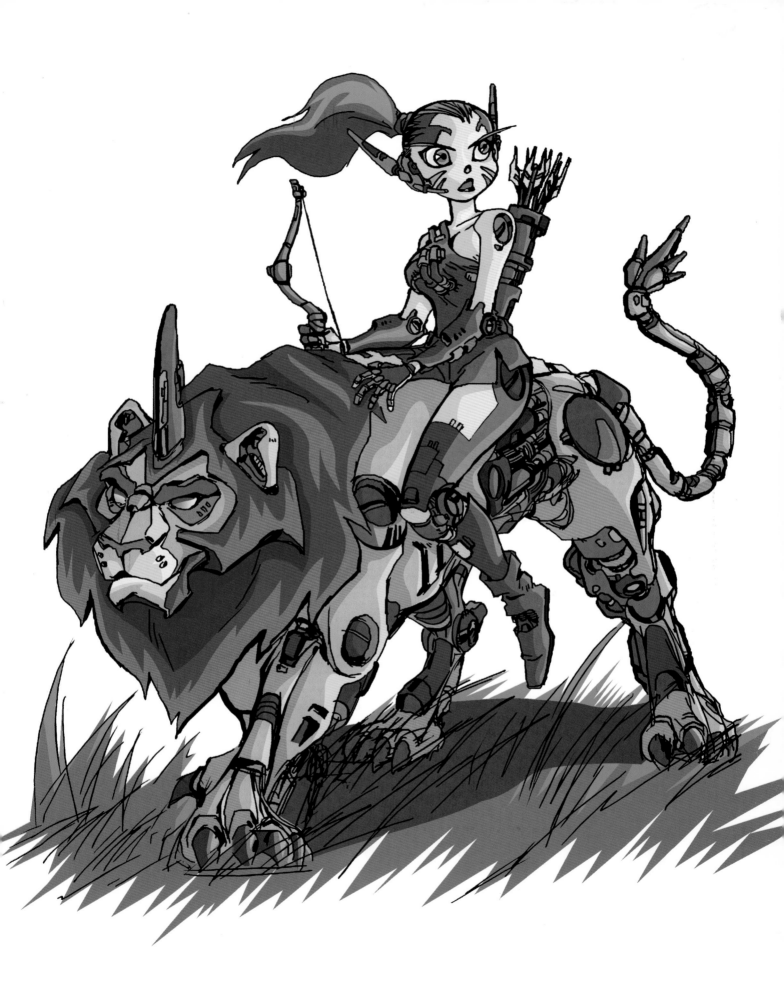

# AQUA MECHA

At the ocean's depths, these dangerous cyborg beauties navigate through the murky darkness like hunters. Their mechanical features should mimic native aquatic species. Flowing fins and webbing (on her feet) catch the water currents. Her body is etched with scales, which have no function other than to signal to the reader that she belongs in this underwater setting. You could devise other underwater motifs for her, such as gills, a dorsal fin, and long catfishlike whiskers.

The prey in this scene is the mecha shark (as opposed to the mako shark). Note that dividing the trunk of the shark's body into sections immediately conveys its mechanical nature.

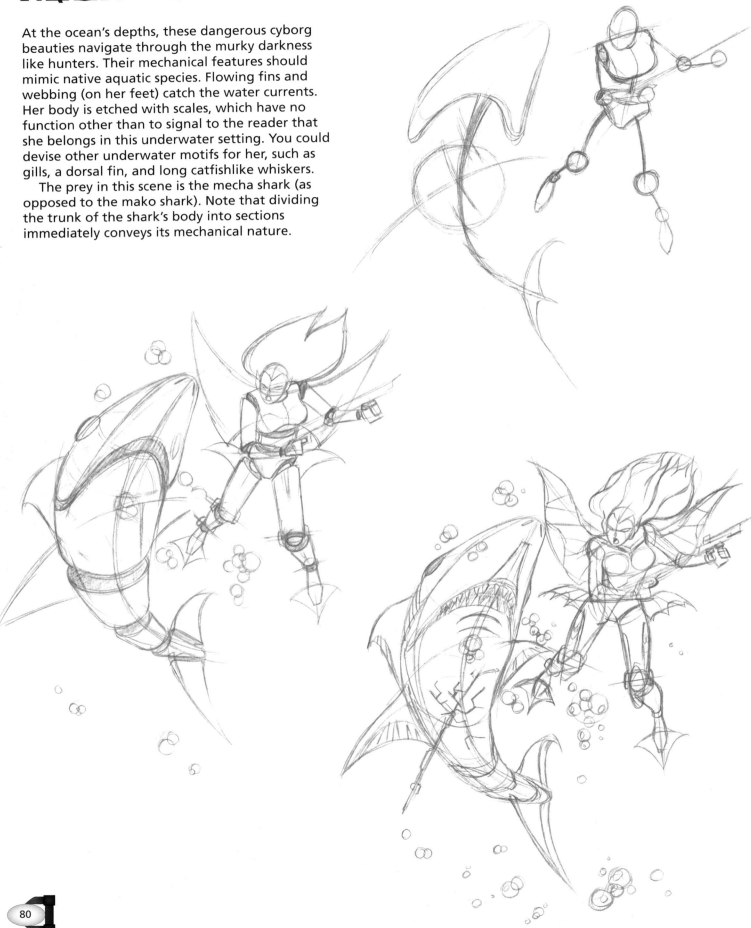

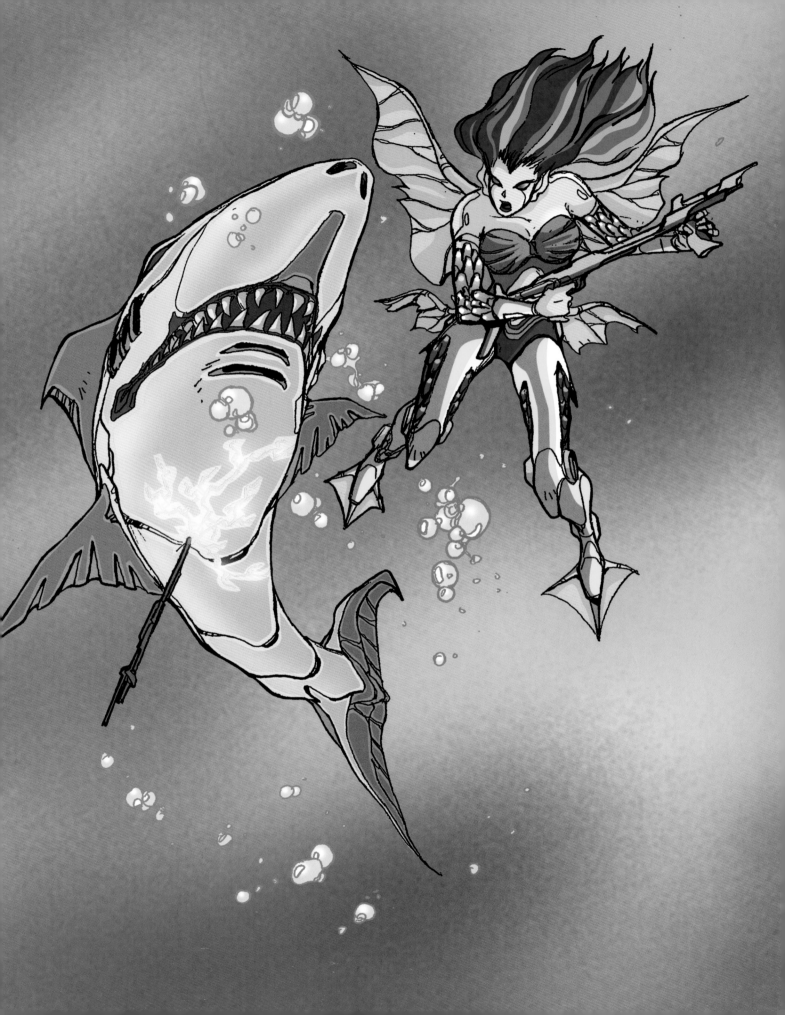

# FANTASTIC MECHA VEHICLES

Mecha takes place in the air, underwater, and on the ground. But the most popular locale is the battleground of outer space. Cool-looking vehicles are a specialty of mecha, and after you tool up for this section maybe it will be your specialty, too.

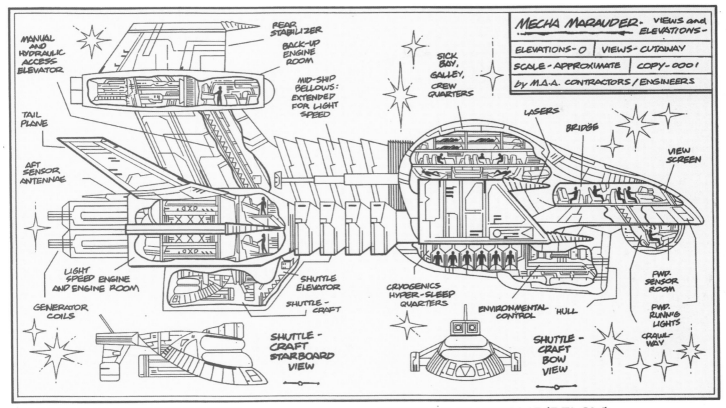

## INTERIOR BLUEPRINT (ABOVE)

Most of the action takes place in the bridge, galley, sick bay, sleeping quarters, and engine rooms. Since the ship docks in space and never actually lands on the ground, the bottom of the ship doesn't have to be flat.

## EXTERIOR BLUEPRINT (BELOW)

The spacecraft should look like a carnivore: sleek, aggressive, and confident. The rear boasts numerous large engines and a series of smaller boosters. There are arrow-tipped lasers mounted all over the craft.

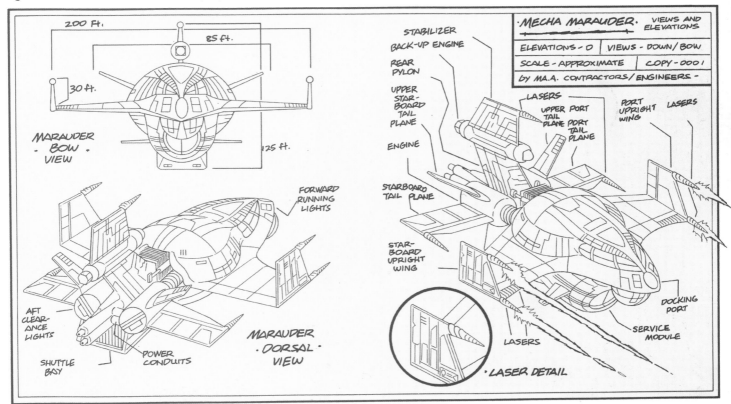

# EXTREME PERSPECTIVE

Spaceships flying toward the viewer or away from the viewer are the most famous extreme angles. They warp and distort the ships, making them seem in your face. But don't guess these angles; use *vanishing lines* to ensure that your drawings will come out in correct perspective each time.

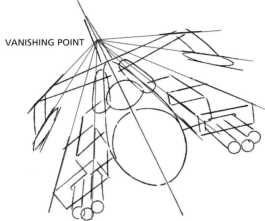

VANISHING POINT

*Vanishing lines are straight lines that travel toward or away from the viewer, and appear to converge at a single point on the horizon—the vanishing point. (Note that this point is not always visible in an image and could lie somewhere off the page.) As these straight lines travel out from the vanishing point, they widen out. This is why the front of a ship that's coming at you looks much wider and larger than its tail, which is farther away. Artists use vanishing lines to increase or diminish the size of an object at the proper rate, drawing their subjects along the lines for guidance and then erasing them if necessary when the drawing is complete.*

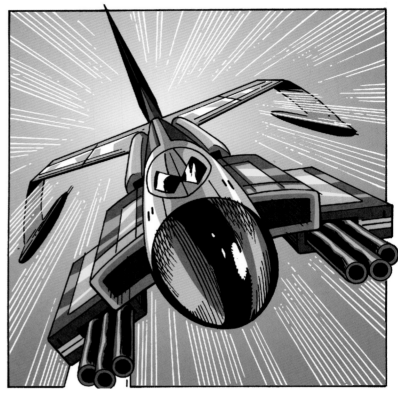

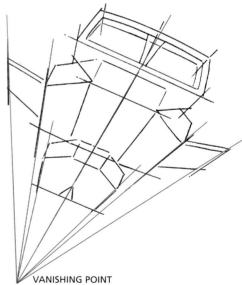

VANISHING POINT

## IN-YOUR-FACE AFTERBURNERS AND BELLY SHOTS

*When a spaceship speeds away from you, the rockets appear to be the largest part of the ship. In this case, the front of the ship is closest to the vanishing point. This greatly conveys the feeling that the ship is soaring overhead and away from you.*

*Belly shots of ships (in which you're looking up at the underside) are very cool. They make a bigger impression than shots in which you look down at an object. When you look down at something, you feel like an impartial observer, unaffected by the action. When a ship flies directly overhead, however, you really feel its presence, as if someone had just lowered the ceiling on you.*

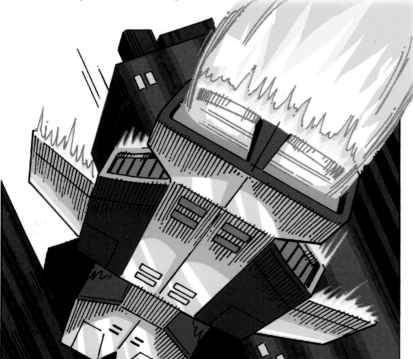

# BUG-EYED SPACESHIPS

Bug eyes have always been used as a motif for sci-fi creatures. They also provide inspiration for mecha spacecraft design. Two oval domes placed on twin bridges create a spacecraft with a distinctly insectlike appearance. Insects are relentless predators, and the visual analogy won't be lost on your audience.

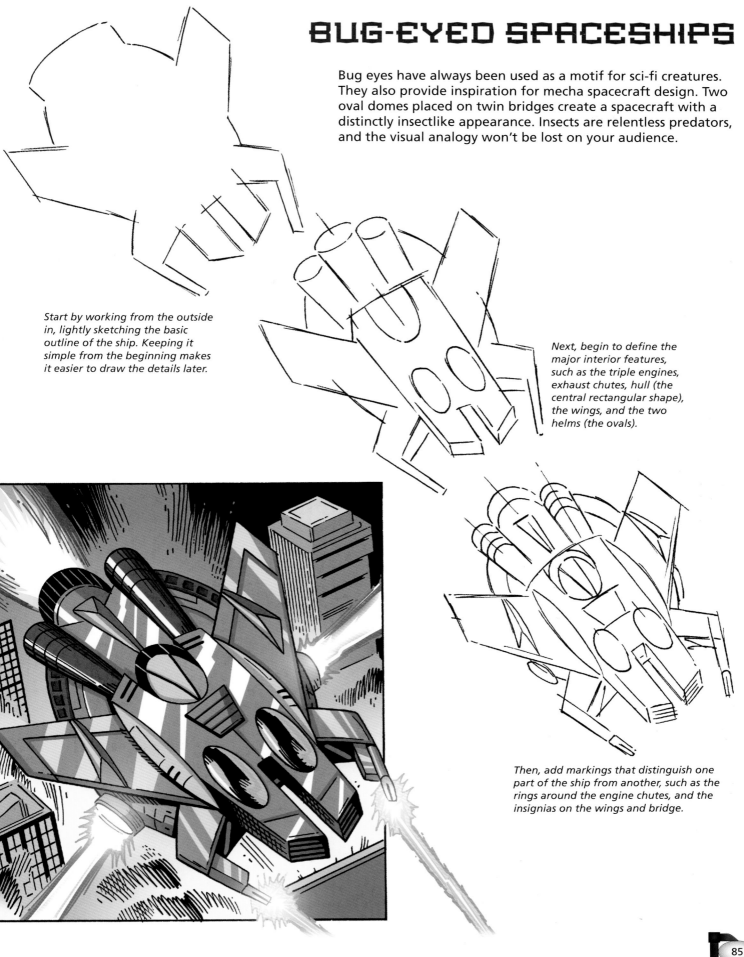

*Start by working from the outside in, lightly sketching the basic outline of the ship. Keeping it simple from the beginning makes it easier to draw the details later.*

*Next, begin to define the major interior features, such as the triple engines, exhaust chutes, hull (the central rectangular shape), the wings, and the two helms (the ovals).*

*Then, add markings that distinguish one part of the ship from another, such as the rings around the engine chutes, and the insignias on the wings and bridge.*

# CITY DESTROYERS

Most people think of space when they think of spaceships. Why not? But, some spaceships are built to descend into the atmosphere and attack cities at such blinding speeds that they are all but unstoppable. These low-flying spaceships have jetlike wings to enable them to navigate in the atmosphere's air currents and cream everything in sight. They also have three powerful engines to rocket them to speeds unimaginable to jet pilots. The horseshoe-shaped tail is razor thin to cut through the air.

*The body of the main craft is quite short, and the wings are long. The tail is a horseshoe shape that wraps around and hooks up to the wings.*

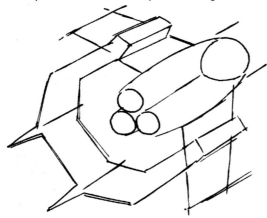

*Define the three powerful engines, the bridge of the ship, and the compartments (on the tops of the wings) that link the wraparound tail to the wings.*

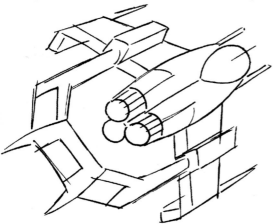

*Add the thin gun mounts and the markings (as in the finished image).*

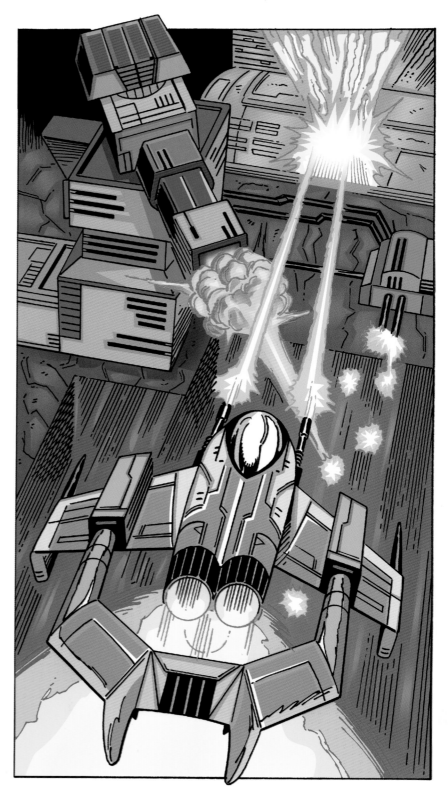

# SPACE TANKS

These are the armed assault ships of the galaxy. Ganging up, they bulldoze their way past any space-based defense a planetary outpost can hope to mount. Trading a sleek, aerodynamic design for a fortress of metal, these spaceships make awesome invaders.

*Start with an oval body and short wings. Draw a rounded triangle on the rear of the ship, propped up by two stabilizers.*

*Carve out the center of the triangle, and divide the hull (the body of the craft) into upper and lower sections, with the lower section out in front.*

*Mount a gun turret on the front of the upper hull, and start blasting away at those ugly aliens!*

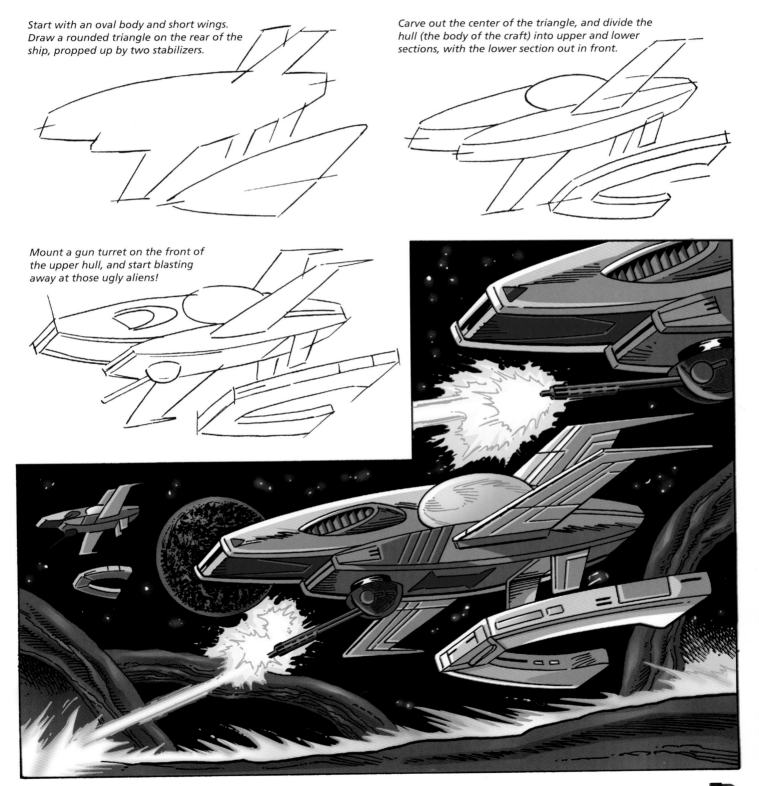

# SPACE WEAPONS SYSTEMS

To create an exciting visual, energy beams have some advantages over missiles. You can draw energy beams as a steady stream that can stretch across the page. And, since the background of space is black, the bright colors of the energy beams stand out. These beams are also multipurpose weapons. They can, of course, be used as lasers, but they can also pull, repel, shield, cocoon, freeze, overheat, or explode enemy craft.

Missiles can also provide good visuals if you give them an interesting trajectory that results in a captivating explosion. Drawing missiles also offers its own advantage over energy beams: You can draw the scene from the missile's point of view, as if you were riding on the missile's back.

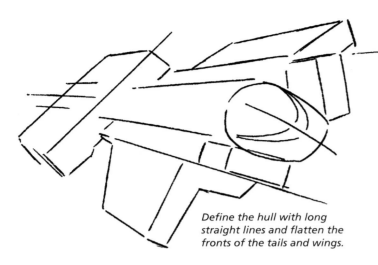

*Define the hull with long straight lines and flatten the fronts of the tails and wings.*

*Draw the openings for blasting energy beams, and add patterns to the hull and wings.*

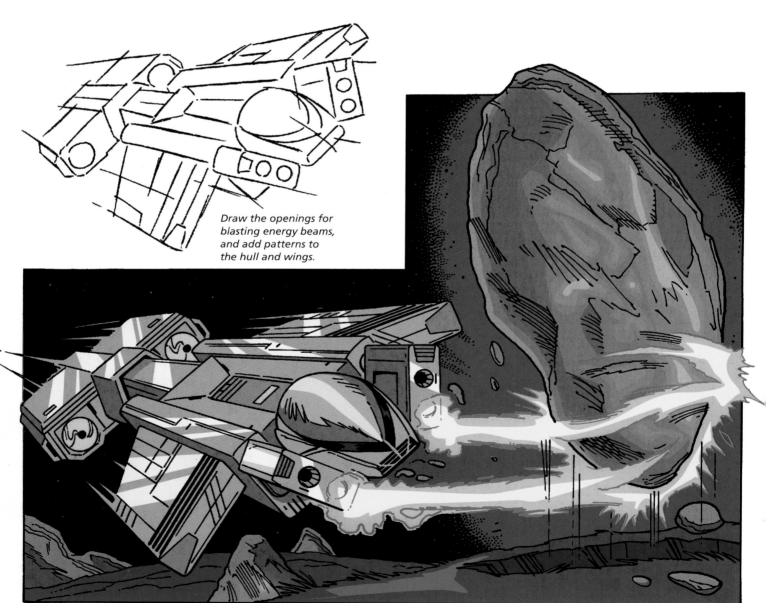

# ALIEN SPACECRAFT: THE BAD GUYS!

If you've followed along with the step-by-step illustrations on the previous pages, then you've no doubt gotten a feel for drawing cool spaceships. But, wait. Have you stopped to ask yourself where all of those spaceships are headed? To engage the aliens who want to take over the Earth, of course. So get ready. It's us against them! Good vs. evil! Flesh and blood vs. green goopy ooze. The very existence of the galaxy looms in the balance!

## INVADER SHIP

Aliens inhabit a world very different from our own, and this is reflected in the design of their spaceships. Since humans are oriented toward geometric shapes, when designing ships for aliens, go in the other direction. Make spaceships that are curvy, serpentine, and swirling. In short, the stuff of nightmares.

*It often helps to find a symbol to inspire your drawing. Something weird and repulsive works well for a dreaded alien civilization. What I'm thinking of is a bat. A bat flies, like an alien spacecraft. And, it's repulsive, too. After all, what is a bat? It's a rat with wings and fangs. Nobody likes bats, not even baby bats. Other good alien inspirations are spiders, wasps, dragonflies, scorpions, snakes, eels, and stingrays.*

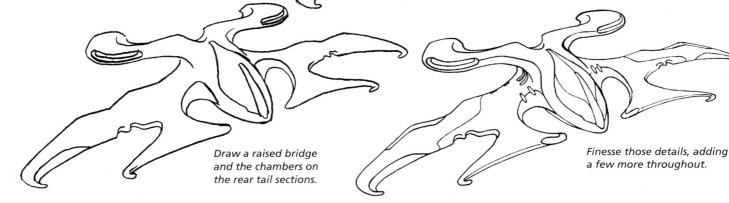

*Start with huge wings that curve slightly forward (the wings of human spaceships sweep backward). Add lots of twists and curves.*

*Draw a raised bridge and the chambers on the rear tail sections.*

*Finesse those details, adding a few more throughout.*

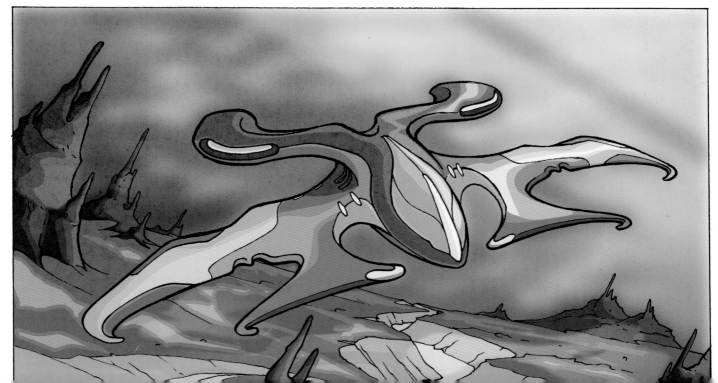

## ALIEN SQUADRON FIGHTERS: SINGLE-PILOT ATTACK SHIPS

These are the small but fast ships that inflict great harm on the Earth fleet. Alien squadron fighter ships are not designed for long voyages. There's no on-board cafeteria. You eat out of a plastic squeeze-pouch. Shaped like a dart, these ships can sting. They can fly upright, belly up, on their sides, or even corkscrew. The wings are severely backswept, emphasizing the aerodynamic sleekness of the ship. The nose is very long and thin, again, for the same reason.

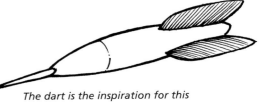

*The dart is the inspiration for this little craft that packs a lot of sting.*

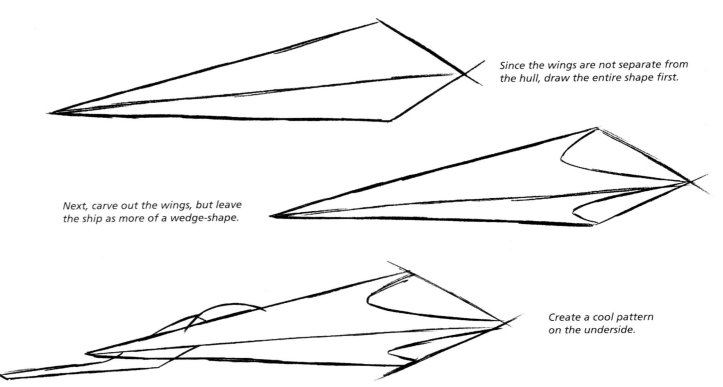

*Since the wings are not separate from the hull, draw the entire shape first.*

*Next, carve out the wings, but leave the ship as more of a wedge-shape.*

*Create a cool pattern on the underside.*

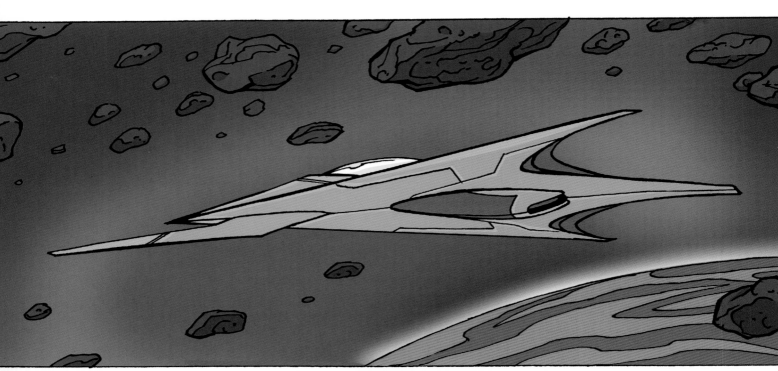

## ALIEN BATTLE CRUISER: THE BREEDER SHIP

This is the mother of all alien spaceships. Within its walls lies an entire army of aliens, enough to populate and then subsume a weaker race. Note the squadron ships being sent ahead to soften up the air defenses of what will be, if all goes according to plan, the "host" planet. The hosts better get ready to do a lot of hosting. These alien "guests" have plans to overstay their welcome by, oh, about a few centuries—or until all of the natural resources of the planet run dry. For drawing humongous transport systems such as this, think of submarines, blimps, jumbo jets, battleships, and whales.

*Draw a full fuselage (main body), with a larger rear segment.*

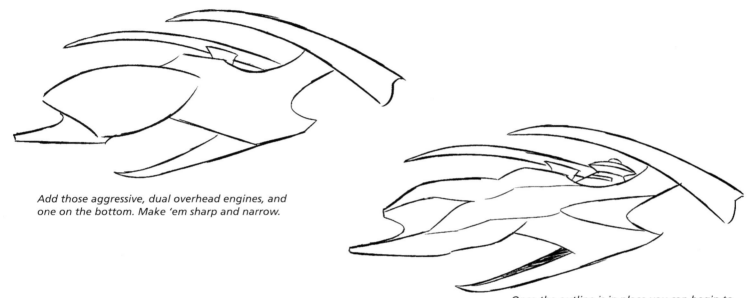

*Add those aggressive, dual overhead engines, and one on the bottom. Make 'em sharp and narrow.*

*Once the outline is in place you can begin to define the interior contours of the ship. Draw the bridge between the dual engines.*

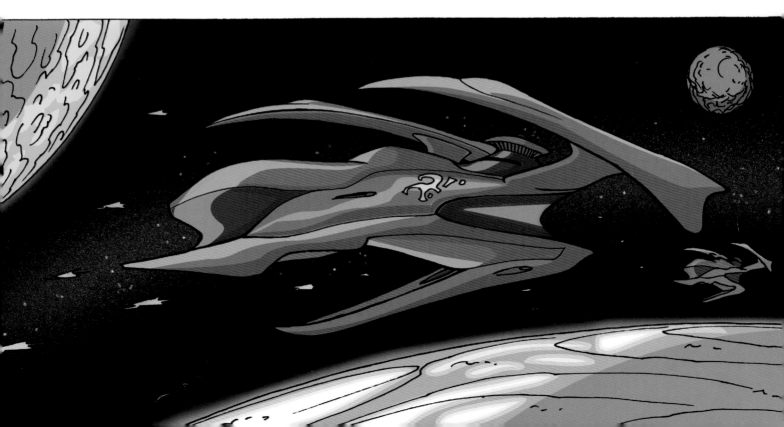

# THE ALIEN CREW AT THE HELM

Hey, someone or some*thing* has got to man the controls of these alien crafts. Japanese comics often feature shots of flybys in which the reader gets a glimpse of the alien pilot at the helm. And often, when an alien ship is hit, you see the interior of the bridge with the alien desperately trying to save itself before it blows. So, here are a few character suggestions for drawing the command center of an alien battle cruiser. Note that you can easily spot aliens. It's not like they can get a fake green card and blend. They're ugly, greedy, vengeful, and proud of it.

SUPREME COMMANDER

SQUADRON
LEADER

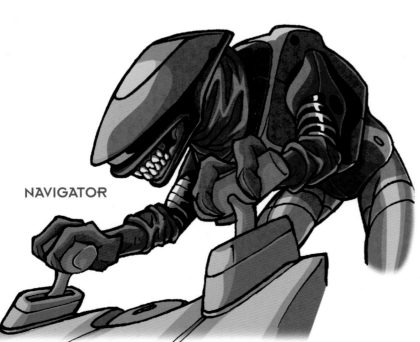

NAVIGATOR

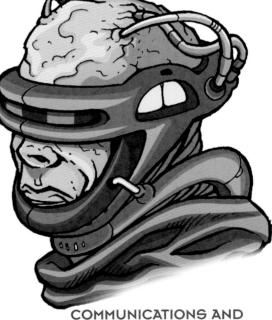

COMMUNICATIONS AND
TRACKING OFFICER

This combat jet provides a good example of drawing wings at extreme angles. The 3/4 angle is the most attractive angle at which to portray a jet in flight. The side shot is great, don't get me wrong, but it's not as dramatic because it's flat. It isn't flying toward you or away from you, it's going sideways.

However, when drawing a jet in a 3/4 angle, it's tempting to make one of two mistakes: (1) omitting the far wing entirely because it's mostly obscured anyway, and/or (2) drawing the far wing too large because it just doesn't "feel right" to draw only the tiny tip peeking out from behind the fuselage.

The problem with both of these approaches is that they aren't accurate. The far wing hasn't disappeared, so you still have to draw it, but since only the tip shows in this angle, you can't make it longer so that it "feels" right. The idea is to get comfortable drawing correctly, rather than drawing incorrectly because it feels comfortable. You'll adapt to the correct method fast and be amazed that you were ever tempted to fudge it.

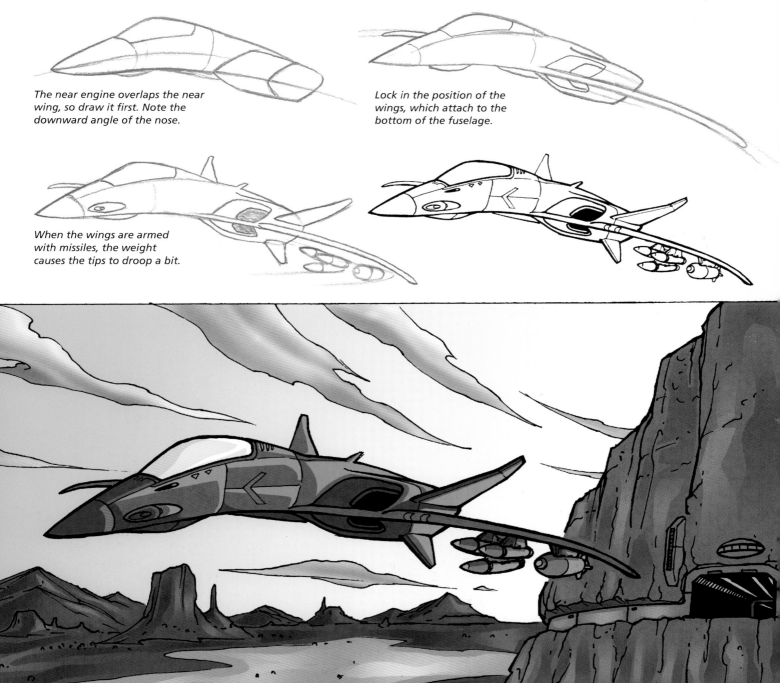

*The near engine overlaps the near wing, so draw it first. Note the downward angle of the nose.*

*Lock in the position of the wings, which attach to the bottom of the fuselage.*

*When the wings are armed with missiles, the weight causes the tips to droop a bit.*

# RECONNAISSANCE JET

The purpose of reconnaissance aircraft is to gather intelligence on the ground, not to fight. Reconnaissance jets are the eyes and ears of the fighting force, relaying valuable information about enemy troop movements back to the fleet. To do that, they're equipped with advanced radar systems. Since these jets have extremely limited firepower, they must soar at high altitudes and also at incredible speeds—out of range of the combat jets; therefore, the wings of reconnaissance aircraft have huge, powerful jets, rather than an arsenal of weapons.

As mentioned on page 84, the belly shot (also called the undershot) is a very effective angle at which to portray this high-flying jet. It shows the jet against a background of the sky. It also has the advantage of displaying a large portion of the aircraft, including its cool stabilizers (the short, vertical wings hanging from the underside).

*The body can be broken down into three parts: the fuselage and each of the two massive jet engines. Note that by angling the nose down slightly, you impart a faster, tougher look to your aircraft.*

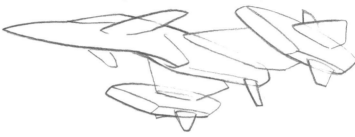

*Fill in two pairs of wings: the first are short wings off the cockpit and the second are longer but wider wings off the rear.*

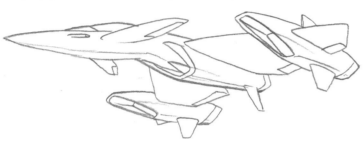

*Affix the lower stabilizers to the hull and the jet engines. Hollow out the front of the engines to create the air-intake chambers.*

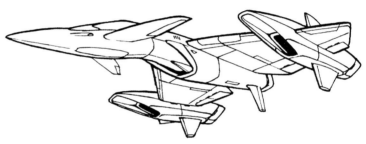

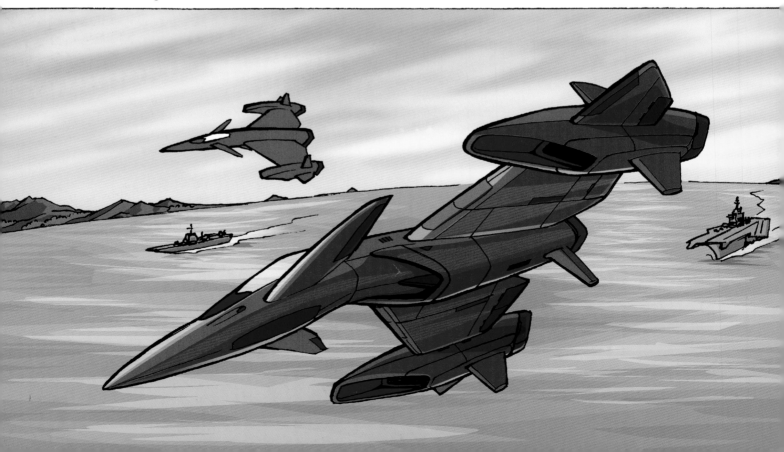

# TRANSPORTS

When you see this baby comin' your way, you've got troubles. This is a flying warehouse. But, it's not bringing books of poetry. It's ferrying tanks, munitions, trucks, and an army of high-tech support personnel inside, waiting to be unleashed on the ground.

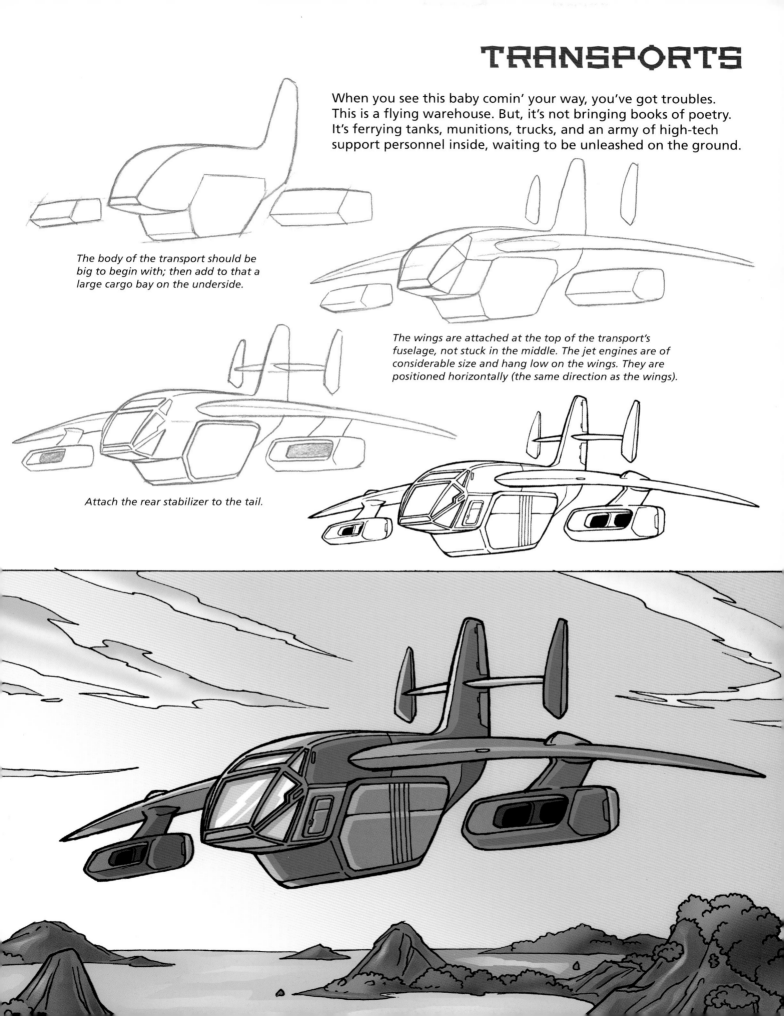

*The body of the transport should be big to begin with; then add to that a large cargo bay on the underside.*

*The wings are attached at the top of the transport's fuselage, not stuck in the middle. The jet engines are of considerable size and hang low on the wings. They are positioned horizontally (the same direction as the wings).*

*Attach the rear stabilizer to the tail.*

# UNDERWATER JET MOTORCYCLE

The water makes an excellent hiding place from which to launch surprise attacks. Under the canopy of the murky, blue liquid, submersibles of all kinds roam the sea, picking off much larger battleships. The vision down below is poor, and the speed is slow. Yet despite these obstacles, the advantage of stealth continues to make the underwater world a popular arena in which the battle for victory rages on.

Something as small as an underwater jet motorcycle, navigated by a lone saboteur, can take down a giant destroyer. The saboteur carries explosives, which he (or she) will place at strategically sensitive areas of the ship.

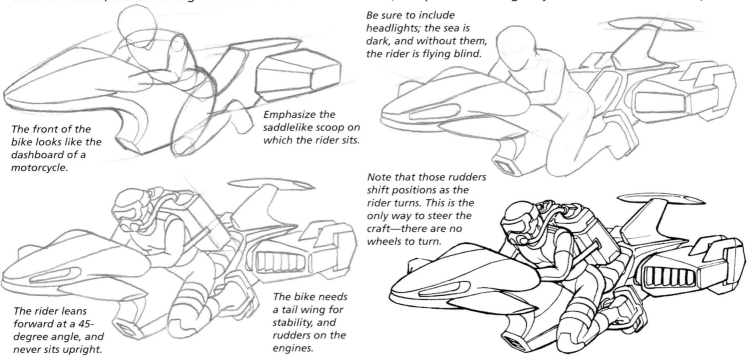

*The front of the bike looks like the dashboard of a motorcycle.*

*Emphasize the saddlelike scoop on which the rider sits.*

*Be sure to include headlights; the sea is dark, and without them, the rider is flying blind.*

*The rider leans forward at a 45-degree angle, and never sits upright.*

*The bike needs a tail wing for stability, and rudders on the engines.*

*Note that those rudders shift positions as the rider turns. This is the only way to steer the craft—there are no wheels to turn.*

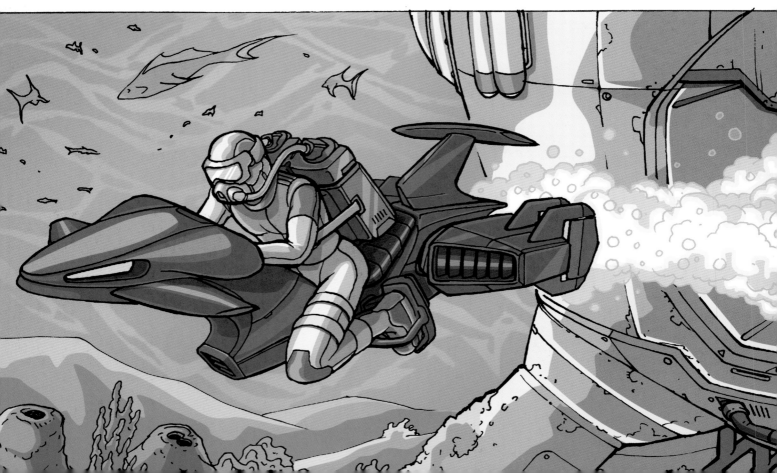

Unlike their behemoth full-size brothers, the minisubs are much more agile and have long, working arms for making repairs. One arm holds a spotlight to illuminate the damaged area (at these depths, it's quite dark), while the clamp in the other hand does the work. The minisub can maneuver itself into tight places and can even sink down to the bottom of the sea.

*It's the shape of an elongated blimp, with a propeller encasement on the rear.*

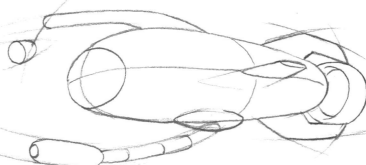

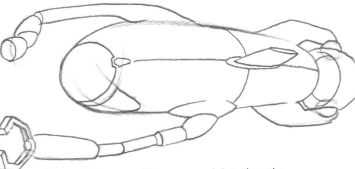

*The working arm will have more joints than the arm with the spotlight, because it requires more dexterity. Note the short side fins for stability.*

*Twin tail fins serve to hold the propeller in place. Note: The propeller moves from side to side, like a mounted desk fan, to turn the craft left or right.*

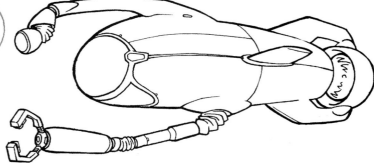

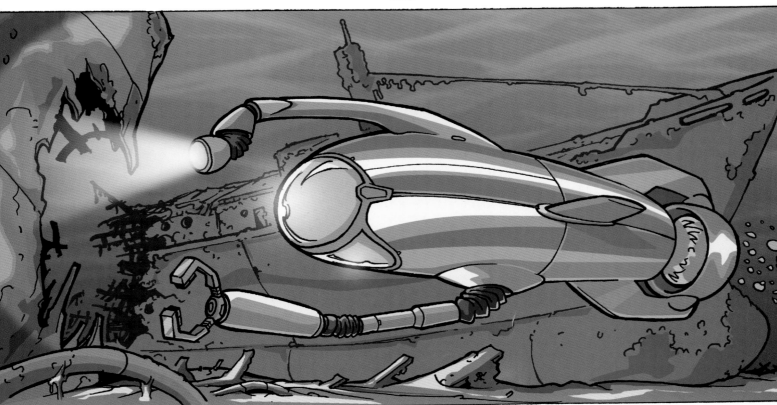

# DEEP-SEA SUB

Submarines typically carry science crews on dangerous missions to locate new sources of energy, unexplored areas, or strange life forms. Whatever it is they're looking for, they won't find it until one of the crew is exposed as a spy, another tries to mutiny, one goes mad, they collide with an iceberg, take on gushing water, begin to run out of air, lose power and communications, and someone steals the escape pod.

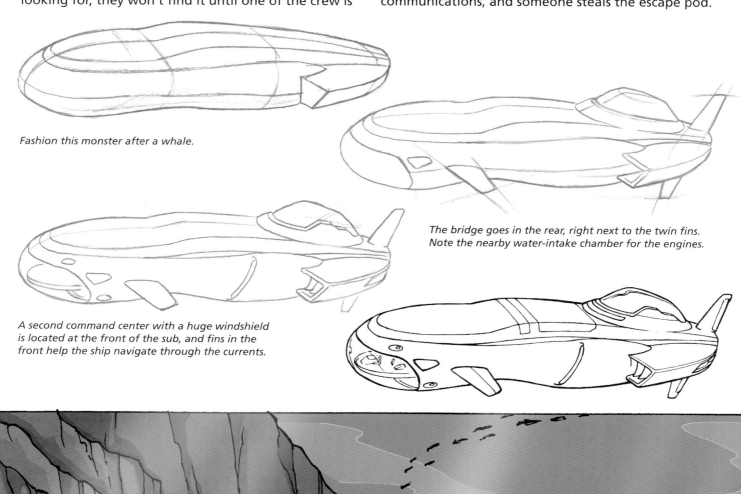

*Fashion this monster after a whale.*

*The bridge goes in the rear, right next to the twin fins. Note the nearby water-intake chamber for the engines.*

*A second command center with a huge windshield is located at the front of the sub, and fins in the front help the ship navigate through the currents.*

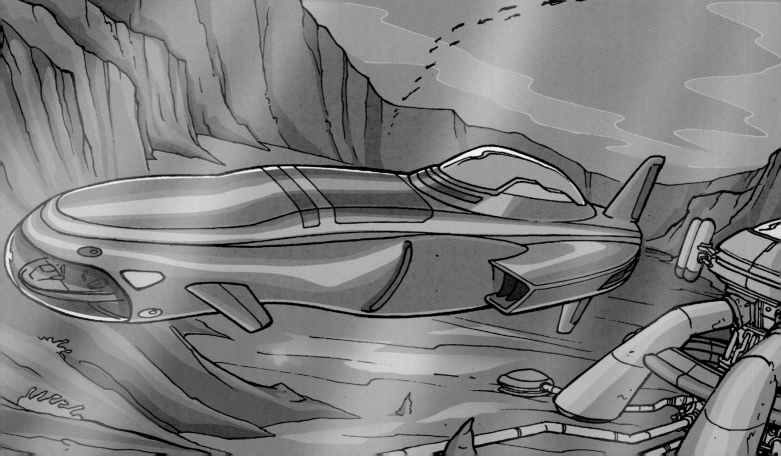

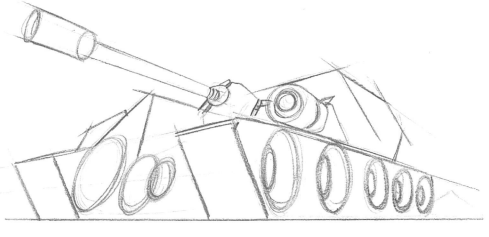

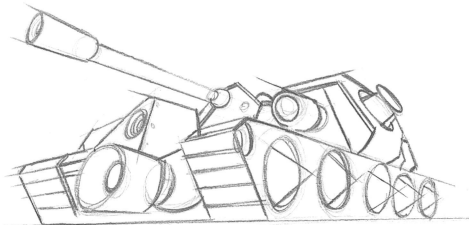

Military vehicles crawl over the rubble left by giant robots. However, if the robots have not yet left the scene of destruction, this is usually not a wise choice for the driver. Military vehicles get blown up by giant robots big-time, with trucks and tanks doing loop-di-loops in the air. Sometimes, the military is on the same side as the giant robots, for better or for worse.

## ARMY TANKS

Whether it's crushing everything in its tracks or blasting away with its big gun, the tank is a feared machine. The treads are segmented into small, individual strips, which gives them flexibility over rock and rough going. The pointed rollers inside of the tracks are very cool. The gun, which is mounted on a turret, can fire 360 degrees around.

The tank also happens to be one of the most popular targets in a mecha war. You can't be effective if you're being fired upon, so you have to go in with your tanks and take out the resistance. When a tank's about to blow, the soldiers typically escape through the hatch.

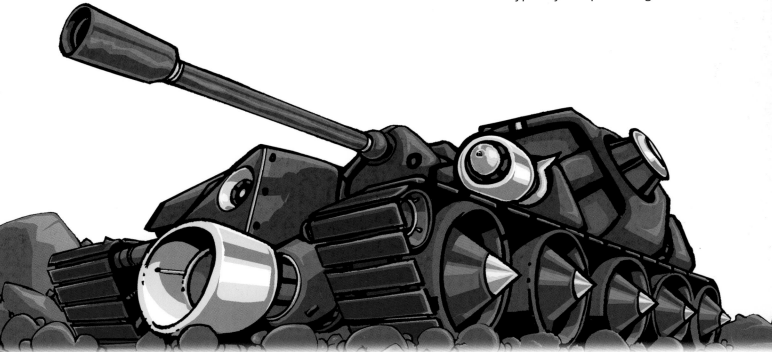

## ARMORED PERSONNEL CARRIERS

Military vehicles are very boxlike and tough. These six-wheeled armored personnel trucks carry soldiers into harm's way. They are rugged looking and can drive over any terrain. They make SUVs look like minivans. Not built for speed, they are, nevertheless, reinforced, tough, and surefooted. Although the soldiers inside are heavily armed, the truck itself is not. Therefore, when attacked by giant robot missile fire, the best option is running like heck!

The tires on these vehicles are not the same proportions as tires on cars and commercial trucks. They're taller and thinner than regular tires, which gives them a hardcore, off-road appearance. Make sure that the tip of the windshield falls in the middle of the vehicle and looks symmetrical.

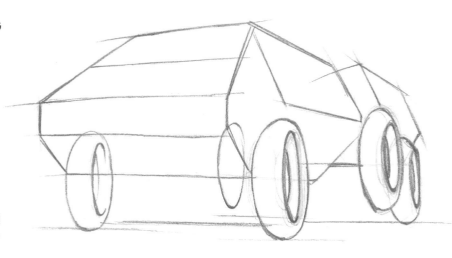

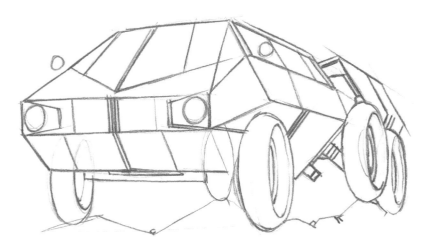

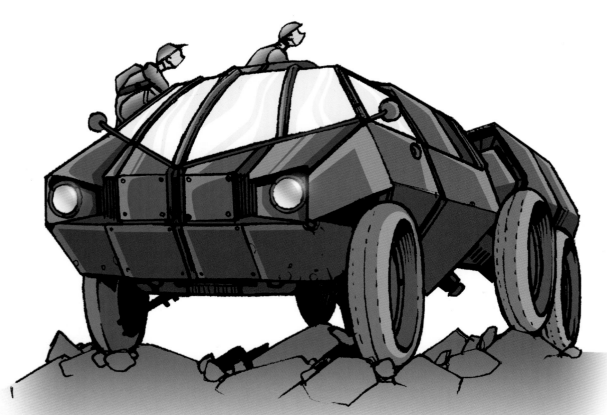

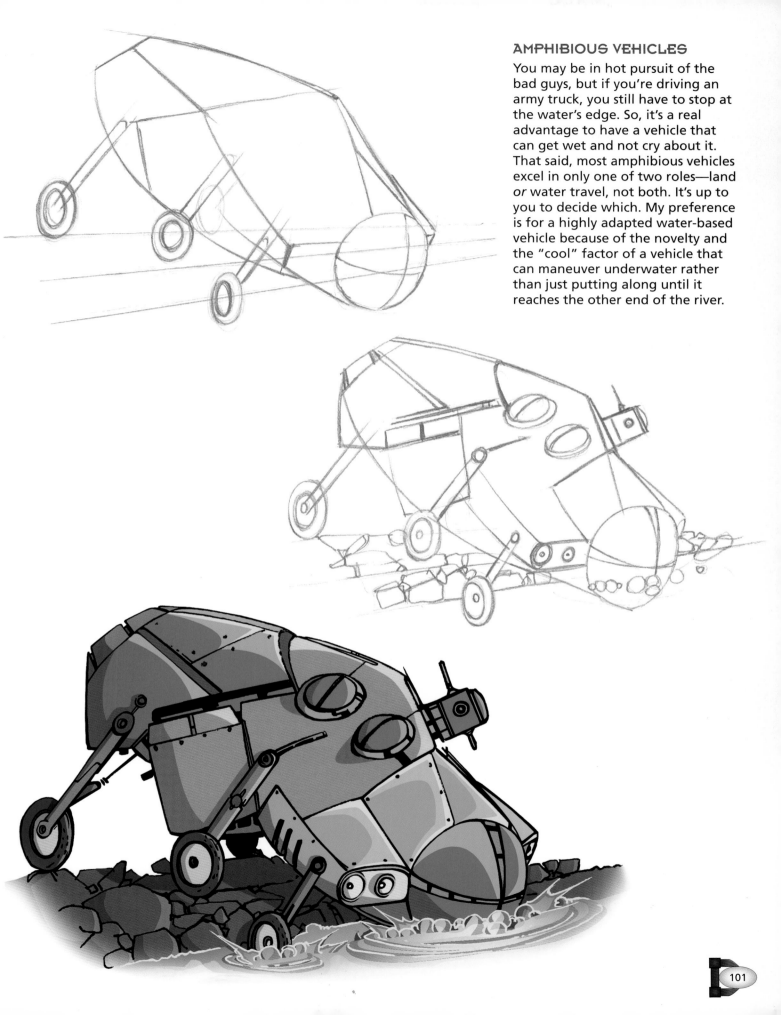

## AMPHIBIOUS VEHICLES

You may be in hot pursuit of the bad guys, but if you're driving an army truck, you still have to stop at the water's edge. So, it's a real advantage to have a vehicle that can get wet and not cry about it. That said, most amphibious vehicles excel in only one of two roles—land *or* water travel, not both. It's up to you to decide which. My preference is for a highly adapted water-based vehicle because of the novelty and the "cool" factor of a vehicle that can maneuver underwater rather than just putting along until it reaches the other end of the river.

# AMERICAN MECHA

American comic books have used mechanical heroes and villains since the golden age of comics. Robot bad guys and metallic heroes have always been prominent in the medium. But American artists, who as kids were fans of mecha-based shows, have begun to tweak their styles to reflect their passion for all things mecha. The result is a cool hybrid. It's Japanese influenced but American at heart. It's mechanical and futuristic but bold, emotional, and heroic in a uniquely American way.

# CHROME AND STEEL

American artists are obsessed with chrome, that shiny metal that glistens in the light. They like to render their robotic surfaces with plenty of highlights.

Shadows and textures are used to evoke powerful moods. Simply adjusting the highlight shines and shadows can significantly alter the look of a character.

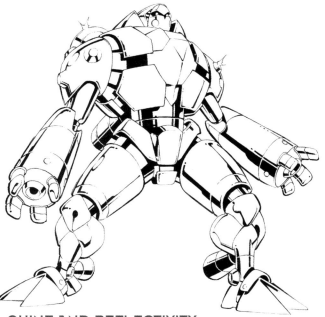

## SHINE AND REFLECTIVITY

This is the standard American mecha. Shadows are kept to a minimum and are mainly used to highlight round shapes, like the thin streaks of shadow on the robot's cylindrical forearms and thighs. Note the small, shining bursts on the shoulders, as well.

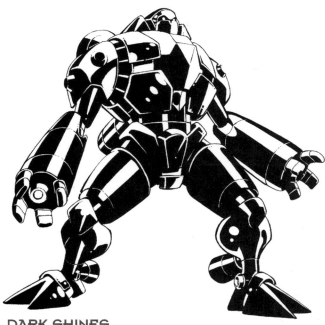

## DARK SHINES

The more intense and evil a character is, the more it's bathed in shadow. By using long, thick streaks of light to break up the shadow, you maintain the appearance of a slick, metallic surface.

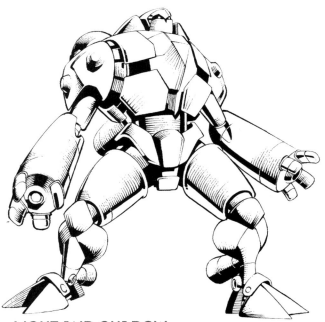

## LIGHT AND SHADOW

Graduated highlights are another popular look. These are used to reflect an environment that's not brilliantly lit. Therefore, the shadows aren't crisp and clean; the bright parts of the metal gradually turn to shadow until the shadow turns completely black.

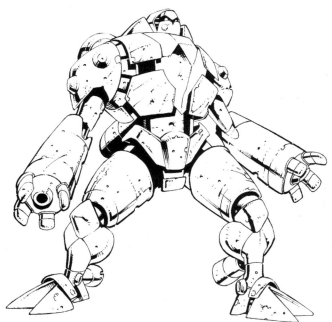

## WEATHERED AND BATTLE WORN

Like a car that's been parked in a store parking lot, this guy has lots of dings and dents. Except that his dings were made by missiles, not car doors. The long streaks of shadow are not as neat, straight, or dark. Pockmarks and scratches complete the look.

# CREATING MOOD WITH POSTURE

Not all American mecha-style giant robots are piloted by humans inside the cockpit. Some are sentient beings, albeit with a limited range of emotions. They're akin to the classic evil monster created by the mad scientist. There are also evil robots whose computer processors have absorbed all of the brain functions of their masters in a laboratory experiment, making a complete transfer of consciousness. The more sophisticated the brain function of the robot, the more poignant and complex the posture and poses will be.

For most people, the word posture conjures up memories of your mother nagging you to "stop slouching and sit up straight!" But to artists, posture is an essential tool with which to communicate the drama going on inside of your robot. Don't rely on comic book speech balloons or the dialogue spoken in animated shows to convey the emotions of a scene.

The old adage "Don't say it; show it" is particularly important in comics illustration, because it's such a visual medium. A good pose can often make the dialogue redundant and unnecessary. Effective posing includes several key elements:

1. It should make a clean silhouette. If the pose doesn't read in silhouette, chances are it's not direct enough.

2. The curve of the back is important. Bold, aggressive, confident stances make use of an arched back with the chest out. Sad, weak, and anguished poses display a drooping back with a concave chest.

3. Shoulder action is important. Hunched shoulders are very expressive and work well to convey the seemingly somewhat contradictory emotions of defeat and evil (see next page).

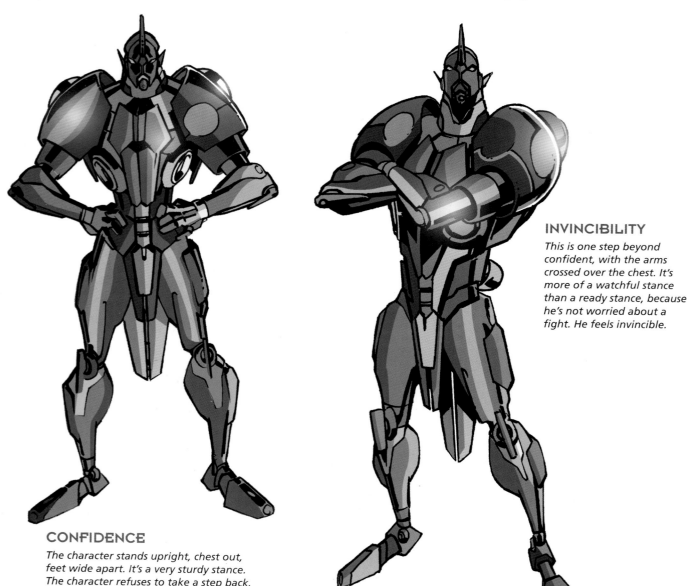

## INVINCIBILITY

*This is one step beyond confident, with the arms crossed over the chest. It's more of a watchful stance than a ready stance, because he's not worried about a fight. He feels invincible.*

## CONFIDENCE

*The character stands upright, chest out, feet wide apart. It's a very sturdy stance. The character refuses to take a step back.*

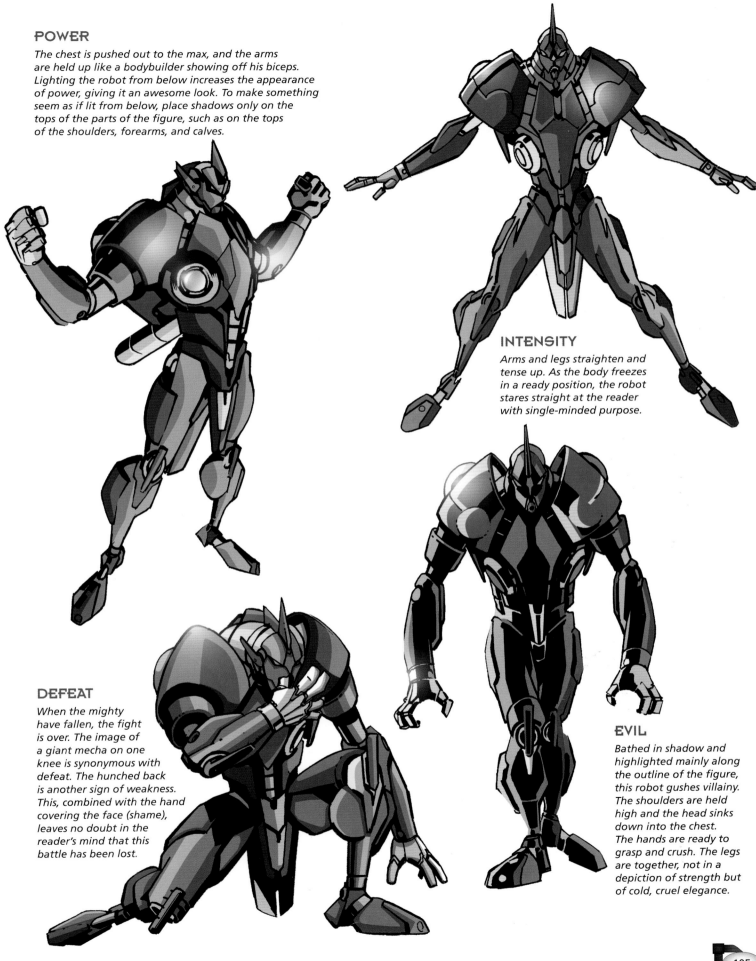

## POWER

*The chest is pushed out to the max, and the arms are held up like a bodybuilder showing off his biceps. Lighting the robot from below increases the appearance of power, giving it an awesome look. To make something seem as if lit from below, place shadows only on the tops of the parts of the figure, such as on the tops of the shoulders, forearms, and calves.*

## INTENSITY

*Arms and legs straighten and tense up. As the body freezes in a ready position, the robot stares straight at the reader with single-minded purpose.*

## DEFEAT

*When the mighty have fallen, the fight is over. The image of a giant mecha on one knee is synonymous with defeat. The hunched back is another sign of weakness. This, combined with the hand covering the face (shame), leaves no doubt in the reader's mind that this battle has been lost.*

## EVIL

*Bathed in shadow and highlighted mainly along the outline of the figure, this robot gushes villainy. The shoulders are held high and the head sinks down into the chest. The hands are ready to grasp and crush. The legs are together, not in a depiction of strength but of cold, cruel elegance.*

# SOME ASSEMBLY REQUIRED

There are no fashionable shoulder flares on the American robots, just 2-ton shoulder protectors. And while Japanese robots look like towering warriors with heroic armor, western-style robots look like tough guys in titanium. Another trademark of Japanese-style robots is the thick, elaborate boots. Western robots don't focus so much attention on the robot's lower body, and so the mecha, instead, tend to be top-heavy. They exude strength, rather than fire power. Japanese robots display military and medieval helmets, and elaborate headdress over a quasi-human face. Western-style robots, on the other hand, don't appear to be wearing helmets; the metal plate *is* the face.

As for the overall construction, American mecha designs tend to be logical. It looks as if you could assemble the robot by reading the instructions. Japanese robots often emphasize ultracool, complex mechanisms and weapons systems. Plus, they usually have more hidden weapons.

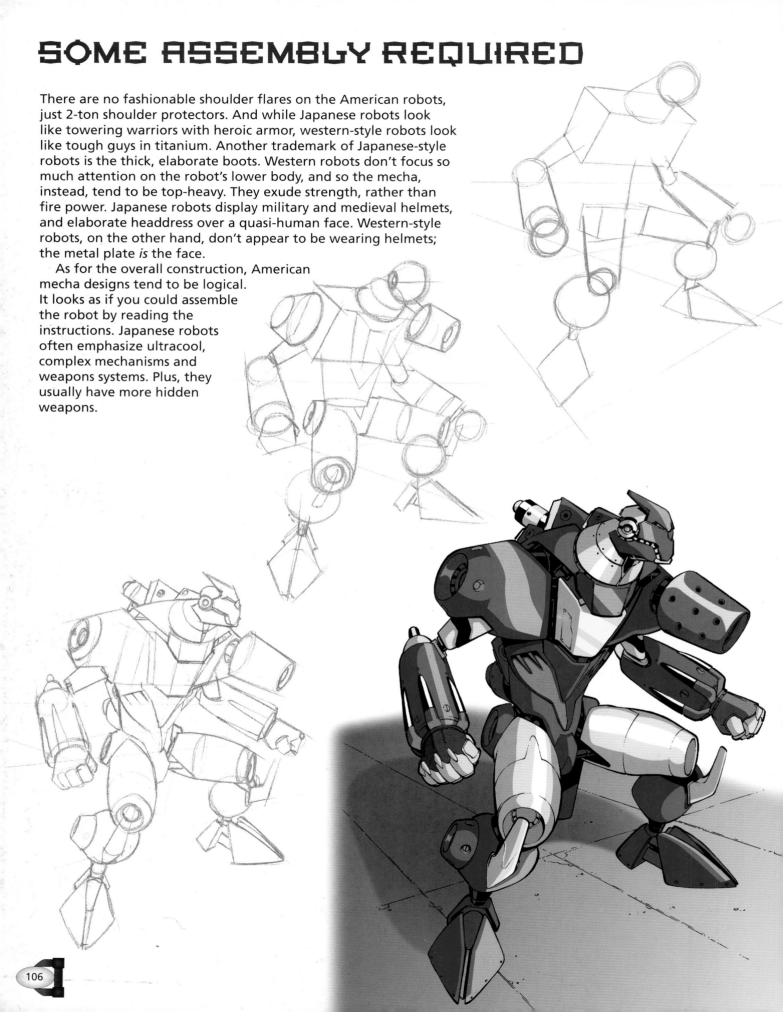

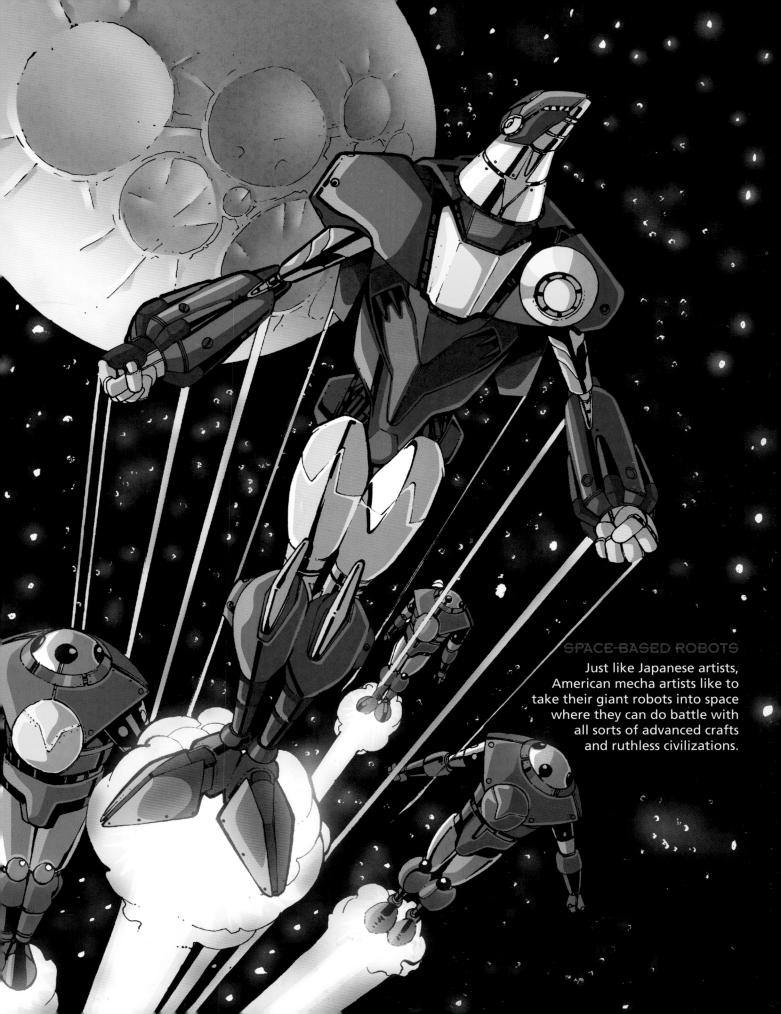

## SPACE-BASED ROBOTS

Just like Japanese artists, American mecha artists like to take their giant robots into space where they can do battle with all sorts of advanced crafts and ruthless civilizations.

# BODYGUARDS

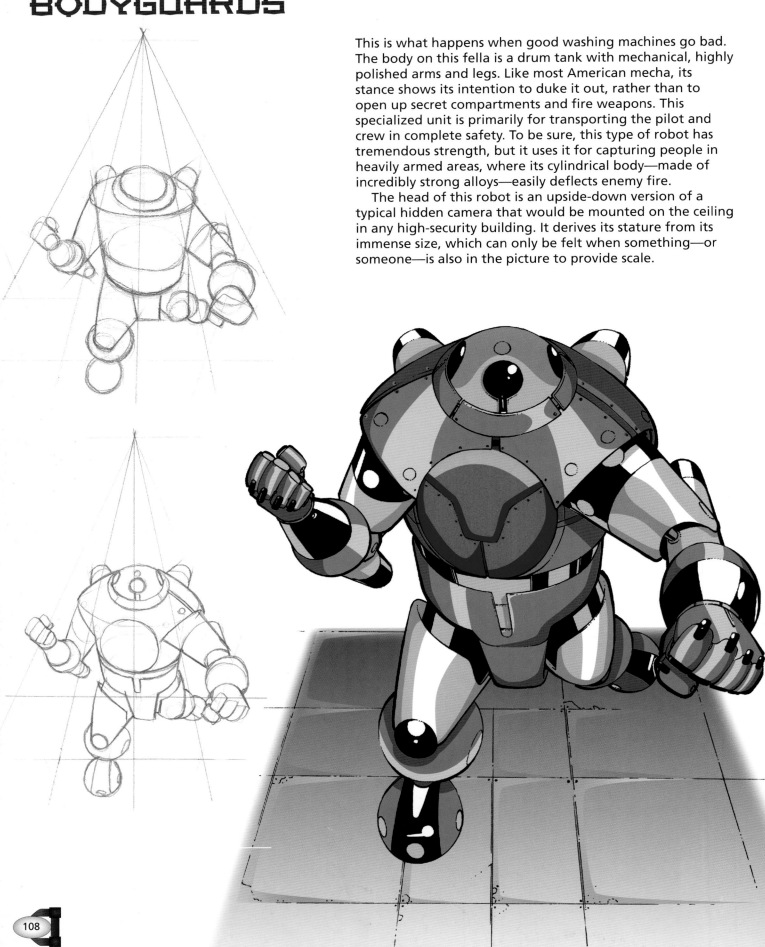

This is what happens when good washing machines go bad. The body on this fella is a drum tank with mechanical, highly polished arms and legs. Like most American mecha, its stance shows its intention to duke it out, rather than to open up secret compartments and fire weapons. This specialized unit is primarily for transporting the pilot and crew in complete safety. To be sure, this type of robot has tremendous strength, but it uses it for capturing people in heavily armed areas, where its cylindrical body—made of incredibly strong alloys—easily deflects enemy fire.

The head of this robot is an upside-down version of a typical hidden camera that would be mounted on the ceiling in any high-security building. It derives its stature from its immense size, which can only be felt when something—or someone—is also in the picture to provide scale.

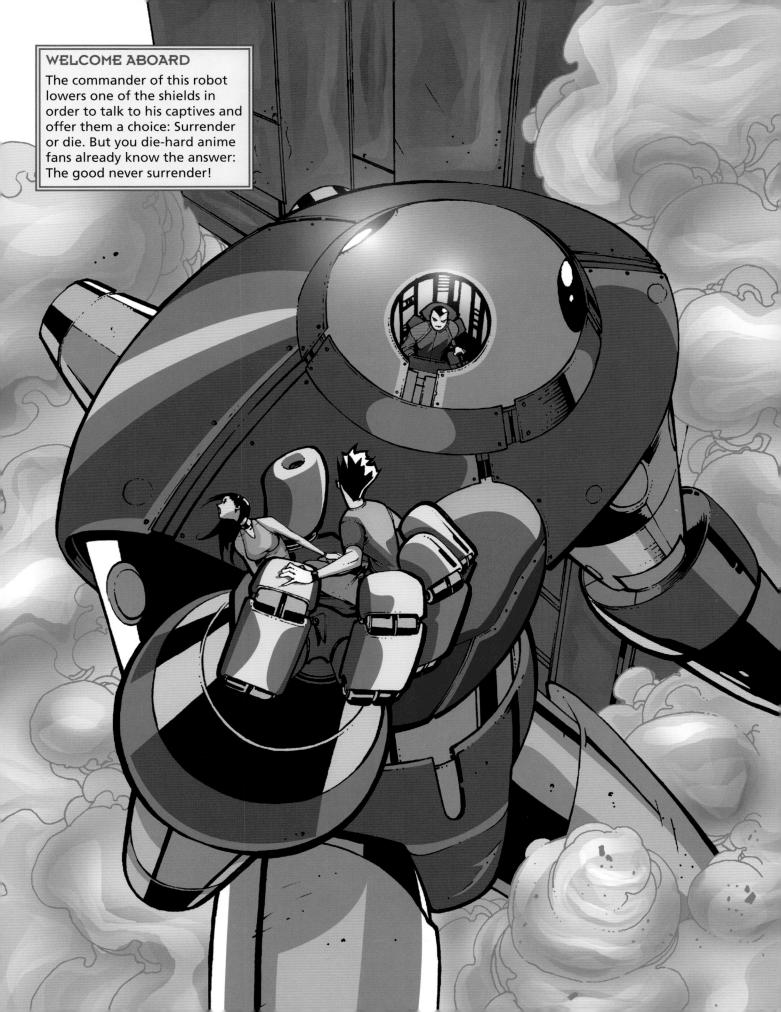

**WELCOME ABOARD**
The commander of this robot lowers one of the shields in order to talk to his captives and offer them a choice: Surrender or die. But you die-hard anime fans already know the answer: The good never surrender!

# SHOULDER-MOUNTED CANNON

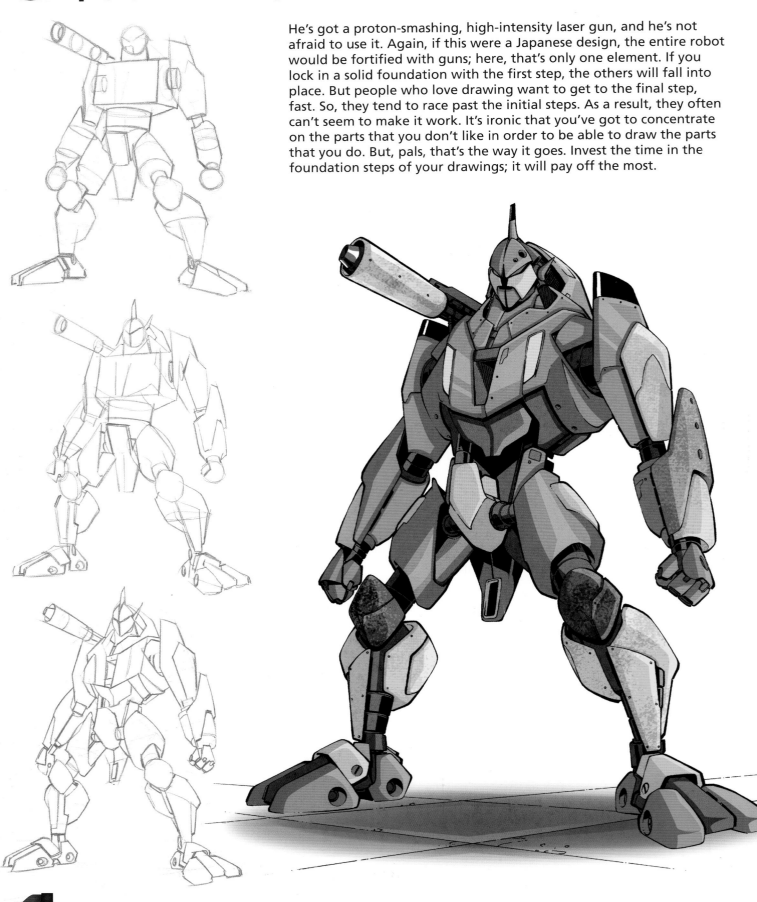

He's got a proton-smashing, high-intensity laser gun, and he's not afraid to use it. Again, if this were a Japanese design, the entire robot would be fortified with guns; here, that's only one element. If you lock in a solid foundation with the first step, the others will fall into place. But people who love drawing want to get to the final step, fast. So, they tend to race past the initial steps. As a result, they often can't seem to make it work. It's ironic that you've got to concentrate on the parts that you don't like in order to be able to draw the parts that you do. But, pals, that's the way it goes. Invest the time in the foundation steps of your drawings; it will pay off the most.

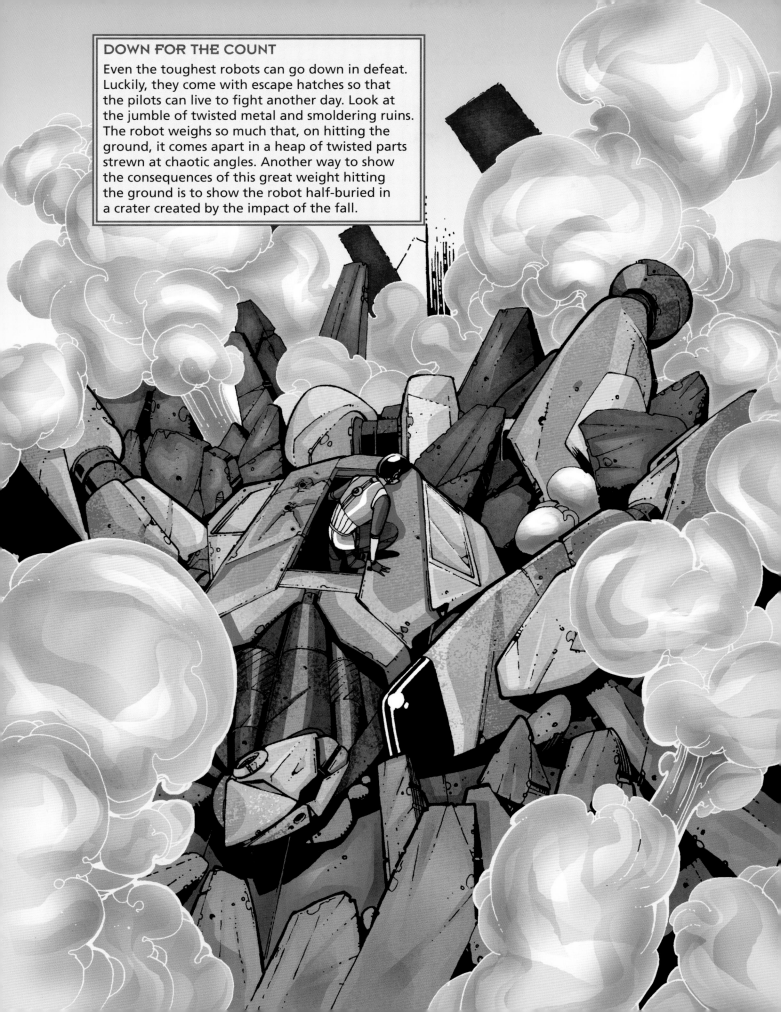

## DOWN FOR THE COUNT

Even the toughest robots can go down in defeat. Luckily, they come with escape hatches so that the pilots can live to fight another day. Look at the jumble of twisted metal and smoldering ruins. The robot weighs so much that, on hitting the ground, it comes apart in a heap of twisted parts strewn at chaotic angles. Another way to show the consequences of this great weight hitting the ground is to show the robot half-buried in a crater created by the impact of the fall.

# EVERYTHING OLD IS NEW AGAIN

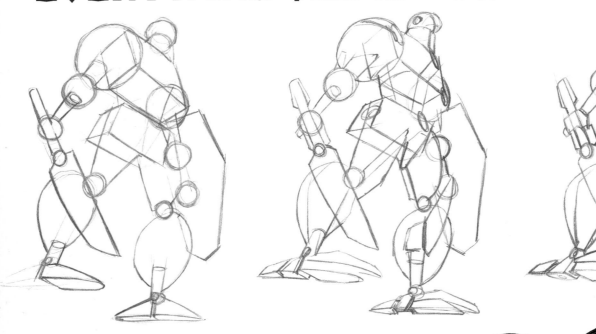

Although it's been over five hundred years since knights fought with swords and shields, they're still very popular. No comic book artists worth their salt ever throw out a good source of inspiration, and the medieval theme is a perennial. It keeps getting reinvented and popping up in new forms. That's how this odd coupling of sword and sorcery gets paired with mecha. Mecha is, after all, derived from the armor of the Middle Ages. Pilots in giant robots are really just knights in armor. Complete the image with a sword and shield.

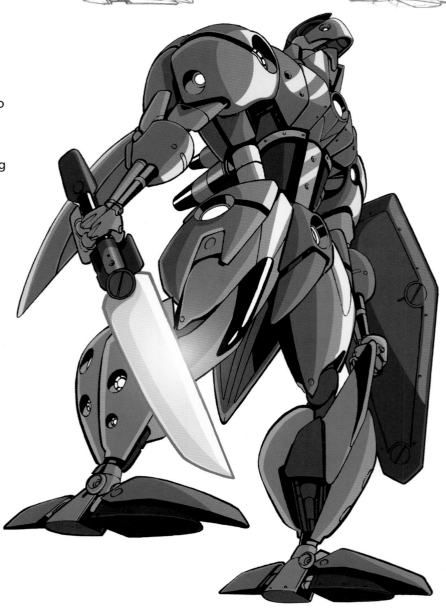

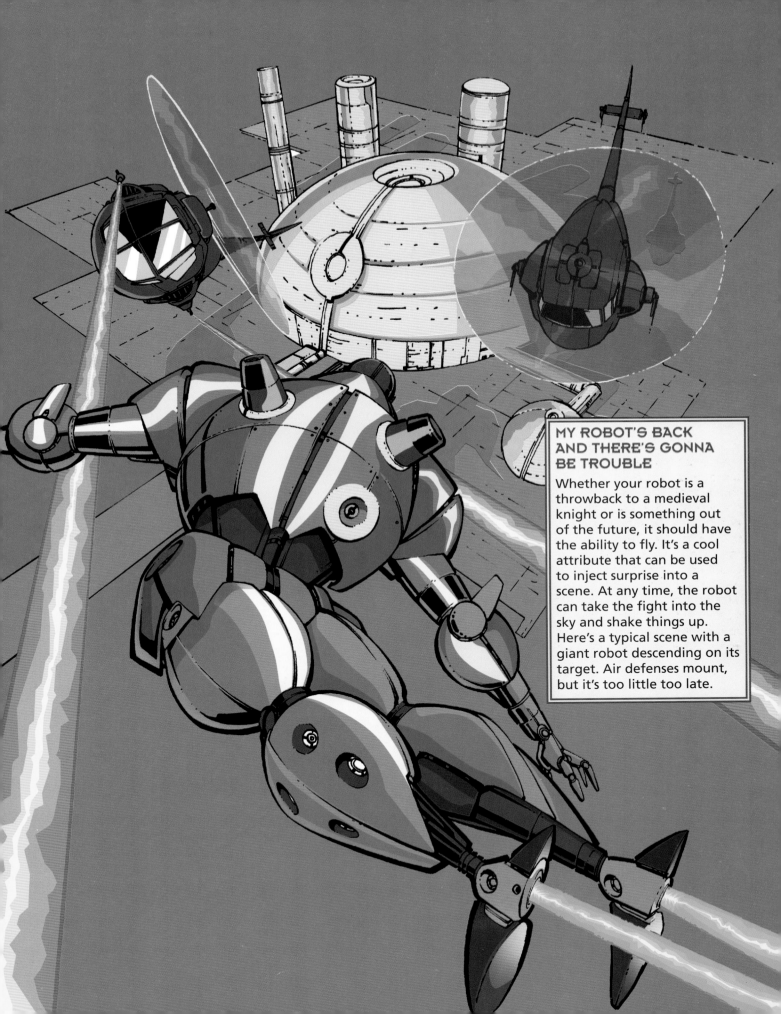

## MY ROBOT'S BACK AND THERE'S GONNA BE TROUBLE

Whether your robot is a throwback to a medieval knight or is something out of the future, it should have the ability to fly. It's a cool attribute that can be used to inject surprise into a scene. At any time, the robot can take the fight into the sky and shake things up. Here's a typical scene with a giant robot descending on its target. Air defenses mount, but it's too little too late.

# OUT TO LAUNCH

Here's an angle that's quite popular in mecha: the robot launches from the hangar with the scientists and engineers watching in awe from below. Robots typically launch straight up, so the view from the ground is drawn at an extreme angle. Draw the rocket burners big, the body medium-size, and the head small (almost obscured from view). The burners don't look big solely because of the perspective in this extreme angle, but because they *are,* in fact, big. The power under the machine has got to be substantial for a successful liftoff—and without big burners, you couldn't justify all of those cool clouds of smoke on the opposite page.

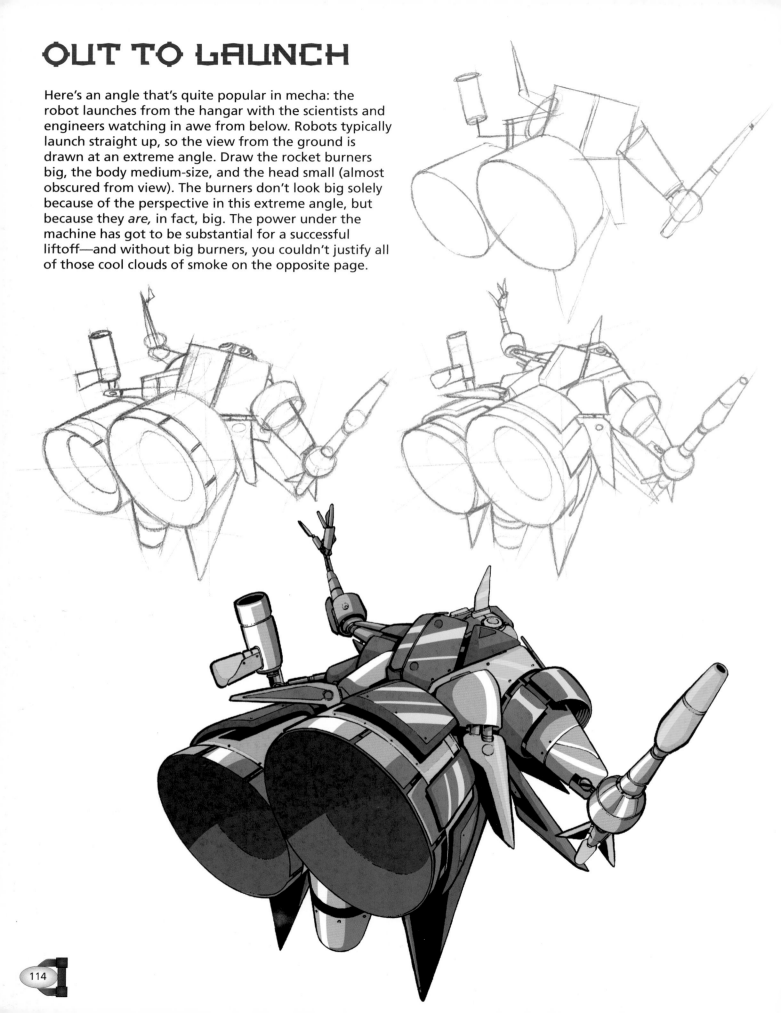

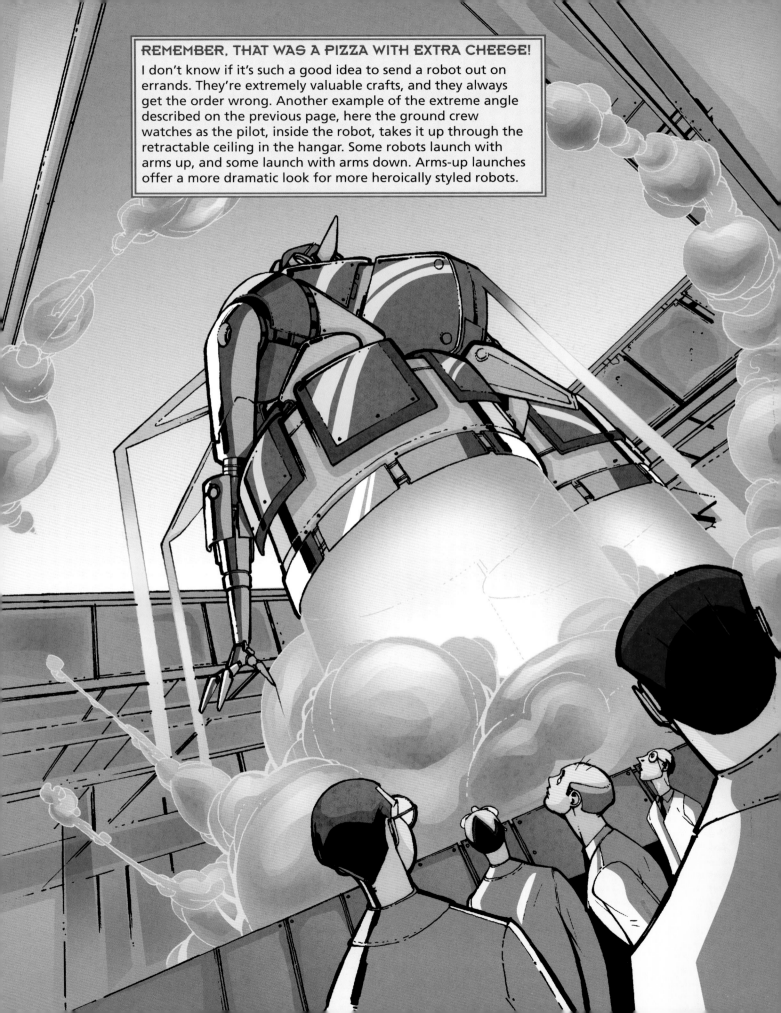

**REMEMBER, THAT WAS A PIZZA WITH EXTRA CHEESE!**
I don't know if it's such a good idea to send a robot out on errands. They're extremely valuable crafts, and they always get the order wrong. Another example of the extreme angle described on the previous page, here the ground crew watches as the pilot, inside the robot, takes it up through the retractable ceiling in the hangar. Some robots launch with arms up, and some launch with arms down. Arms-up launches offer a more dramatic look for more heroically styled robots.

# FIGHTING MAD

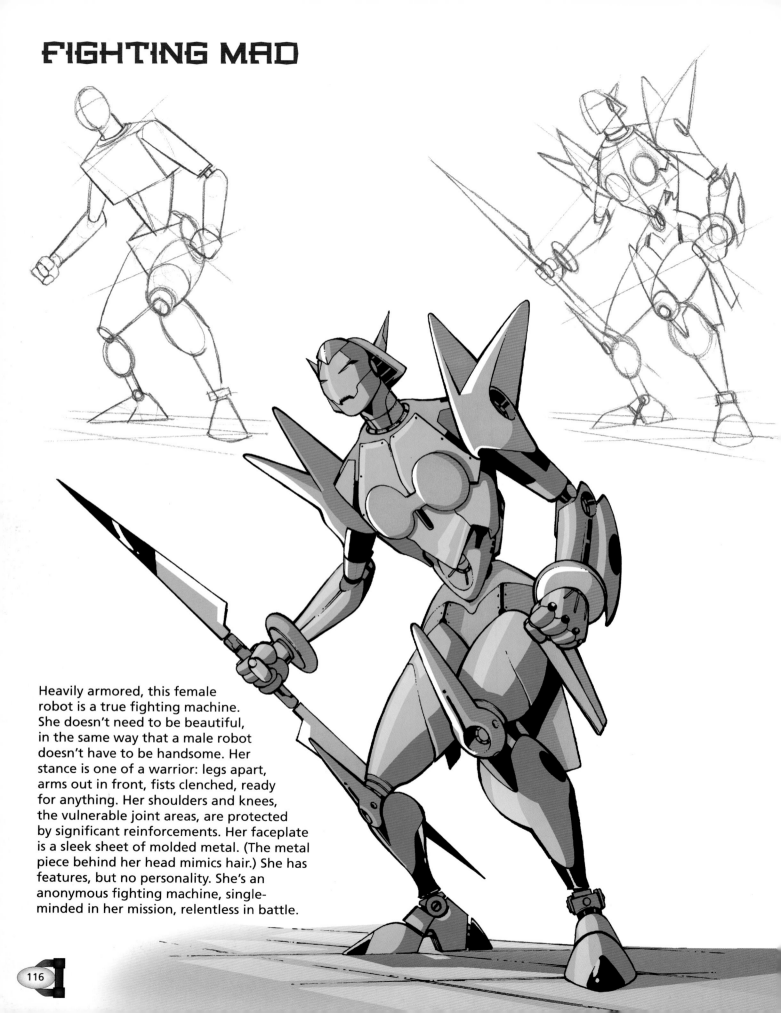

Heavily armored, this female robot is a true fighting machine. She doesn't need to be beautiful, in the same way that a male robot doesn't have to be handsome. Her stance is one of a warrior: legs apart, arms out in front, fists clenched, ready for anything. Her shoulders and knees, the vulnerable joint areas, are protected by significant reinforcements. Her faceplate is a sleek sheet of molded metal. (The metal piece behind her head mimics hair.) She has features, but no personality. She's an anonymous fighting machine, single-minded in her mission, relentless in battle.

## TIME FOR COUNSELING

These two mecha lovebirds are having a little spat, which might just obliterate a city. I hope they can work it out, but I'm not counting on it. Maybe if he bought her a dozen spark plugs? When these behemoths fight, the sparks really fly. Entire cities can tumble, and tidal waves can flatten seaside resorts. Don't focus exclusively on the main characters. Show the chaos that occurs in the environment when two giants collide.

Who doesn't love computer and video games? They're so cool. Many of the popular games rely heavily on mecha-style themes and characters. And, it's a cutting-edge field that artists should consider as a career choice. Yeah, yeah, I know. Your old man wants you to become a doctor or a lawyer. But how much fun is that? Do you really want to spend your life looking into people's ear canals? And how many times do you think you'll be able to read, "The party of the first part," before wanting to scream? On the other hand, what if you could draw stuff and play computer games all day—and get paid for it? I mean, it's not even close.

# AN INSIDE LOOK AT THE FAMOUS FASA STUDIO AT MICROSOFT

MARK DUNCAN AND HEINZ SCHULLER, FASA STUDIO/MICROSOFT GAMES STUDIOS

# AN INTERVIEW WITH HEINZ SCHULLER

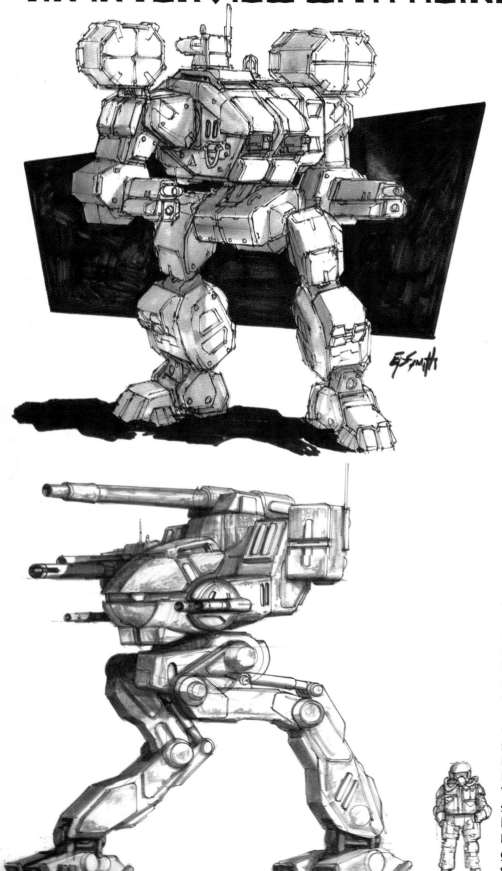

BOTH IMAGES: EDDIE SMITH, FASA STUDIO/MICROSOFT GAMES STUDIOS'

So, how, exactly, does a person get into the field? Where does he or she start? What's it like to design computer and video games? Sit tight, because you're about to get the answers. It's with great pleasure that I bring you this exclusive interview with Heinz Schuller, the art director of the famous Fasa Studio at Microsoft, producers of PC and X-Box games based on the Battletech license. Their MechWarrior 4: Vengeance® has been a top-ten best-selling PC action game since its Christmas 2000 release and continues the eight-year legacy of highly popular MechWarrior computer games.

**Chris Hart:** Heinz, can you give me an overview of your company?
**Heinz Schuller:** Fasa Studio is a group of game artists, programmers, designers, and managers that makes video games. We work as part of Microsoft Game Studios in Redmond, WA, and we are part of Microsoft Corporation. Our group is a very focused and intense bunch who love games and are passionate about making great game experiences. We all play games and really enjoy multiplayer battles. We are very fortunate to have jobs where we can dream about futuristic universes in great detail, then bring them to life using virtual reality and the Internet.

**CH:** What platforms has your company designed games for?
**HS:** Our company focuses on game software for console (X-Box) and PC (personal computers).

**CH:** Which have been your best-selling titles?
**HS:** The most notable game we have produced is MechWarrior 4: Vengeance, a futuristic vehicle simulation where pilots command huge walking tanks called BattleMechs. This title premiered to great reviews and is still selling very strong over a year after its initial release in November 2000. We

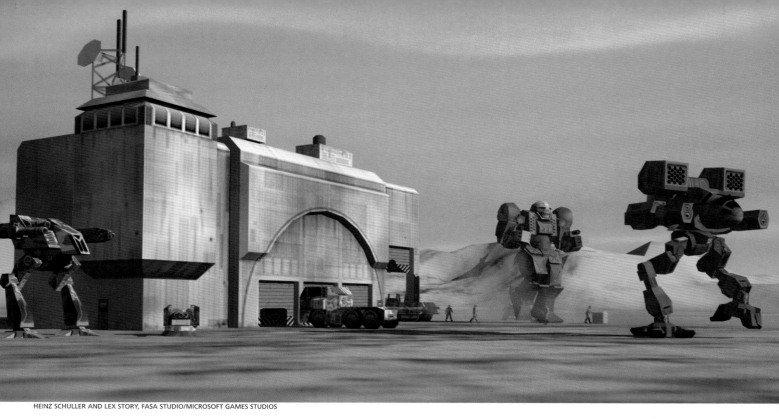

HEINZ SCHULLER AND LEX STORY, FASA STUDIO/MICROSOFT GAMES STUDIOS

EDDIE SMITH, FASA STUDIO/MICROSOFT GAMES STUDIOS

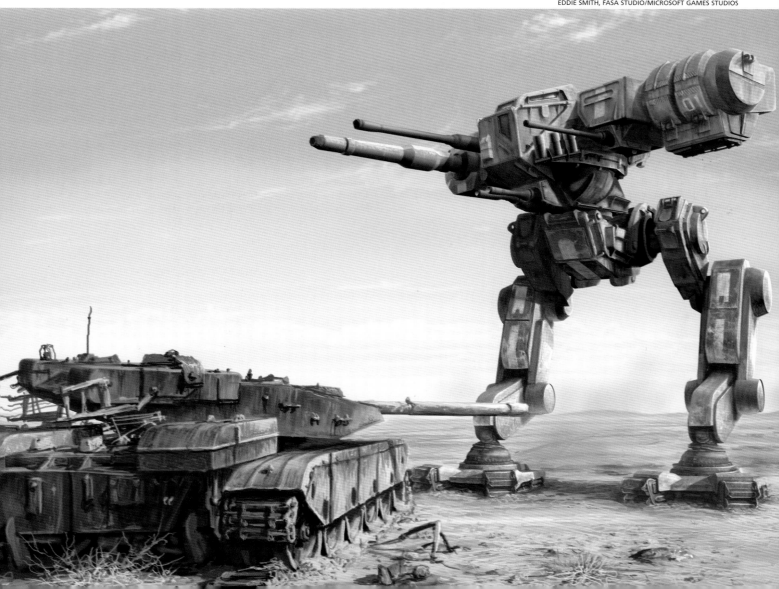

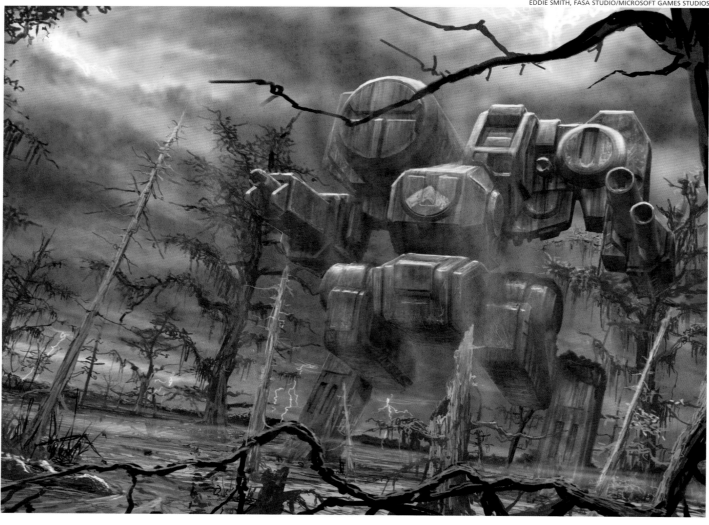

recently released an expansion pack with new missions and vehicles called MechWarrior 4: Black Knight. The game is also very popular in the on-line gaming community; you can go on-line almost any time, day or night, and find games to join.

CH: In the movie industry, there are "must-have" moments, certain types of scenes, like car crashes, that every action flick has. What are some must-have features that games and game characters need in order to be successful?

HS: If we speak in terms of action games, I guess the must-have characteristic is making the player feel supremely powerful—the hero, performing actions impossible to achieve in real life. Another must-have is creating a believable universe in which to immerse the player, [one that's] interesting to

explore and brings the player to places he has not imagined.

CH: How does someone go about getting a job designing game characters? And, what type of work does the job entail?

HS: Artists specializing in character design come to us from a variety of sources. Some are very proficient as traditional illustrators, some are great using three-dimensional tools and modeling software. It's less about the medium for us as much as the results.

Establishing oneself as a game artist just requires a passion for the work and a strong desire to learn the process of making games. A degree or formal education is great but not a requirement for us. We look for talent, and for those who can work well with a group of people in a project scenario. We

look for people on the Internet, through referrals, recruiters, pretty much any channel available to find good people.

Getting a job in the game industry from scratch can happen lots of different ways. But if I had to make recommendations, I'd say start by studying the game companies that make your favorite games, the ones you want to work for, those that make the best quality games and have good reputations as creative leaders. Most of them have on-line forums in support of their games, or third-party fan sites with discussion boards. Get involved in the communities; seek out contacts that can give you information as to who the key people are in the art departments.

While you're doing that, go absolutely nuts creating artwork

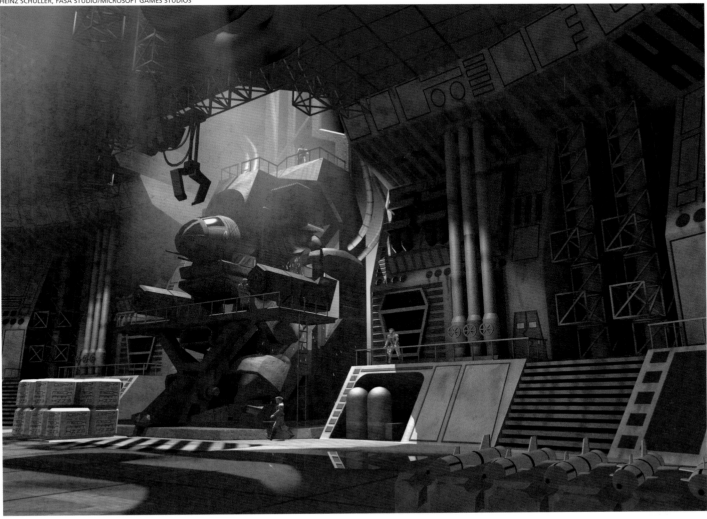

that relates to the game you like. Come up with your own visual ideas that fit the universe you are studying. Create a miniportfolio dedicated to the one game you'd like to work on the most, and use it to supplement your normal portfolio if you get an opening to show your work to someone.

Establish yourself on the Internet; build yourself a small gallery website so that you can link people to it and get others to link to you. Search for on-line graphics forums that specialize in the type of art you love. Build a buzz over time with your work and get known a bit. All of this can lead to contacts. It only takes one to get your foot in the door.

Subscribe to magazines like *Computer Game Developer,* and study the process of making games. These days, it's no longer [only]

about being a great artist but having knowledge of the technical process, being cross-disciplined, and knowing good from bad can all give you an edge over other candidates. Immerse yourself in available resources.

**CH:** When you consider an applicant as a game designer, what do you want to see in a portfolio, and what form should that portfolio come in?
**HS:** Initial contact with artists usually happens on-line, having some sort of on-line web space or portfolio is key to first impressions. When we call someone in for an interview, we like to see traditional portfolios in print or digital disk.

**CH:** How important is the ability to draw freehand, as opposed to working solely on the computer?

**HS:** For our conceptual and matte artists, freehand drawing is key. A good portion of our game visuals are created directly from detailed concept drawings created by skilled traditional artists. They have an incredible impact on the look of the game, from character design to structures, environments, vehicles, etc. They also do paintings we use for box art, certain splash screens in the game, and many other areas. I consider our traditional artists to weigh in equally with our digital artists in terms of design impact for our games.

**CH:** What's the best educational background to have, as an artist, if you want to work in this industry?
**HS:** The key is whether one is talented and has an intense passion for this type of work. A degree in fine arts is a strong asset because it

ultimately means the individual has experience in the process at several levels and has a learned approach to art. More specifically, it means there's much less chance of some large gap in the individual's knowledge when it comes to process. However, because this is still a relatively young industry, we've seen people come from every walk of life imaginable, really. Do you have a vision? Can you work hard and express it in a very focused, precise way? Is your head overflowing with ideas? Can you do it over and over again until it's nearly perfect? I think you get the picture. We don't exclude anybody based on their background, but they have to be prepared to work hard and prove themselves in a production environment.

**CH:** Which is more difficult, designing a first game, or reinventing it to expand your line extension?
**HS:** Any time you sit down to create a new product, whether it's original or a continuation of a series, it's a challenge. On the marketing side, sure it's hard to sell an unknown property versus an established one. But on the creative side of making the game, you still have to make a rich, compelling experience that makes the player feel satisfied each time. And arguably, sequels are harder because the concept is no longer fresh and new; you end up working very hard to keep it interesting.

**CH:** In preproduction, do you work the entire game out on storyboards, like animators?
**HS:** Video games are a bit different than movies; in the most obvious way, they are a player-controlled interactive experience versus a passive viewing experience like cinema. While cinema can be explicitly scripted out to the last letter, designing a video game requires extensive planning in anticipation of all the things a player can do. So from an art standpoint, we do extensive concept art of the robots and other

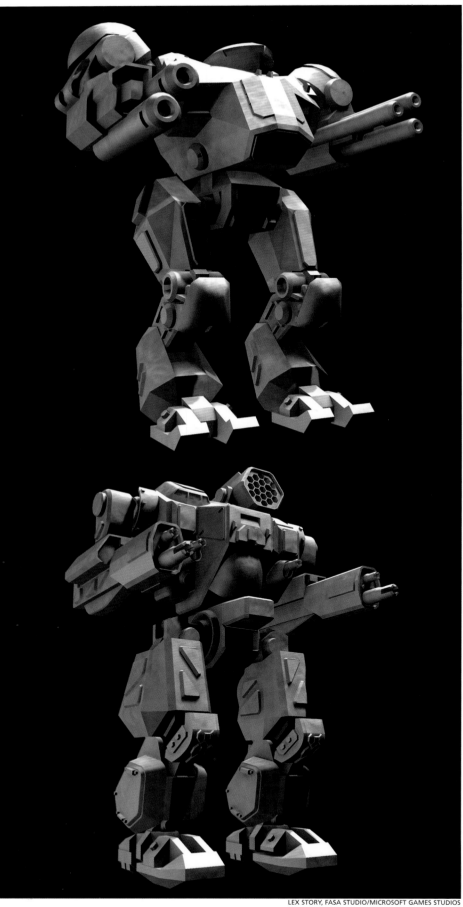

LEX STORY, FASA STUDIO/MICROSOFT GAMES STUDIOS

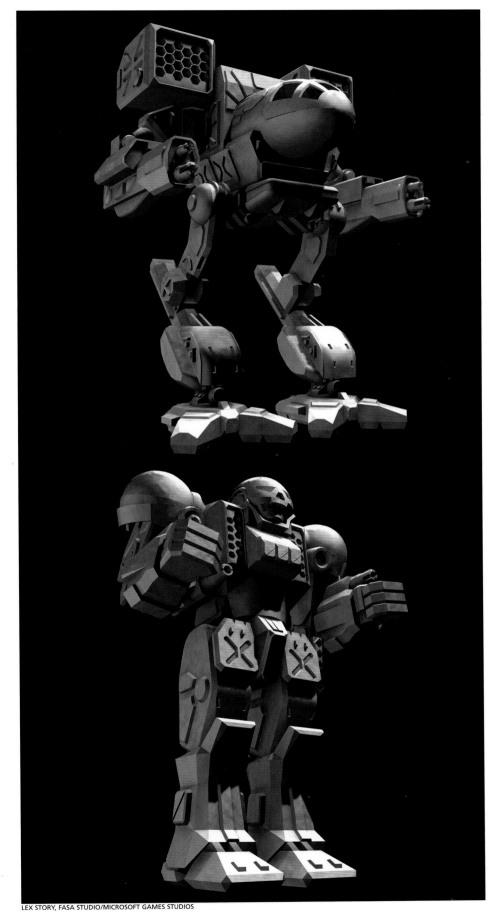

LEX STORY, FASA STUDIO/MICROSOFT GAMES STUDIOS

vehicles and environments used in the game. We work closely with the game designers to try and figure out everything the player sees, does, and reacts to. In a game like MechWarrior, we look at all the things the robots can do and try to produce prototypes of animation, special effects, and environments that help us work out how we will ultimately get things on screen. Certainly, we do storyboards for any cinematics used in the game, or any scripted in-game movies where the player is not in control.

**CH:** How much do the characters change when they go from hand-drawn concepts to computer-simulated characters, and in what way do they change?

**HS:** That's an interesting question. I guess there are good and bad surprises sometimes. Sometimes a perspective can be achieved in a drawing that's actually impossible to attain in three-dimensional space. Usually, this comes from artists who don't think along horizon lines or more exacting drawing methods. This isn't necessarily bad; it's sometimes attributable to drawing styles. In any case, we will occasionally get something built in three dimensions and go, Whoa that looks different than the drawing. Then we usually tweak it to get the compromise between the intention and the execution. And then, more often, we get good surprises, like the excitement of seeing a drawing realized in three-dimensional space and bringing it to life with animation.

**CH:** What types of jobs should artists apply for when they want to break into this business?

**HS:** It all depends on the artist's interests. If we're talking about somebody new to the industry, most often one will apply for a junior-level position on a game production team, or in a game support organization like marketing. Game companies historically structure their staff to contain a mixture of 3-D modelers,

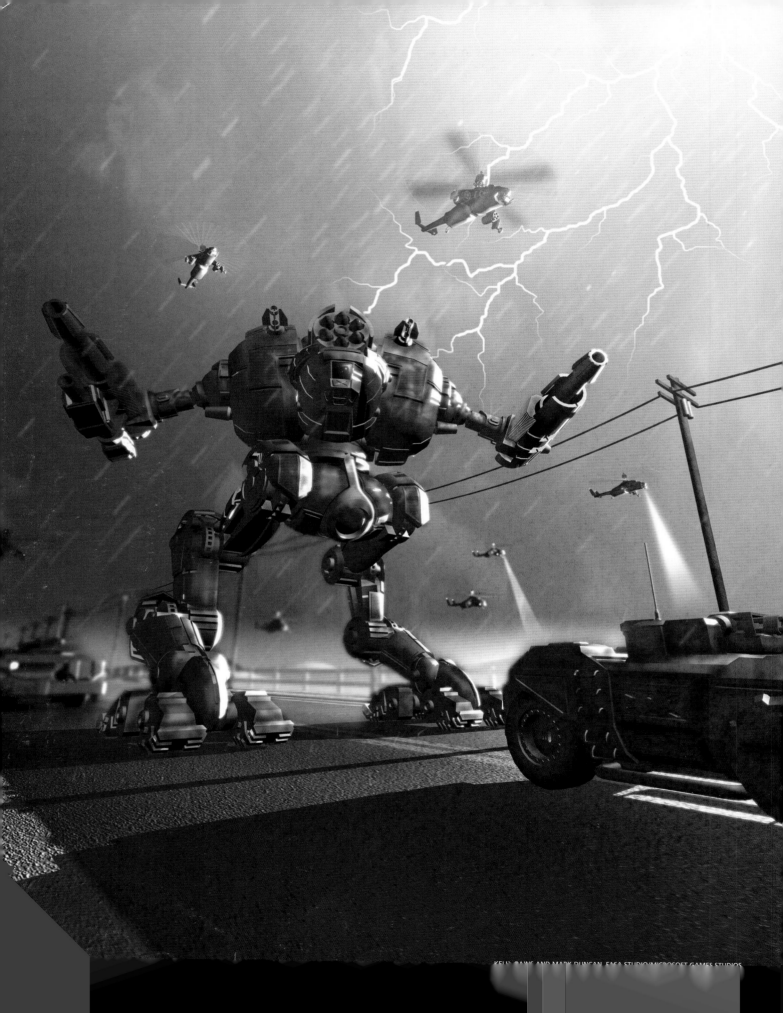

KELLY DAWS AND MARK DUNCAN, FASA STUDIO/MICROSOFT GAMES STUDIOS

3-D animators, 2-D concept artists, and 2-D digital artists. There are junior positions in each category. People applying should demonstrate proficiency in their area of focus, [showing] examples of relevant work and the ability to communicate their experience as articulately as possible. In support organizations, like marketing, there are many jobs like website creation, print and packaging, and internal graphics support.

**CH:** What's the next tier of jobs, the things that artists can aspire to do once they've proven themselves?
**HS:** Game artists usually move up to senior positions within their area of focus; for example, 3-D modelers can expect to receive more challenging and high-profile modeling assignments. Eventually, they can become the "go-to" person for the core characters or important vehicles that make up a game. Ultimately, they will assume responsibility for overseeing a staff of modelers and graduate to art lead or art director positions in the company. There are equivalent paths just like this for most every discipline. That being said, there are those who enjoy staying in production and don't want to manage. It's really up to the individual and his level of motivation.

**CH:** How much does it cost to develop one game for the PC?
**HS:** These days, PC games can get seriously expensive to make. It's not uncommon for a very high-profile or popular game to cost upwards of ten million dollars. Needless to say, the stakes are high and not everyone is successful in these endeavors. I believe this is partially the reason that you are seeing a few very large companies dominate the industry. That's not saying there aren't lots of independent success stories, but given the costs, the industry is most definitely

consolidating. There are fewer game companies today than there were five years ago but a much larger market for video games than ever before.

**CH:** What is the most painstaking process in game development?
**HS:** They're all painstaking. [Laughs] I would probably say in all seriousness that making a great game is the hardest thing to do. To come up with a great original concept, get the funding and form a team of professionals, then sit together for years making an incredibly complex piece of software that needs to be really fun. There are many things that can go wrong, and it takes an extremely motivated and focused group to pull it off successfully. The individual tasks are certainly challenging, but in my opinion, bringing it all together is the hardest thing.

**CH:** Who is your target audience?
**HS:** Our target audience depends on the game. For a game like MechWarrior, we typically target young males between 17 and 29, but the actual audience is much broader. We have lots of people writing us that are women, senior citizens, and even younger kids who really like the giant robot genre.

**CH:** What do you think of the ratings system? Is it important to have it just to show you're a good citizen, or do you think people really make purchasing decisions based on them?
**HS:** The rating system for games has been a huge improvement in our ability to communicate what games are appropriate for which age ranges. That was a big problem in the past. Now we can give parents a resource to know what type of content is in the game their kids are playing. It's also great for me as a father to weed out things inappropriate for my kids. It's a relief actually.

**CH:** Do game designers have to be on your real estate, or is telecommuting part of the job?
**HS:** We really need the core team members to be on-site at our facility. The most single important aspect to making a game is communication with your team members and face-to-face availability for problem solving. However, we do contract artists, programmers, and designers to work with us under contract on specific aspects of the game that we may not be able to cover ourselves. Many of these people are remote, either locally or out of state. But the key team members need to be together or things can really break down quickly.

**CH:** Of the artists you work with, which backgrounds come in most useful: comic book illustrator, animator, cartoonist, graphic designer, or something else?
**HS:** This really depends on the type of game we are making. For MechWarrior we benefit from those with mechanical design experience, people who love to draw hardware. In character-driven games or first-person games, the art style can range from cartoon to photo-realism to almost anything. Traditional or cel animators even have opportunities in games, as 'toon games are very popular. Many times, they are all drawn by hand, and scanned and colorized in the digital realm. That's one of the great things about this industry; it really leverages almost every aspect of traditional and computer art.

I think the opportunities are endless. Heck, my art skills were almost completely rooted in photography when I transitioned into the game business. I was able to transfer my skills and learn three-dimensional software packages pretty easily, as the concepts are very similar. If I can do it, anyone can!